YOUNG
LEONARDO

YOUNG LEONARDO

THE EVOLUTION OF A
REVOLUTIONARY ARTIST, 1472–1499

Jean-Pierre Isbouts
and Christopher Heath Brown

Thomas Dunne Books
St. Martin's Press ⋈ New York

THOMAS DUNNE BOOKS.
An imprint of St. Martin's Press.

YOUNG LEONARDO. Copyright © 2017 by Jean-Pierre Isbouts and Christopher Heath Brown.
All rights reserved. Printed in the United States of America. For information, address St. Martin's Press, 175 Fifth Avenue, New York, N.Y. 10010.

All images courtesy of Brown Discoveries, LLC, unless otherwise noted.

www.thomasdunnebooks.com
www.stmartins.com

The Library of Congress Cataloging-in-Publication Data is available upon request.

ISBN 978-1-250-12935-2 (hardcover)
ISBN 978-1-250-12936-9 (e-book)

Our books may be purchased in bulk for promotional, educational, or business use. Please contact your local bookseller or the Macmillan Corporate and Premium Sales Department at 1-800-221-7945, extension 5442, or by e-mail at MacmillanSpecialMarkets@macmillan.com.

First Edition: May 2017

10 9 8 7 6 5 4 3 2

CONTENTS

Contents

INTRODUCTION

The noblest pleasure is the joy of understanding.
—LEONARDO DA VINCI

The traditional view of Leonardo's early career is that he was recognized as a prodigy in the workshop of Verrocchio, enjoyed a promising start in Florence, and then moved to Milan to become the celebrated court artist of Duke Ludovico Sforza, the ruler of the Duchy of Milan. As this book aims to show, the opposite is true. Almost from the beginning, Leonardo struggled to develop a style that rejected the formulaic Quattrocento "brand" of his master, Andrea del Verrocchio, but he was stymied in his efforts to finish his first masterpiece in Florence. He then left for Milan on little more than a wing and a prayer, but for many years was studiously ignored by Ludovico. It was only because of his association with the de Predis brothers that he was able to survive. Worse, when he finally did receive a ducal commission—the famous Sforza equestrian monument—it ended in failure, whereupon he had to satisfy himself with secondary commissions, such as the portraits of Sforza's mistresses.

In fact, the reader may be astonished by the questions that still swirl around the work of young Leonardo. For example, what is the true reason that *The Adoration of the Magi,* the seminal work of his early Florentine period, is unfinished? And why did Leonardo decide to move to Milan, of all places—a court known more for its wealth than for the

quality of its artistic endeavors? And why did Milan's ruler, Duke Ludovico Sforza, ignore Leonardo for so many years? Why did all the truly important commissions that emanated from the court of Milan, such as church frescoes, monuments, and "Sforza propaganda art," go to Lombard artists who were much less talented? Indeed, should Leonardo be considered a "court artist" at all? If he was truly Sforza's celebrity painter, the leading light of his court, then why was he not involved in the projects the duke genuinely cared about, such as the decoration of the massive Milan Cathedral, or the Certosa di Pavia monastery complex, or countless other churches, including the Santa Maria delle Grazie itself?

Even the *Last Supper* fresco, about which scores of books have been written, still harbors many mysteries. For example, what is the relationship between *The Last Supper* and the fresco of *The Crucifixion,* which was begun on the opposite wall at exactly the same time as Leonardo began his painting? Is there a hidden program between the two? And why is there such an obvious connection between Leonardo's donor portraits on the *Crucifixion* and the mysterious "Sforza Altarpiece," the *Pala Sforzesca*?

Why have these questions not been addressed before? The answer is perhaps simpler than we might expect. Most modern authors are so focused on the centuries-old effort to physically restore the *Last Supper* fresco, Leonardo's Milanese masterpiece, that they are almost blindsided by it. And while the latest restoration, completed in 1999, is certainly impressive from a technical point of view, its outcome is rather sobering: only some 20 percent of Leonardo's original masterpiece is still extant.

The conclusion is inevitable: *we no longer know what this painting looked like.* Yet, there is no question that with this painting, Leonardo singlehandedly introduced the era of the High Renaissance. But how can we appreciate the work as Leonardo's contemporaries saw it? Is it possible to reconstruct the fresco by other means?

Introduction

This provocative book was written to answer these questions, and to offer a fascinating window on the mind of a young artist as he slowly developed the groundbreaking techniques that would transform Western art.

PART I

Toward The Adoration of the Magi

Leonardo's Early Oeuvre in Florence

PROLOGUE

Art is never finished, only abandoned.
—LEONARDO DA VINCI

They were, by any measure, outrageous terms. Some would have called them downright insulting. For the contract stipulated that, to begin with, the artist was expected to pay for the commission *himself*—not just his brushes, pigments, and all other materials, but also the cost of the assistants who would be mixing the paints, prepping the panel, and applying the gesso, the preparatory coat of gypsum and glue. Worst of all, the artist would not be paid for his labors until the work was completed, delivered, and duly accepted to the patron's satisfaction. Even then, the painter would not be paid in cash, but in kind—in the form of a portion of a small estate in the Val d'Elsa that a benefactor had bequeathed to the monastery some months before. On the plus side, the property had been valued at three hundred florins (roughly forty thousand dollars in modern currency). On the downside, half of it was supposed to serve as the dowry for the patron's daughter—which, incidentally, the artist was expected to advance as well. And if at any time the painter decided to walk away from the commission, he would, as the friars told him, "forfeit that part of it which he has done."

Outrageous terms indeed—which suggests a few things. For one, it indicates a deep skepticism on the part of the commissioning agency,

the Augustinian monks of San Donato a Scopeto, in Florence, that the artist could actually pull off the commission. Second, it suggests that the good friars would probably not have hired the painter at all had their attorney, a certain Ser Piero da Vinci, not lobbied strenuously on the artist's behalf. He had good reason to do so, for the painter in question was none other than his son—an illegitimate son, to be sure, but his son, his own flesh and blood, nevertheless.

1

BEGINNINGS IN FLORENCE

You can have no dominion greater or less than that over yourself.
—LEONARDO DA VINCI

Ser Piero da Vinci recognized the talents of his young son, Leonardo, early on. That's why, in 1466, he arranged for the boy to be apprenticed at the workshop of Andrea del Verrocchio in Florence when the boy was just fourteen years of age. According to the sixteenth-century author Giorgio Vasari, one of da Vinci's first biographers, Leonardo was soon recognized as a prodigy, which under normal circumstances would have meant that a bright future lay ahead of him. So, in the six years that he worked in Verrocchio's *bottega,* Leonardo learned to draw, to prep wet plaster and wooden panels, to stretch canvas, and to grind and mix pigments in order to create paint. (Ready-made paint tubes of the type we use today would not appear until the nineteenth century.) Eventually he was entrusted with more important tasks, such as transferring a cartoon (a drawing to scale) to a plaster or wooden surface, blending colors in water-based tempera or oils (still a relatively new invention then), and finally, painting lesser elements, such as a background landscape.

Verrocchio's workshop was in high demand, which meant his pupils worked on a wide range of artistic endeavors, not only painting and sculpture (in plaster, wood, or bronze), but also a variety of furnishings, such as wooden chests, chairs, and coats of arms. The studio was also called

upon whenever Lorenzo the Magnificent, the Medici ruler of the city, wished to produce any of the sumptuous masques and pageants for which his rule was famous. This invariably involved all sorts of intricate stage sets and machinery, as well as costumes, tapestries, and the construction of temporary structures such as Roman-style triumphal arches. Leonardo was at the studio when Verrocchio attained one of his greatest triumphs: the completion of a huge gilded ball that, in 1471, was hoisted to the top of the lantern of Brunelleschi's famous dome over the Florence Cathedral. In the process, Leonardo was thoroughly indoctrinated in Verrocchio's unique brand of art: the production of lovely though somewhat soulless and formulaic figures, whether sacred or secular, whose robust *disegno* betrayed the master's preference for sculpture over painting.

Six years after his arrival in Verrocchio's studio, Leonardo was enrolled as a master in the guild of art-ists, which, as it happened, also included the trade of doctors and apothecaries (*medici e spezi-ali*). This enabled him to accept commissions on his own, rather than through his tutor and mas-ter. Leonardo was not the only painter to be enrolled; Sandro Botticelli (a product of Fra Filippo Lippi's workshop) and Pietro Perugino (likewise a pupil of Verrocchio's) were also in-ducted that year.

Leonardo was certainly ready to embark on a career as an art-ist in his own right, but initially that was not the case. As a

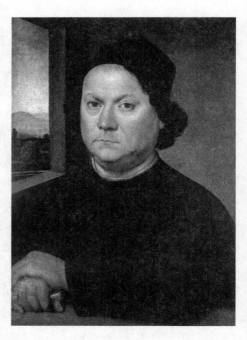

Lorenzo di Credi, *Portrait of a Man*, 1503, believed by some to represent Andrea del Verrocchio.

graduate from this busy atelier, he became one of Verrocchio's associates—a common practice at the time, and one that Leonardo himself would adopt in later years. This meant that the former pupil, now an "assistant," was tasked with working on various parts of paintings, sculptures, and other creations then under development at Verrocchio's *bottega*.

In recent decades, the need for a large stable of assistants had become the norm at the leading studios in Florence. Ever since the plague, the Black Death of the mid-fourteenth century, eliminated many of Florence's principal rivals in the cloth and banking trade, notably Siena and Pisa, the city had become the source of stupendous bourgeois wealth. As always, wealth seeks an outlet and, in Florence, the rich merchants had long since decided that art should be one of these outlets. They didn't buy paintings for the reasons that wealthy collectors buy art today—as a form of investment, hedging their bets that art appreciates faster than other human artifacts, such as real estate—but for the simple reason that art bestows a certain prestige. Throughout the Middle Ages, the commissioning of art had been the exclusive province of the two powers that ruled Europe: the Church and the aristocracy. Now the bankers and merchants of Florence were emerging as the third most powerful group in the city. Outwardly, they might have mocked and disparaged the nobility as a fading relic of the past, but privately they tried very hard to emulate them.

This development was partly fueled by the idea that Florentine art had undergone an important transformation. While previously, Italian paintings were restricted to the depiction of sacred themes, preferably scenes from the Gospels, Florence had boldly expanded the repertoire by embracing motifs from its ancient past. Even now, anyone who cared to look could find the remnants of Roman sculptures, reliefs, or temples scattered throughout the Tuscan countryside. That the artistry of the Romans was beyond parallel (and, it should be said, technically superior to anything that medieval artists had achieved) was always well known. Unfortunately, such *spolia,* as these fragments were depreciatively called, were also the tangible products of a pagan culture, a society that had wallowed in the

superstitious belief in gods and goddesses, usually depicted in the nude, as sufficient reason for the Church to ban them as heresy.

Yet all that changed at the dawn of the fifteenth century, the Quattrocento, when the classical spirit seeded by the works of Dante, Petrarch, and Boccaccio took root among the citizenry of Florence. And not just the citizenry. Many of the city's pious souls may have been shocked when the committee supervising the production of sacred art for the Florentine cathedral issued a competition for a new set of doors for its baptistery in 1401, and was found to be deeply impressed by the works of two sculptors, Lorenzo Ghiberti and Filippo Brunelleschi. Both competitive designs openly flaunted copies of famous Roman sculptures. Sometime thereafter, Brunelleschi solved a problem that had stumped medieval technology: how to cover the vast crossing space of the Florence Cathedral with a dome. He did so by simply copying the engineering design of the dome of the Roman Pantheon, which is still standing today in the heart of Rome.

From that point on, the floodgates were open. The imitation of all things Roman—in art, in sculpture, in literature, even in the collection of Roman coins—now became the attribute of the New Florentine Man: a sophisticated dilettante as knowledgeable about the Gospels as about the exploits of the Greco-Roman gods.

Of all the arts, however, painting was the one discipline that had been least affected by the new Renaissance. While there were Roman sculptures and architectural pieces aplenty, Roman *paintings* were all believed to have perished in the preceding centuries—or so it was thought, until the discovery of Pompeii in the seventeenth century. Thus, the influence of Roman precedent on Florentine art was limited to the depiction of mythological motifs (*The Birth of Venus,* say), albeit in the late medieval style that skillfully blended the art of Giotto and Masaccio with the new invention of linear perspective.

Verrocchio's workshop embraced the art of Antiquity as eagerly as other studios in the city, particularly when it came to sculpture, or the development of backdrops and costumes for masques (an early form of histori-

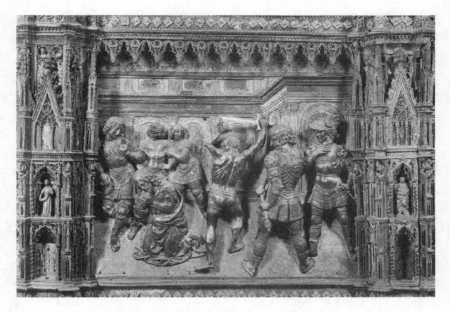

Andrea del Verrocchio, *Beheading of St. John the Baptist.* This relief in the Baptistery in Florence from around 1477 was made while Leonardo served as an apprentice in Verrocchio's workshop, and shows Verrocchio's command of linear perspective.

cal theater). When it came to painting, however, Verrocchio preferred to remain faithful to the Late Gothic style that had swept Europe in the fourteenth and fifteenth centuries. Verrocchio was not a man to take risks. In 1457 he had passed through a period of financial difficulty. His tax statement of that year confessed that he was "losing his shirt" trying to keep the shop in operation. (The Italian expression is *Non guadagniamo le chalze,* or "We can't keep our hose on.")[1]

What's more, Verrocchio thought primarily in plastic terms, since he vastly preferred sculpture over painting (as in the case of Michelangelo), and was happy to leave the tedium of painting to his more experienced pupils. It was this Verrocchio style, an uneasy blend of old and new, of Gothic design and a somewhat sculptural and muscular formalism, that Leonardo fully absorbed during his apprenticeship years, only to improve on it as soon as he got the chance.

That chance came with *The Baptism of Christ* of 1475, a painting

commissioned by the monks of the San Salvi monastery, just outside the Porta alla Croce. Verrocchio charged his young assistant with painting one of the angels. The sixteenth-century biographer Giorgio Vasari claims that when Verrocchio saw what Leonardo had done, and recognized the superior quality of his work, he "never again touched color"—painting, that is. Left unsaid is the way in which Leonardo was able to make his angel more luminous and realistic. Verrocchio's own style was grounded in the use of tempera, the quick-drying, water-based paint that allows for little plasticity. As such, it was perfectly suited for the Quattrocento style of creating figures as colored-in lines, a style exemplified by the art of Botticelli.

Leonardo, however, never thought in terms of drawing lines (*disegno*). His interest lay in creating three-dimensional *shapes,* forms that were suggested, rather than defined, through the use of delicate glazes, of subtle hues and shading. Tempera paint could never achieve such effects. This is why Leonardo preferred to use oils in his paintings, a technique that had been developed by northern European artists and that was relatively new in Florence. Recent X-ray tests of the *Baptism* show that, whereas Verrocchio was still painting his figures as contours in tempera on a white lead base, Leonardo was using thin, superimposed layers of colored oils in the sections assigned to him.[2]

The truth is that when Verrocchio recognized his assistant's virtuosity in this new technique, he was probably relieved. "Great, you can do the paint jobs from now on," he may have said, for this arrangement would have allowed him to focus exclusively on sculpture, a discipline he was far more comfortable with.

Indeed, Leonardo painted other sacred panels while in Verrocchio's employ, including several depictions of the Madonna, using oil on panel. This may explain why he remained faithful to the Verrocchio prototype of feminine grace for quite some time, for his output had to follow to some extent the "brand" established by the master, even though Leonardo soon probed for improvements. There was plenty of opportunity for that, for this series of Madonna paintings was destined not for churches or mon-

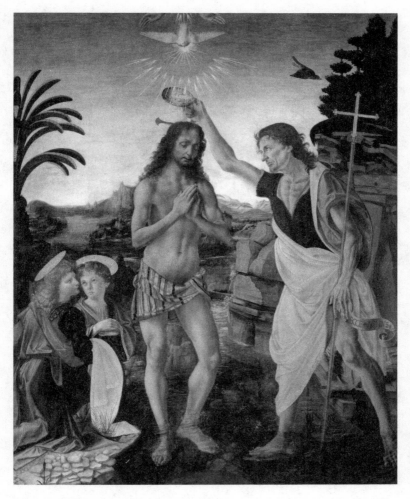

Andrea del Verrocchio, *Baptism of Christ*, 1472–75.

asteries, as was usually the case, but for private homes. The rapid growth of urban centers had led to the rise of a new form of religious society known officially as the Order of Preachers, but more colloquially as the Dominican Order, which included friars and nuns as well as laymen and tertiaries.

The order's purpose was to sustain preaching and piety in a society that was reaping levels of prosperity not seen in Europe in centuries. As part of their program, the Dominicans encouraged the citizenry not only to

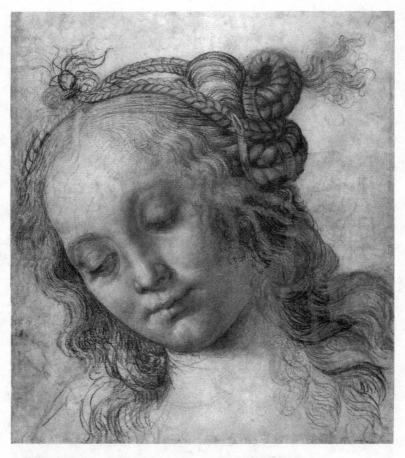

Andrea del Verrocchio, *Study of a Young Woman*, 1470s. This Verrocchio archetype of the Madonna, including the ornamental hairstyle, would dominate Leonardo's portraits of the Virgin and Child until his Milanese period.

attend services in church, but also to spend time in contemplative study and prayer at home.

To facilitate this type of private meditation, many homes began to acquire what in German is called an *Andachtsbild,* a devotional painting of Christ, the Madonna, or saints that would help the faithful focus their prayerful thoughts. Verrocchio's Madonnas from the 1470s, many of which are (at least partly) attributed to Leonardo, are a perfect example of this new motif.

To emphasize the domestic character of the painting, Mary is typically shown in a small, enclosed space, with windows or portals that open up to a splendid, sun-splashed Italianate landscape. What's more, she is shown "in close-up," from the torso up, rather than in the full-length format favored in church frescoes, so as to establish an intimate bond between the figure and the beholder.

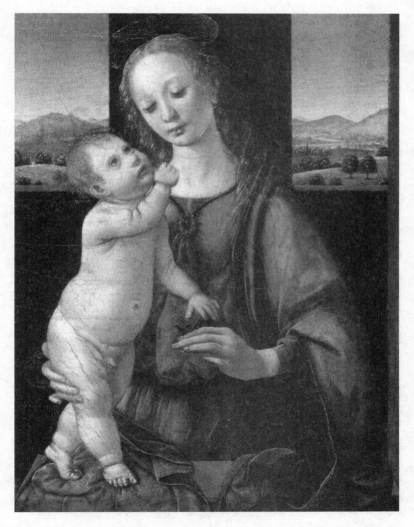

Dreyfus Madonna, ca. 1472. The artist may be Lorenzo di Credi, Verrocchio, or even Leonardo.

The so-called *Dreyfus Madonna* of around 1472, traditionally attributed to Lorenzo di Credi but more recently to Verrocchio or even Leonardo, is a perfect example. The parallels between this panel and one of Leonardo's early paintings, *The Madonna of the Carnation,* are obvious. Mary's pose and the treatment of her garment are almost identical in the two works, as is the position of the Child, although, in *The Madonna of the Carnation* he is seated, rather than standing, on Mary's lap. Perhaps

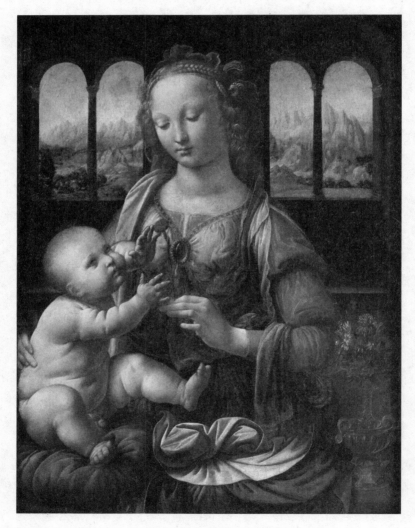

Leonardo da Vinci, *The Madonna of the Carnation,* ca. 1478.

the sheer impossibility of balancing an infant on his mother's right leg offended Leonardo's devotion to verisimilitude.

Nevertheless, *The Madonna of the Carnation* dutifully follows the custom, borrowed from northern European painters, of enhancing a scene with various floral types, each endowed with a symbolic meaning. Thus, the Child is reaching for the red carnation in Mary's left hand, not yet knowing that this is an allegory of his future suffering on the Cross. Balancing the composition, on the right, is a crystal vase filled with a bouquet of flowers, a symbol of Mary's purity as a virgin.

In all these respects, *The Madonna of the Carnation* may be a typical product of the Verrocchio workshop, but other intriguing details already reveal Leonardo's talent for exploring new solutions. Whereas the *Dreyfus Madonna* is universally lit, as if the scene were painted outdoors against the prop of a back wall, Leonardo, in his panel, uses the indoor setting to cast the figures in a daring chiaroscuro, a contrast of brightly lit passages and deep shadows, using Mary's face and the baby's skin as the transition between darkness and light. Particularly in the treatment of Mary's face, with its soft glow of hues, Leonardo shows himself a prodigy in oils, wielding a technique that would become the hallmark of his style.

Another feature that would return in Leonardo's mature works was his fascination with deep landscape vistas. In this, once again, northern European artists such as Jan van Eyck and Rogier van der Weyden preceded him, but with an important difference. Northern artists created a form of landscape in which nature has been tamed by man, with soft rolling hills dotted by picturesque villages, and rivers dutifully winding themselves into the distance—the very image of Christian medieval order. By contrast, the landscape glimpsed through the windows of *The Madonna of the Carnation* is a wild, untamed land of jagged rocks and forbidding glaciers towering high on the horizon. The resemblance between this panorama and that of *The Virgin of the Rocks,* or even the *Mona Lisa* and the *Saint Anne,* is striking.

In sum, *The Madonna of the Carnation* is perhaps the first painting that signals Leonardo's determination to break away from Verrocchio's cloying

stereotypes in order to survey paths of his own. His contemporaries did not fail to recognize this. Vasari called the painting "a most excellent work," and reserved special praise for the "glass vase full of water, containing some flowers, in which, besides its marvelous naturalness, he had imitated the dew drops on the flowers, so that it seemed more real than the reality." In fact, the painting was sufficiently admired to make its way ultimately into the collection of Pope Clement VII, or so Vasari claimed.

THE NEED FOR MEDICI PATRONAGE

To be a successful artist in the 1470s meant one had to have a connection to the wellspring of patronage of Lorenzo de' Medici, the powerful "Lorenzo il Magnifico," who ruled Florence as a private fiefdom. A skillful diplomat and crafty politician, Lorenzo thought of himself as a gentleman scholar and poet who had reluctantly accepted the yoke of political leadership. He liked to surround himself with leading intellectuals such as Pico della Mirandola and Marsilio Ficino and, in his free time, discuss Neoplatonic ideas that blended Christology with Plato's

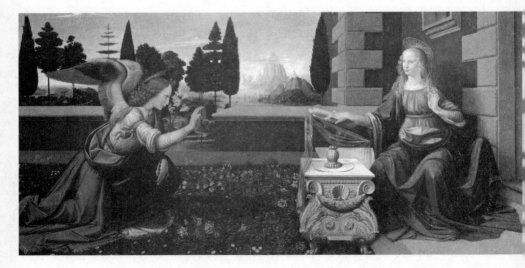

Verrocchio workshop, including Leonardo da Vinci, *The Annunciation*, ca. 1474.

reason. He expected his artists to be equally comfortable in such an intellectual milieu and, in many cases, they were.

Ghiberti, the sculptor of the famous *Gates of Paradise* on the Florentine Baptistry, had studied astronomy, history, philosophy, medicine, and arithmetic. The great architect Alberti prided himself on his knowledge of rhetoric, poetry, and history. Many others in Lorenzo's circle, including Botticelli, Ghirlandaio, Verrocchio, and the Pollaiuolo brothers, could all claim some form of classical education. Even Lorenzo's young protégé, the fourteen-year-old Michelangelo, who would shortly be invited to live in his patron's house and eat at his table, was beginning to write his own sonnets. As an illegitimate child, however, Leonardo never had the benefit of a classical education. He did not have the knowledge of Greek and Roman history, literature, and mythology that many of his rivals were equipped with.

This may explain why we never hear of Leonardo as being in Lorenzo's entourage. Facts are difficult to come by, but it seems that Lorenzo was rather cool toward this talented young artist in his city. Authors have offered various explanations for this attitude. One theory suggests that throughout the 1470s, Leonardo was still closely associated with Verrocchio's business, and the old master may simply have subcontracted a number of Medici projects to him under his own name.

The Annunciation, detail of the Virgin Mary.

It's a reasonable assumption, though none of these putative works has survived, with the possible exception of the *Annunciation,* painted around 1474. While the quality of the *Annunciation* is uneven, and certain elements (such as the awkward marble chest in the center, inspired by the Medici tomb) betray the formalism of Verrocchio's workshop, other elements could very well be by Leonardo. Details such as the wings of the angel, the delicate interplay of hands, and the startlingly pubescent face of Mary all point to Leonardesque features that will reappear in our story later on.

THE PORTRAIT OF GINEVRA DE' BENCI

At around the same time that he was working on *The Annunciation,* Leonardo was commissioned, doubtlessly through the agency of Verrocchio's studio, to paint the portrait of a young woman: his first secular portrait. The occasion, we believe, was her wedding, at age sixteen, to Luigi di Bernardo Niccolini. At first glance, this portrait appears to be another typical workshop product: the treatment of the young girl's face follows Verrocchio's highly stylized beauty ideal, without much room for individual personality or emotion. But when we look closer, we see that the work explores new ground in other, subtler ways.

Ginevra is placed in what is known as the *trois-quarts,* or "three-quarter," position. Her head, however, is turned in a different direction, to a position midway between the orientation of her torso and the viewpoint of the beholder. As a result, she seems to be in the process of *turning toward us,* an effect that imbues the portrait with a sense of movement. This heightens the impression that we are dealing with a real, living person endowed with a distinct identity.

In the original composition, the liveliness of the portrait was further strengthened by the position of the hands. Of course, the hands are no longer visible, but that they were once present is clearly indicated by the awkward framing—the wide space above the subject's head is quite a contrast to the narrow framing of her bodice and shoulders below. In

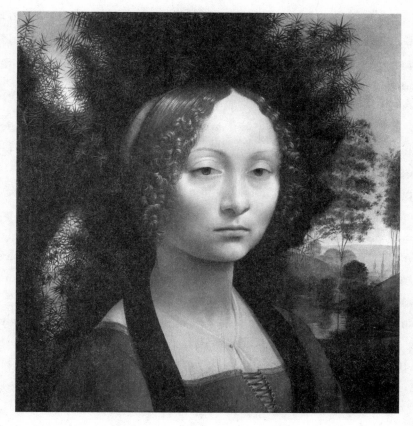

Leonardo da Vinci, *Portrait of Ginevra de' Benci*, ca. 1474.

other words, the lower part of the painting must have been cut off at some point. This is evident also on the reverse side of the panel, which contains an emblem in the form of a garland; its bottom section is missing. This was a not uncommon practice, as over the years, paintings often changed hands and, when they did, were sometimes cut to fit a new frame or decorative scheme.

Nevertheless, the portrait reveals Leonardo's first serious attempt to solve the essential problem of portraiture: how to capture the character, the *soul* of the sitter. His solution was to employ a combination of three elements: the naturalism of the face, the movement of the body, and the psychological counterpoint of the hands.

Of course, Leonardo neither signed nor dated the portrait. In the Renaissance, artists had not yet risen to the level where their signature would significantly enhance a painting's value. By the same token, there is no indication anywhere of who the lady in the portrait is. That, too, was not uncommon.

To understand the reason, we must remember that secular portraiture (that is, the depiction of everyday citizens rather than prominent kings or aristocrats, or saints and prominent clerics) was still a fairly recent development in Italy. In the Middle Ages, having one's portrait painted was considered a sign of vanity, certainly if it involved ordinary citizens. The body was a mere mortal shell; what mattered was the soul, which would find eternal peace in heaven if the person lived a pious and moral life. One's physical likeness was therefore of little account, just as the importance of the individual was subsumed by the overarching role of the Christian Church. As a result, art in the Middle Ages was overwhelmingly religious in nature. When portraits of lay citizenry did appear, they were usually reflective of the subject's role as the "donor" of a sacred work of art, as we will see shortly.

The next phase in secular portraiture took place in the Italian fourteenth century, the *Trecento*. This is when authors such as Dante, Petrarch, and Boccaccio created a humanist foundation in literature that would inspire the classical revival of the arts in the century to follow. Following in the footsteps of Greek and Roman authors, this humanism fostered the sense that, after God, the individual was a subject worthy of study as well. This idea is captured in the word *Renaissance* (or *Rinascità* in Italian, meaning "rebirth" [of classical ideals]), which encouraged poets, artists, and sculptors to depict human beings based on the imitation of models from Antiquity, rather than Church doctrine. Liberated from traditional Byzantine stereotypes, Renaissance artists, sculptors, and architects felt emboldened to pursue nature using Greek and Roman precedent, even though their reverence for sacred subjects remained undiminished.

Just as Petrarch and Boccaccio had been inspired by the works of

Virgil and Juvenal, artists now turned to Greek and Roman works of art. Sculptors such as Ghiberti and Donatello needed to go only as far as the fields and valleys of Tuscany to stumble upon all sorts of Roman statuary. The great architect Brunelleschi, designer of the dome over Florence's cathedral, traveled to Rome to study Roman architecture. In the process, he discovered not only the Roman geometric system of proportions, but also a precise way to reproduce it on paper, using the laws of linear perspective.

Renaissance artists such as Masaccio, Filippo Lippi, and Mantegna, however, were bereft of the type of ancient models that their brethren in sculpture and architecture enjoyed. The Greeks and Romans were known to have had some outstanding painters—in his book *Naturalis Historia,* Pliny the Elder extols the talents of the Greek artist Apelles, but actual paintings of his had not survived, or lay slumbering in their graves of pumice in Pompeii and Herculaneum.

There was, however, one clear illustration of what portraiture in Antiquity would have looked like, and that was coinage. Ancient coins, found throughout Italy, typically depicted rulers (e.g., Roman emperors) in profile, since this was the most efficient way of reducing an individual's

Masaccio, *Portrait of a Young Man,* ca. 1425.

physiognomy to two dimensions. As it happened, the discovery of this practice coincided with the new interest in secular portraiture, particularly among those patrons whose wealth and privilege enabled them to collect such coins and discuss them with their humanist friends. It is therefore not surprising that the first "exclusively" secular portraits of the Florentine Renaissance (meaning art for no purpose other than to commemorate the features of the sitter) use

a coinlike profile view of the head as the principal stylistic motif. A typical example is Masaccio's *Portrait of a Young Man,* which is self-consciously modeled on the profile on a Roman coin.

Even as the century progressed, the profile portrait remained the preferred format among the upper classes because of its obvious classicizing tenor; it signaled to the beholder that the subject was fully au courant with ancient art. To compare this painting with Leonardo's portrait of Ginevra de' Benci is instantly to grasp the revolutionary change that Leonardo brought to the genre.

Another unique aspect of the *Ginevra* portrait is Leonardo's use of allegorical clues to identify the sitter. This was in keeping with the growing role of art in the Renaissance as a form of visual poetry—an allegorical conversation piece, in other words. It reflected the urgent desire among many Renaissance artists to be recognized as creative masters and visionary poets, rather than mere artisans, as Leonardo's quote at the beginning of this chapter illustrates: "You can have no dominion greater or less than that over yourself." Consequently, many Renaissance paintings are actually intellectual puzzles that invite the beholder to demonstrate his humanistic pedigree and cultural sophistication.

In the case of the *Ginevra* portrait, Leonardo gives us various subtle clues. One is the monumental tree in the background, which surrounds Ginevra's head like a halo. Close inspection reveals it to be a juniper tree, *ginepro* in Italian, and thus a close approximation of the subject's given name. Another important clue is the emblem on the reverse side of the painting, which features a scroll with the words VIRTUTEM FORMA DECORAT ("Beauty adorns virtue") wrapped around laurel, juniper, and palm branches. As it happened, the laurel and palm were prominently featured in the emblem of Bernardo Bembo, the Venetian ambassador to Florence. This may provide another interesting spin to the portrait, since Bembo was deeply in love with the beautiful Ginevra, as we know from several of his poems. What's more, recent infrared scans of Leonardo's portrait have revealed Bembo's motto, VIRTUE AND HONOR, beneath that of Ginevra.

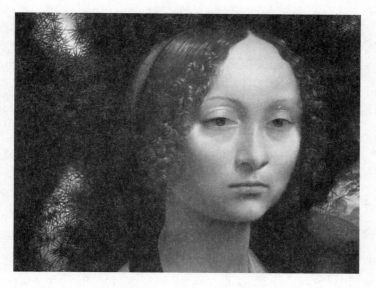

Detail of the portrait of Ginevra de' Benci with the juniper tree in the background.

THE CHARGE OF SODOMY

Two years before completing the *Ginevra*, in 1476, Leonardo suffered one of the most traumatic events of his life. Together with three other young men, he was dragged into court on charges that they had committed sodomy with a seventeen-year-old boy named Jacopo Saltarelli, a goldsmith's apprentice who moonlighted as a prostitute. At that time, homosexuality was tolerated in Florence, certainly among the upper classes, as long as one was discreet. In fact, the practice was so pervasive that, elsewhere in Italy, the "Florentine manner" was a byword for gay sex, and in Germany, homosexual men were called *Florenzer*.

Officially, however, sodomy was on the books as a capital offense, even in Florence; therefore, the hand of the authorities was forced if someone filed an official complaint. To this end, and as a sop to the clergy (who often denounced the city's "immoral" practices), the Florentine governing body, the Signoria, had installed drop boxes (known as *tamburi,* or

"drums") throughout the city, into which any citizen could leave messages anonymously denouncing another citizen. A simple letter was all it took, although the authorities were smart enough to realize that the *tamburi* were also a convenient way to get rid of a business rival, a jilted lover, or an obnoxious neighbor. As a result, denunciations were thoroughly investigated before the city decided to prosecute.

And so it happened that, on April 9, 1476, an anonymous letter was dropped in the *tamburo* of the town hall, the Palazzo della Signoria. The note accused Jacopo Saltarelli of having engaged in "many wretched affairs and consents to please those persons who request such wickedness of him."

The note went on to identify four people who allegedly had had sex with the lad: a tailor named Baccino from Orto San Michele, a goldsmith named Bartolomeo di Pasquino, a certain Leonardo de' Tornabuoni, and Leonardo da Vinci. All four were arraigned in front of the court and asked to explain themselves.

The Palazzo della Signoria, today called the Palazzo Vecchio in Florence (*courtesy Pantheon Studios, Inc.*).

Leonardo must have been mortified. An intensely private person, as his notebooks show, he cared deeply about his appearance and his reputation. More important, the taint of sodomy had the potential of depriving him of Church commissions, and in the late Quattrocento, the churches and monasteries of Florence were still a major source of art patronage.

As the hearing progressed, it soon became obvious that the prosecution had not prepared its case. In response, the court set a two-month adjournment, to allow the state to gather evidence. In the meantime, the men were freed without bail, but with the stern proviso of *retamburentur*, of being summoned "back to the drum," as soon as new evidence was brought forward. We can only imagine Leonardo's state of mind in those two months, when his career, his livelihood, indeed his life itself hung in the balance. Two months is a very long time, and no doubt word of the proceedings spread throughout the city.

On June 7 the court convened again, and the accused were ordered to appear. The judge asked the prosecution to present its case, whereupon the investigators confessed that they had failed to uncover any corroborating evidence. The charges were dropped.

Some authors believe that the Medici had a hand in this. One of the accused, Leonardo de' Tornabuoni, was quite possibly related to Lorenzo de' Medici's mother, Lucrezia de' Tornabuoni. This could have motivated Lorenzo to intervene in the proceedings and bury the matter to avoid embarrassment to his family. Strangely, some historians have suggested that this episode could have brought Leonardo and Lorenzo closer. Obviously, the opposite is true. Leonardo's involvement in this affair, and its potential to tarnish the Medici family name, would certainly not have helped his chances of winning Medici favor.

Much to Leonardo's relief (or so we should assume), the *tamburi* affair did not affect his reputation with regard to Church commissions. Two years after the court case, while Florence still reverberated with the aftershocks of the assassination attempt on Lorenzo by the Pazzi family,

Leonardo scribbled in his notebook, "I have begun the two Virgin Marys ("le due Vergini Marie")."

THE TURNING POINT: *THE BENOIS MADONNA*

The reference to *two* Leonardo portraits of the Virgin Mary has led historians to conclude that one of these may be the so-called *Benois Madonna,* now in the Hermitage in St. Petersburg. The contrast with Leonardo's previous Madonnas is startling. Whereas in *The Madonna of the Carnation,* Leonardo experimented along the periphery of the Madonna archetype as it were, in the *Benois Madonna* he went straight to the heart of the matter: a radical transformation of the Madonna figure itself.

The Madonna motif has its roots in Byzantine art, which had ruled Italian art for most of the preceding four centuries. In the Byzantine tradition, Mary was venerated as the *Theotokos* (the "God-bearer") and as the ruling queen of the heavenly pantheon, on a par with Christ. This produced the motif of the Virgin enthroned: Mary on her heavenly throne, looking suitably stern as she wears the crown given to her by her son. During the fourteenth century, the *Trecento,* under the capable hands of artists such as Duccio and Giotto, Mary slowly reclaimed her appearance as a young woman of flesh and blood, but her gaze remained no less regal and austere. Similarly, while her throne and baldachin slowly assumed a more realistic, three-dimensional projection, it remained a heavenly throne nevertheless. The Quattrocento Mary may have looked more human, but she was still a queen, the ruler of the heavens.

Leonardo, then twenty-six years old, decided to change this paradigm. As numerous sketches from this period attest, the young artist was increasingly relying on his personal observation of natural phenomena, whether this involved the movement of water or the shimmering optical effects of distant mountains in the warmth of a summer evening. So, we suppose, he may have been equally struck by the natural intimacy between a young mother and her newborn child.

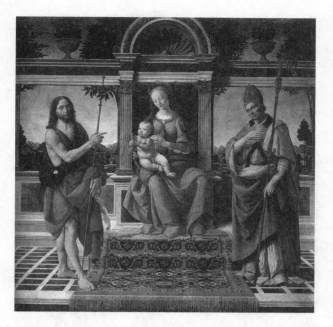

Andrea del Verrocchio, *The Madonna with St. John the Baptist and a Saint*, ca. 1480. Mary is depicted as a heavenly queen on her throne.

Compared to this very private, very affectionate bond, the rather distracted look of Mary in *The Madonna of the Carnation* (which some scholars believe may be the second of the "Two Virgins" described by Leonardo in 1478) fully conforms to Verrocchio's formulaic approach to depicting young women. This may now have struck Leonardo as absurd. If Mary was a young girl, as the Gospels clearly attest, and Jesus her newborn son, why should she have behaved differently from any other young girl? Why would she not have gazed upon her child with the same look of love and devotion that any new mother would have for her baby?

This idea, doubtlessly informed by personal observation, explains the transformation of Mary's demeanor in the *Benois Madonna*. It is as if she has truly come alive, this smiling young mother so utterly absorbed in her young son as his chubby little fingers try to wrest a flower from her grip. Rather than facing us, the beholders, as a regal queen, she turns her

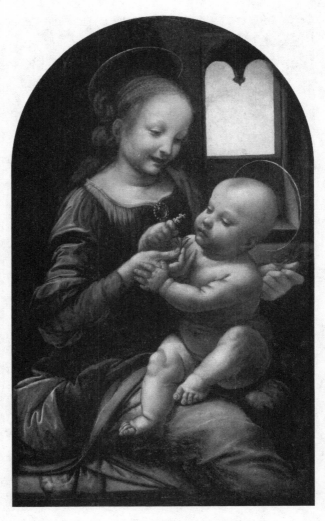

Leonardo da Vinci, *The Benois Madonna*, ca. 1478.

body toward her child, making him the sole focus of her attention—just as the child's torso is turned toward her, almost mirroring her pose. Thus, Leonardo turned a Byzantine stereotype into a heartwarming genre scene of everyday domesticity. As Frank Zöllner writes, the *Benois Madonna* marks the "appearance of an independent artist who has arrived at his own formal style."[3] In virtually every aspect (color, tone,

shading, poise, and emotion), this painting is a radical departure from the Verrocchio brand.

A group of drawings, now in the Uffizi and tentatively dated between 1478 and 1480, takes this newly discovered intimacy between mother and child even further. In one, Mary watches fondly as Jesus wrestles with a young cat. In another, a pen-and-ink drawing finished with a delicate washed shading, Mary bathes the infant's feet in a large bowl. Quite possibly, these are not studies for a particular panel, but rather flights of Leonardo's imagination, to see how far he could push the motif.

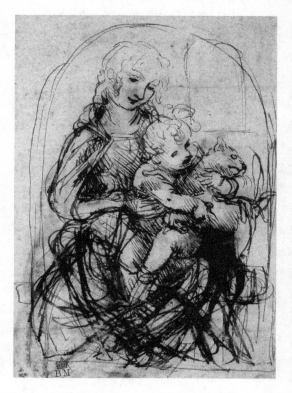

Leonardo da Vinci, *Drawing of the Virgin and Jesus Playing with a Cat*, ca. 1480.

THE FIRST INDEPENDENT COMMISSION

As it happened, an opportunity to put some of these ideas to practice—not in a small *Andachtsbild,* but in a veritable large-scale painting, an *altarpiece*—arrived shortly thereafter. It was a prestigious commission, destined for the Chapel of San Bernardo inside the Palazzo della Signoria, seat of the Florentine government (today known as the Palazzo Vecchio). No doubt, it was brokered by Leonardo's father, Ser Piero, who served

as notary for a number of Signoria council members. The commission may have come about because the artist originally chosen for the job, Piero del Pollaiuolo, decided to pass on it. This may have added some urgency to the matter, and persuaded the Signoria to hand the work to a relatively young and untried artist.

And so Leonardo received his first major independent commission. After he signed the contract, he was given the princely advance of 25 florins (around $3,360). The subject of the new altarpiece, as it turned out, was the apparition of the Virgin Mary to Saint Bernard. Bernard of Clairvaux was a twelfth-century saint who, among others, was responsible for founding the Cistercian Order. More than any other Christian prelate, Bernard, who lost his mother when he was only nineteen years old, was responsible for developing the cult of Mary in medieval Europe, a devotion that in some ways was a response to Scholasticism and its rational approach to faith. This idea of Mary as the intercessor in human affairs is expressed in the motif that Leonardo was expected to depict: that of Mary appearing to Bernard in a vision. This was also the subject of a painting by the Gothic artist Bernardo Daddi (ca. 1280–1348) that had graced the Signoria from the fourteenth century, but that was now hopelessly out of fashion.

Then a curious thing happened: Leonardo didn't execute the work. Nor did he execute any preparatory drawings, as far as we can determine— though it's always possible that whatever he drew has been lost. It is as if the commission had never happened. Perhaps the subject (and its rather prescribed iconography, which left little room for experimentation) did not appeal to Leonardo's fertile mind, so keen was he to match his visual observation and scientific study. There is a passage in a 1542 book by the so-called Anonimo Gaddiano (the "anonymous member of the Gaddi family," a very colorful though not always very trustworthy source) that Leonardo did start a number of preparatory drawings, but that in the end it was Filippino Lippi who wound up painting the panel.

Interestingly, Lippi *did* paint an altarpiece entitled *The Vision of St. Bernard,* and it *is* dated around 1480, roughly the same time frame. How-

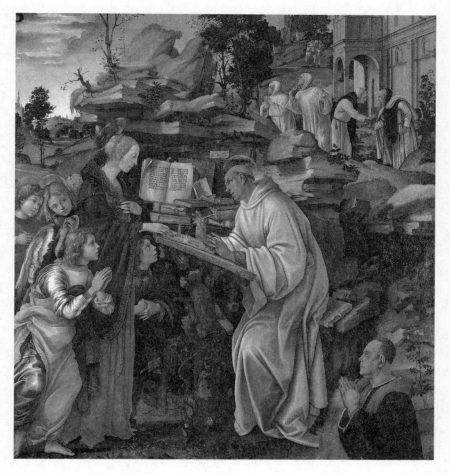

Filippino Lippi, *Vision of St. Bernard*, ca. 1480.

ever, this altarpiece was commissioned by another agency altogether, the family of del Pugliese, who wanted it for their private chapel in Marignolle, a village near Florence.

Try as we might, we find it very difficult to distinguish anything of a Leonardesque influence in this very static and conventional composition, although some have detected Leonardo in the treatment of the saint's face and hands. Then again, it might be that Gaddiano was simply confusing this painting with another commission, where Filippino Lippi did indeed replace Leonardo, as we will see shortly.

2

THE ADORATION OF THE MAGI

*The mind of the painter must resemble a mirror, which
always takes the color of the object it reflects.*
—LEONARDO DA VINCI

Leonardo's failure to fulfill his first commission may serve to explain why, as we saw in the introduction to his book, the terms of his second commission were considerably more punitive than those attached to the San Bernardo project. That Leonardo accepted them may reflect the urgent need he felt to demonstrate his bona fides, and to prove his ability to actually execute a major painting. There is another reason Leonardo was no longer in a position to bargain. His mentor and partner, Verrocchio, had left for Venice, there to work on the massive equestrian statue of Colleoni, a captain-general of Venetian mercenary forces. That meant that he could no longer rely on new commissions funneled through Verrocchio's workshop. Perhaps the wily friars were aware of that as well, which would have strengthened their hand in negotiations.

On the plus side, the subject of his new commission, an Adoration of the Magi (the visit of the three kings to the newborn Jesus in a stable in Bethlehem), must have appealed to Leonardo. The Adoration was a popular motif in Florence, for it gave artists (and their donors) the opportunity to clothe the magi, or "kings," from the East in all sorts of exotic finery, thus advertising the fine cloth that Florentine merchants were selling all over the world.

An early study of the Adoration, which may or may not be directly related to final work, reveals a rather conventional composition of the scene. Mary, with her infant Jesus, is seated in front of a barnlike structure, while graciously accepting the gift that a kneeling figure is presenting to her. The only discordant note, if we can call it such, is the addition of elderly, toga-clad characters on either side of the painting, who seem to observe the scene with a studied lack of reverence, even with skepticism. Also, there is an odd clutch of figures in the background whose purpose is not clear.

Finally, the scene is shown from an unusually high vantage point. This would be acceptable if there were anything of interest in the background, such as a group of servants, or shepherds. This is what motivated Gentile da Fabriano, a Florentine painter who remained stubbornly loyal to the Gothic tradition, to choose a high horizon in his version of the Adoration. It enabled him to show the three kings at the head of a long train of worthies stretching all the way back to the gates of Jerusalem.

In Leonardo's design, there is hardly anything in the background that would justify the high viewpoint, other than a rather indistinct group of characters, and two stairways separated by a double arch, the purpose of which is not obvious.

Indeed, the inspiration for this design may not be da Fabriano's *Adoration* but, rather, Sandro Botticelli's. In 1475, just seven years before Leonardo received his commission, Botticelli, who inherited his unique sense of linear grace from his master, Filippo Lippi, executed an exceptional depiction of the Adoration that was praised throughout Florence— in fact, Vasari calls it the "pinnacle" of Botticelli's art. Its fame was in no small measure due to the fact that it featured the most important political figures of the day in the act of humble obeisance to Mary and her Child: Cosimo de' Medici, patriarch of the family, and his sons Piero and Giovanni, cast in the roles of the three kings; and Cosimo's grandsons Lorenzo and Giuliano. The fact that Cosimo, Piero, and Giovanni were all dead by the time Botticelli painted the work made it even more poignant, and indeed highly effective as an instance of Medici family propaganda.

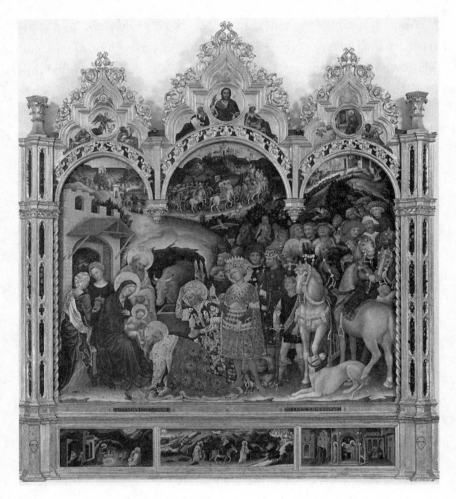

Gentile da Fabriano, *Adoration of the Magi*, ca. 1423.

Although the panel was commissioned by a banker named Gaspare del Lama (portrayed in the painting as the silver-haired man in a blue robe, pointing at the beholder), del Lama's close connections to the Medici family leave little doubt that Botticelli's *Adoration* was intended as a tribute to Lorenzo the Magnificent, the de facto ruler of the city. Botticelli decided to place himself in this company of august characters. He is the young man with blond hair, dressed in a golden robe, at the far right of

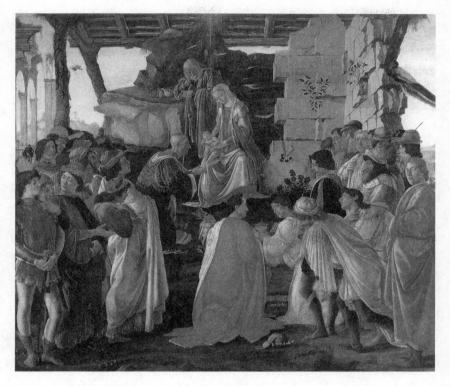

Sandro Botticelli, *The Adoration of the Magi*, 1475. The man in yellow robes at the far right, looking at the beholder, may be a self-portrait of Botticelli himself.

the painting. Of the work, Vaspari gushed, "It is a marvelous work in color, design and composition."

All this may explain why Leonardo would have made an effort to see the work while planning his own *Adoration*. Fortunately, it was exhibited in a public place, the Del Lama Chapel in the Santa Maria Novella.

Indeed, Leonardo's original conception (Mary in the center and two groups of worshippers lining up on either side) clearly betrays the influence of Botticelli's painting. There are, in fact, a number of other features that would return in Leonardo's work: the placement of the scene in the ruins of a stable; the grouping of a number of people displaying varying degrees of interest in the scene before them (including the members of

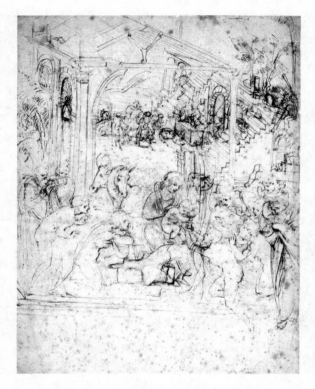

Leonardo da Vinci, *Study for an Adoration of the Magi,* ca. 1480.

the Medici family and their retinue); and what appears to be the colonnade of a Roman temple on the far left of Botticelli's version. These ancient ruins may simply be a stage prop, designed to place the scene in Roman Palestine. However, some have argued for a link to a medieval legend that suggested that the Basilica of Maxentius, the largest Roman ruin still visible in Rome at that time, had collapsed on the night of Jesus' birth.

What makes Botticelli's composition so original is the way in which the artist arranges the large group of mostly elderly men around Mary and the Child, quite apart from the fact that, other than the magi, none of these figures has any business being shown in a Nativity scene from the Gospels. That the patron, Gaspare del Lama, as a protégé of the Medici dynasty, compelled the artist to include these men is fairly obvious, but Botticelli pulls it

off with a certain panache. As Vasari puts it, "The beauty of the heads in this scene is indescribable, their attitudes all different, some full-face, some in profile, some three-quarters, some bent down, and in various other ways, while the expressions of the attendants, both young and old, are greatly varied, displaying the artist's perfect mastery of his profession."

LEONARDO'S PANEL AS AN ENSEMBLE WORK

The daring of Botticelli's conception may have prompted Leonardo to attempt something even more revolutionary, even more risqué: to surround Mary with all the contradictions of medieval Christianity that her son's Passion would ultimately engender. Fortunately, there was plenty of space to do so, because the panel that the San Donato friars had secured for the work was positively *huge:* ninety-seven by ninety-six inches, almost eight by eight feet. Up to this point, Leonardo had worked only on small paintings featuring no more than one or two figures, such as the Madonna pieces or the portrait of *Ginevra de' Benci.* (The unfinished panel of *St. Jerome* in the Vatican Museum has now been convincingly dated to a much later period.) To be able to paint a large ensemble piece on a vast scale must have been an irresistible proposition.

In fact, the problem of amassing a large group of people on a two-dimensional surface had been a major challenge for artists since Antiquity. Unlike a sculptor, a painter cannot arrange his models in three-dimensional space; he has to arrange them on a flat surface in such a way that each individual is recognizable for his or her meaning within the context of the scene and for the role he or she is meant to play, while still maintaining an aesthetically pleasing composition.

The Byzantine artist, who was not constrained by the demands of linear perspective, solved the problem by simply scaffolding his characters on multiple levels. Byzantine art was not preoccupied with three-dimensional naturalism because its principal protagonists were sacred figures in heaven.

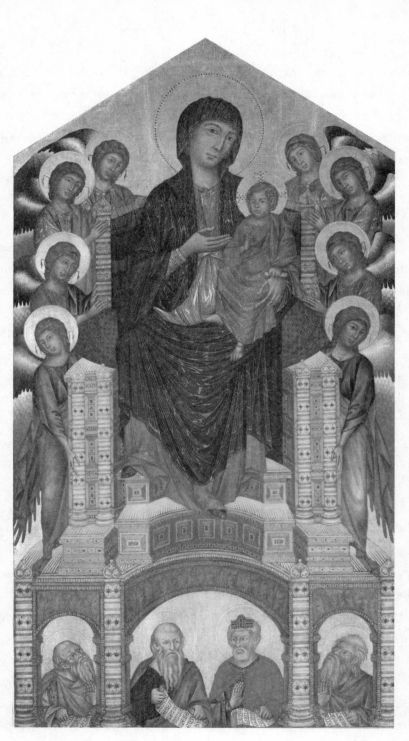

Cimabue, *Maestà*, ca. 1285.

These figures, therefore, were expected to float as ethereal beings against an infinite background of gold—medieval shorthand for the glory of heaven. The need for realism or linear perspective would have struck these artists as absurd, given the task they were meant to achieve.

Things began to change with artists such as Cimabue (ca. 1240–1302). While Cimabue remained faithful to Byzantine paradigms, he cautiously moved his figures closer to earth by endowing their faces with a certain individuality, and by rendering architectural elements, such as Mary's massive throne in his famous *Maestà* (ca. 1285), with a modicum of foreshortening that suggests depth and space. Still, the stacking of the angels on either side of the Madonna, regardless of spatial considerations, is entirely in keeping with Byzantine form.

When the growing prosperity of the *Trecento* led to the construction of new churches and chapels, the monumental fresco became an important new genre for artists. Unlike a panel, a fresco demands some form of reconciliation between the painted illusion and the architectural reality that surrounds it.

Agnolo Gaddi, *Entry of Emperor Heraclius in Jerusalem*, ca. 1384–87.

In Agnolo Gaddi's *Entry of Emperor Heraclius in Jerusalem,* for example, painted in the 1380s in the Santa Croce in Florence, the artist still avails himself of two superimposed levels, as in a modern comic strip, to depict separate episodes from the story. As a concession to actual space, however, the group on the higher level is separated from the lower register by a series of rocks, signifying the hills of Jerusalem. Yet, the real novelty in Gaddi's fresco is the way in which the obvious monotony in the depiction of a large group of people is resolved. Gaddi gives each of these figures a different posture and orientation. Unlike Cimabue, the artist thus makes a conscious attempt to *individualize* his characters, not only by the use of different clothing and facial expressions, but also in the way the heads are pointing in different directions, as if drawn to events beyond our view.

Gaddi's solution, which owed much to Giotto's frescoes of a generation earlier, would essentially become the norm of Early Renaissance painting, just when artists began to struggle with the new and unyielding demands of linear perspective. Masaccio's *Raising of the Son of Theophilus,* in the Brancacci Chapel of the Santa Maria del Carmine (ca. 1426–27), in Florence, is a perfect example. Masaccio also relies on a strong individualization of facial features, but his figures are more fully developed as realistic bodies in the round, due to the growing confidence of the Florentine artist with human anatomy.

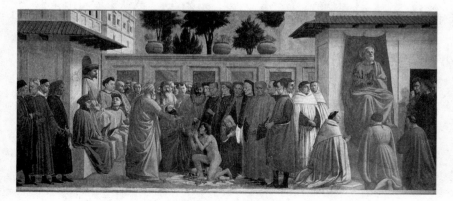

Masaccio, *Raising of the Son of Theophilus,* ca. 1426.

There was one thing, however, that Masaccio and his collaborator Filippino Lippi could no longer do. They no longer had the freedom to stack their figures arbitrarily across the surface, as Gothic and Byzantine artists had done for centuries. With the laws of perspective now firmly established as the required canon for Florentine art, the figures had to be convincingly placed within the composition—that is, *on the same level*. This once again threatened to produce the same monotony that artists had struggled with in the past.

Up to this point, Leonardo had never grappled with such large ensemble pictures, but he was undoubtedly aware of the challenge of large group portraits. In his book *On the Practice of Painting,* he wrote:

> *When you have well learnt perspective and have by heart the parts and forms of objects, you must go about, and constantly, as you go, observe, note and consider the circumstances and behavior of men in talking, quarreling or laughing or fighting together: the action of the men themselves and the actions of the bystanders, who separate them or who look on.*[1]

Though Leonardo wrote these lines some ten years later, they reveal the revolutionary new approach he was about to bring to the genre. For in plotting his *Adoration of the Magi,* and the multitude of figures he planned to stage in it, he was not going to content himself with merely endowing each character with a different pose. What was going to make his ensemble truly realistic, truly *revolutionary,* was a repertoire of expressions and gestures that would reveal the unique emotional *psychology* of the figures.

This was something new for Florence. At this point, Florentine artists had been so preoccupied with the transformative changes in *rendering* both in terms of Masaccio's bold modeling and in Brunelleschi's and Alberti's linear perspective, that the inner life of painted figures had never been a major consideration. True, there is a disarming sweetness about the Madonnas of Fra Filippo Lippi, and an alluring innocence, tinged

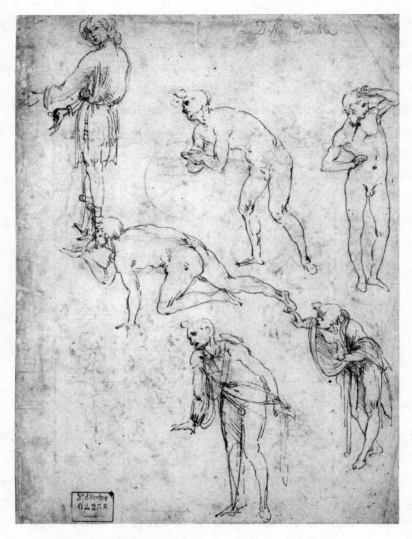

Leonardo da Vinci, *Studies for the Adoration of the Magi,* 1481–82.

with subtle eroticism, in Botticelli's *Birth of Venus,* but capturing the *soul* of the sitter had never been a principal goal. This is where Leonardo would produce a truly transformative change in Italian art. As he would later write, "That figure is most admirable, which by its actions best expresses the passion of its soul" (*esprime la passione del suo animo*).

This, then, is the *Leitmotiv,* the "great purpose," of Leonardo's first

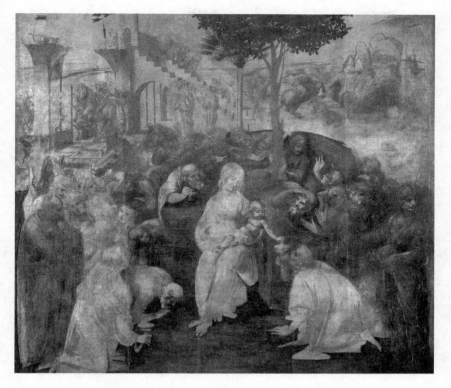

Leonardo da Vinci, *The Adoration of the Magi*, 1481–82. The young man at the far right, looking away from the Nativity scene, may be Leonardo's self-portrait.

major painting: to express the full range of wonder and delight, of envy and despair, provoked by the birth of Jesus and, indeed, Christianity itself. His objective is not to show an entourage of Florentine worthies dressed as Eastern potentates, in the act of rendering homage to the Prince of Peace as pious camouflage of their desire for prestige. In Leonardo's vision, both the good and the bad, the faithful and the wicked of fifteenth-century Florence, would be on full display.

Should we therefore see his *Adoration* as an early example of art as social criticism? It is tempting, perhaps, to draw a parallel between this brooding panel and the fiery sermons of a Dominican friar named Girolamo Savonarola (1452–98). Repelled by the embrace of Greco-Roman motifs in the work of early Renaissance artists, and by the excesses of the

papacy, Savonarola vehemently attacked the new "paganism" in the city. Many in Florence rallied to his words, and countless Renaissance paintings and books were burned in a "Bonfire of the Vanities." But a direct parallel between Savonarola's movement and Leonardo's iconoclastic approach to the Adoration motif is difficult to prove. Until late in life, Leonardo was not a man much troubled by theological issues, and Savonarola's sermons did not hit full stride until 1482, when Leonardo was ready to turn his back on Florence.

What probably concerned Leonardo more was the question of how to realize his highly ambitious vision on the large, almost square panel. His solution was to organize the action on three levels. In the center foreground is Mary, fondly gazing at her newborn with that warm intimacy that we recognize from the *Benois Madonna.* On either side of her are the three magi, or kings, kneeling to give their respects. As described in the Gospels, the king to Mary's left is in the process of presenting a cup of frankincense, a perfuming agent, which appears to have the interest of the baby Jesus. His childlike delight in the shiny vessel is made poignant by its symbolic meaning: frankincense will be used for the anointing of his body after the Passion.

Over this foreground rises a human arc of astonishing emotional intensity, stirred by the challenge of what this birth represents. At least twenty-five different faces can be discerned in this nebula of human turmoil, some merely sketched, others more defined using wash and paint. One figure points upward to the crown of the tree planted just behind Mary. Medieval viewers would have readily recognized the arbor as the allegorical Tree of Jesse, which in the Gospels of Matthew and Luke connects Jesus to the House of King David. This pedigree seals his status as God's anointed (*Mashiach,* or "Messiah," in Hebrew; *Christos,* or "Christ," in Greek). The gesture of the upturned finger, pointing at the divine meaning of the scene, would become a popular Leonardo motif, returning in his *Last Supper,* the Burlington House Cartoon of *Saint Anne,* and his late portrait of *John the Baptist.*

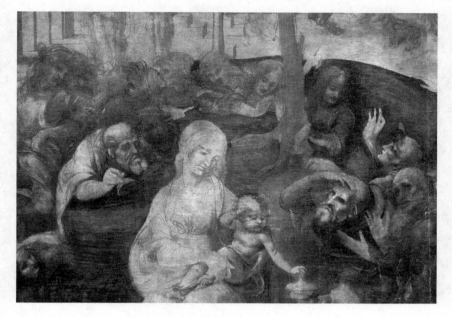

Adoration of the Magi, detail of the center.

Behind this swirling arc of human emotion, another series of actions is unfolding on the third level: the background. Its connection to the foreground is not immediately apparent. The most prominent feature is the ruins of an ancient monument. We recognize this structure from Leonardo's perspective study in which a variety of people and animals vaguely Asian in origin (featuring, among others, a camel) is superimposed on the perspective grid converging to a vanishing point.

In the *Adoration* painting, the architectural elements have been simplified, but the people who populate them are no less exotic. Should we interpret this group as the entourage of the three kings, with all the exotic panoply that a medieval European would expect from an Eastern court? Are the riders on horseback to the far right merely exercising their mounts, or anticipating the wars and enmity that Christianity would provoke, in shrill contrast to Jesus' message as the Prince of Peace? Or should the palatial ruins be interpreted as an evocation of the palace of King David,

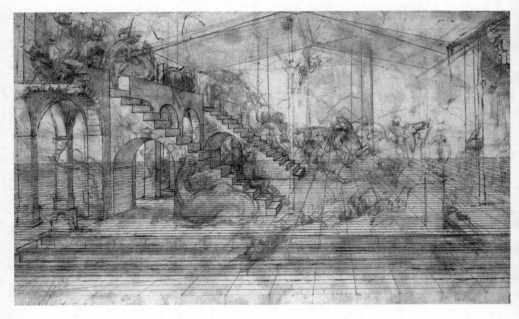

Leonardo da Vinci, *Study for the Adoration of the Magi*, ca. 1481.

rather than the Basilica of Maxentius, and therefore, by extension, an allegorical representation of Jesus' Kingdom of God?

One thing is certain: this panel is an intellectual and artistic tour de force with few parallels in Quattrocento painting, indeed in European painting altogether. And precisely because the work is unfinished, we are privileged to see these figures in the moment of their initial conception, fresh from Leonardo's mind, and rendered with an intensity in gesture and expression that almost presages the Baroque rather than the High Renaissance.

Unfortunately, much of that intensity is barely visible. We can only speculate as to what would have happened if Leonardo had been in a position to finish the painting. Quite possibly, the singular importance that we now attach to *The Last Supper,* as the first great work of the High Renaissance, may have been preempted by this work. But as we know, that's not how things turned out.

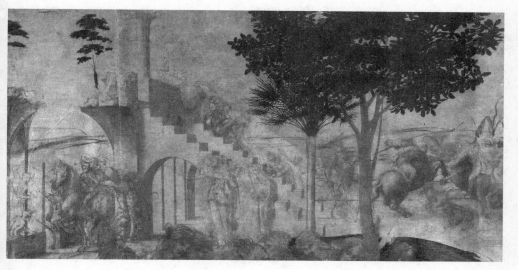

Adoration of the Magi, detail of background.

WHY IS THE *ADORATION* UNFINISHED?

Notwithstanding his ardor for the project, Leonardo soon ran into the familiar difficulty of paying for his materials, his daily upkeep, and the cost of his assistants. We know at least one of them: Tommaso di Giovanni Masini. According to one seventeenth-century source, Masini, sometimes referred to as Maestro Tommaso or by his nickname Zoroastro, joined Leonardo's Florence studio before Leonardo departed for Milan.[2] Just three months after signing the contract for the *Adoration,* when the dowry payment of 150 florins became due, Leonardo informed the friars that he was unable to pay it. The Augustinian monks advanced the funds, and paid again when it transpired that Leonardo was unable to pay for his pigments. Their records show that he was further debited for a sack of grain and a barrel of wine. Clearly, Leonardo was living hand to mouth.

Is this the reason he decided to leave Florence in early 1482 and set his sights on the court of Milan? Had the burden of financing his small studio while working on the most ambitious work of his early career finally

caught up with him? Was the prospect of working as an artist at one of the most glamorous courts in Italy too good to pass up? That, at least, has been the traditional narrative in most modern Leonardo biographies. From one day to the next, or so the story goes, the famously fickle Leonardo decided to drop everything and rush off to reap the riches of the Sforza court in Milan. But on closer examination, this theory doesn't hold water.

First of all, and contrary to popular perception, the duke of Milan, Ludovico "il Moro" Sforza, did *not* offer Leonardo a position in 1482, and in fact would not begin to pay Leonardo any form of compensation until *seven* years after the artist's arrival in Milan. Ludovico, a usurper who was desperate to cloak the illegitimacy of his rule with the splendor of a Renaissance court, was certainly on the lookout for celebrity "talent," but, the truth is, in 1482, Leonardo was neither a celebrity nor the favorite of a celebrity patron.

Second, the idea that Leonardo could have abandoned his most ambitious work, at a critical stage of its conception, was refuted by a series of X-ray and infrared tests conducted by the Italian art historian Maurizio Seracini in 2002. Seracini found that there was a considerable time lapse between the original underdrawing of the *Adoration* and the painted segments. In addition, the paint had been applied in a rather cursory manner, one that was strikingly different from Leonardo's meticulous technique.[3]

Seracini concluded that the *Adoration* was halted when the monks saw the drawn composition in full on the panel. The Augustinian friars were probably expecting a conventional Nativity scene: the holy family grouped around the manger as the three kings kneel to pay homage. The monks weren't interested in moving the boundaries of Italian art; their purpose was to obtain an altarpiece that could elicit devotion and prayerful contemplation among the faithful. That meant the altarpiece had to observe certain conventions that worshippers were familiar with, that they could recognize. Nativity paintings, probably the most popular form of sacred

art after Crucifixion scenes, needed to follow an iconographic program that the largely illiterate population of Florence could understand.

Yet Leonardo was not interested in conformity. Fired by his growing scientific endeavors and his observations of nature, he saw an opportunity to pull Early Renaissance art out of its formulaic approach and into a world of new discovery: a world ruled by the emotions, motives, and desires of its painted figures. The Augustinian monks had that opportunity in their grasp, but they ignored it. For them, nothing in the swirling mass of characters and gestures could be connected even remotely with the beloved Adoration motif. Consequently, we believe, as several other authors have done, that the monks simply terminated Leonardo's modern experiment. As is well attested, they then decided to approach Domenico Ghirlandaio, a well-established artist in fresco, to replace him. In the end, though, it was Filippino Lippi who satisfied their need by painting a perfectly conventional *Adoration*.

Leonardo's unfinished painting was consigned to storage. According to Vasari, it was placed in the home of Amerigo Benci and kept there for years afterward. Seracini posits that things changed when, many years later, Leonardo's fame began to spread throughout Europe. At that time, someone (either Benci himself, his heirs, or the friars) commissioned an artist to try to "paint in" some of the drawing to make it more attractive for resale, given that Leonardo's works were then in high demand.

In 1482, however, that reevaluation lay well in the future. Leonardo's great moment, the opportunity to revolutionize Italian art, would be delayed for another fifteen years.

PART II

Toward The Last Supper

Leonardo's Oeuvre in Milan

3

AN ARTIST IN MILAN

Necessity is the mistress and guide of nature.
—LEONARDO DA VINCI

At some point in 1482, Leonardo left his lodgings in Florence and moved north, toward Lombardy. We don't know if any of his friends came out to bid him farewell, or if Florence took notice of his departure at all. The Florence of 1482 was no longer the glorious city that had launched the Renaissance in the beginning of the century under the firm but generous hand of Cosimo de' Medici. Cosimo's grandson Lorenzo had boosted the city's reputation as the "Athens on the Arno," the proud preserve of poets, sculptors, painters, and architects, but the *Pax Medicea* had been shaken to its foundation by the Pazzi Conspiracy of 1478.

It's not clear which upset the Medici more: the near success of the plot to eliminate Lorenzo and members of his administration or the discovery that a very large number of Florentines had joined the Pazzi family in hatching the conspiracy. It was even rumored that the Archbishop of Pisa and the pope, Sixtus IV, had given their blessing, not in the least because the Salviati, the papal bankers, considered the Medici Bank their most important rival.[1]

This may also explain the sheer brazenness of the act, when it finally came to pass. On April 26, Lorenzo de Medici had entered the Florentine cathedral, the Duomo, to hear Sunday Mass, as was his custom. He

was accompanied by his wife, Clarice Orsini, and his brother Giuliano de' Medici, a handsome lad who, among Florence's trendy set, had the reputation of being somewhat of a playboy. Just as the priest raised the host during the consecration, Francesco de Pazzi and a paid assassin, Bernardo di Bandino Baroncelli, sprang up and drew their swords and knives. While the congregation bowed down to the raised host, the assassins first pounced on Giuliano, so as to eliminate the only person who could come to Lorenzo's aid. The young man was stabbed and slashed nineteen times; Baroncelli, while plunging his dagger into Giuliano's abdomen, cried, "Here, traitor!"

As Giuliano sank to the floor, there to die in a pool of blood, the murderers turned on Lorenzo. But by now, Lorenzo was alerted. Though Francesco succeeded in stabbing him several times, Lorenzo was saved (fittingly, perhaps) by one of the poets he had patronized. This was Angelo Ambrogini, nicknamed Poliziano, who ironically had been hard at work on a poem, *La Giostra,* extolling Giuliano's victory in a tournament. Taking advantage of the mayhem now spreading through the church, Poliziano quickly led the bleeding Lorenzo to the sacristy and locked the door behind them. Seeing that Lorenzo had escaped from their grasp, the conspirators made a halfhearted attempt to capture the Signoria, the republican council that formally ruled the city, and its president, the *gonfaloniere*. But this coup attempt failed as well.

As the news spread through the city, the population rose in anger. This vast *levée en masse* poured into the narrow streets between the Duomo and the Medici palace, determined to capture anyone belonging to the Pazzi family and its allies. Some, perhaps, enthusiastically joined the crowd so as to deflect any suspicion from their own complicity.

Any coconspirators and Pazzi family members who had the misfortune of being caught were killed on the spot. Throughout the night, armed bands roamed the city shouting, "Palle! Palle!" the battle cry of the Medici (after the six balls on their coat of arms). One prominent Pazzi member, Jacopo, was unceremoniously tossed out of a window and fell to his death.

Many others were put to the sword, sometimes on dubious pretexts. The Archbishop of Pisa and the head of the Salviati Bank, who had been waiting for news of the conspiracy's success, were trapped before they had a chance to escape. The beautiful city of Florence, praised throughout Italy as the center of art and learning, had become the stage for an orgy of murder.

Lorenzo's revenge was swift. Those conspirators who had escaped were hunted to the far reaches of Italy and brought to justice. Baroncelli, the principal assassin, had fled as far as Constantinople, the glorious Byzantine capital that recently had been conquered by the Ottoman Turks. But the great Sultan Mehmet apparently prized Florentine cloth more than the need to offer sanctuary to infidels. The sultan graciously invited Florentine officials to sail to Constantinople and take the fugitive into custody—which they did, on Christmas Eve.

Meanwhile, all the Pazzi possessions were confiscated. The family name and emblem were erased from homes, chapels, and churches. Companies owned by the Pazzi were despoiled. The head of the Salviati Bank was hanged from the Palazzo Vecchio. Even the Archbishop of Pisa was executed.

The principal assassin, Baroncelli, was condemned to die in the courtyard of the courthouse known as the Palazzo del Podestà (today known as the Bargello). As his lifeless body swung from a rope, Leonardo was among the spectators, rapidly sketching a drawing of the condemned. With his eye for detail, particularly where it concerned matters of fashion, Leonardo scribbled a quick description of the man's clothing.

A tan-colored skull-cap, a doublet of black serge, a black jerkin, lined, and the collar covered with a black and red stippled velvet. A blue coat lined with fur of fox's breasts. Black hose. Bernardo di Bandino Baroncelli.

Although, on the surface, the Medici appeared to have reasserted their control of the city, the conspiracy would cast a long shadow. Incensed over

the bungling of the plot and the execution of the Archbishop of Pisa, Pope Sixtus IV took the unprecedented step of excommunicating the entire city of Florence, thus depriving its population of the solace of the sacraments, including Mass. But the pontiff's real ire was directed toward those tiresome Medici. Before long, the pope, a member of the della Rovere family, not known for their gentle manners, had roused his ally King Ferdinand of Naples to march on Florence and finish what the Pazzi started. Ferdinand was all too happy to oblige. The son of the Spaniard Alfonso V of Aragon and a mistress, Giraldona Carlino, Ferdinand himself had narrowly escaped a coup attempt by John of Anjou, who had dealt Ferdinand a stinging defeat at the Battle of Sarno. The king was saved by the forces of a condottiere named Alessandro Sforza, who sent the Anjou militia packing.

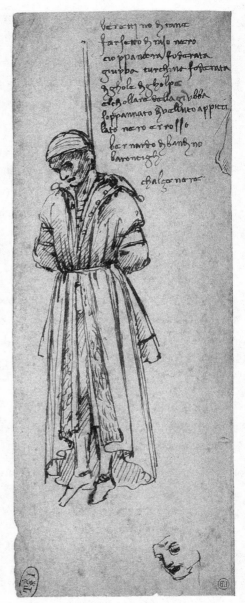

Drawing of a Hanged man, 1478.

As a result, Ferdinand considered himself something of an expert in warfare, and the pope's invitation to put the haughty Florentines in their place was welcomed with open arms. In 1478, Ferdinand let loose his army

of seasoned Aragon mercenaries, sending them northward. By the beginning of the summer, they succeeded in defeating Florence's principal line of defense, the fortress at Castellina, in Chianti. Florence's forces crumbled. Delighted, the Aragonese poured into the shade of the Chianti valleys, so different from the harsh shrub and pitiless sun of summertime Calabria. From there, they leisurely raped, killed, and drank their way to Florence.

Now the city was gripped by panic. Traders and merchants fled, commerce dried up, and countless businesses failed. In desperation, Lorenzo de Medici appealed to the city-states of Bologna and Milan, but neither was in any mood to get involved in this unseemly squabble between Florence and the pope's allies. Lorenzo had no choice but to jump on a ship and rush to Naples. Here, he was able to negotiate a treaty in the nick of time, just before the king's troops reached the outskirts of Florence. Peace had been restored, but the great age of Medici Florence had passed its zenith. Several branches of the Medici Bank collapsed because of bad loans. Lorenzo himself was suspected of misappropriating state funds to prop up his family bank. The era of Medici patronage was drawing to an end—and the city itself would never be the same.

All this should be sufficient reason to put a question mark after the claim by Anonimo Gaddiano that Leonardo was "dispatched" to Milan by none other than Lorenzo de Medici himself. As Charles Nicholl has noted, Vasari says nothing of the sort, and Vasari was the chief apologist and propaganda artist for the Medici family—in this case, Duke Cosimo I, the autocratic ruler of Florence after the return of the Medici. Had Lorenzo indeed been involved in Leonardo's move to Milan, Vasari would certainly have cited the story as another example of the boundless munificence and foresight of the Medici dynasty.[2]

Instead, it is more likely that "Anonimo" was confused by the fact that, in 1481, after Pope Sixtus IV and Lorenzo had reconciled, the pope asked Lorenzo to send him six of the city's finest artists to help decorate a new chapel in the Vatican. This structure, named after Sixtus himself, was called the Sistine Chapel. Lorenzo complied, and dispatched the cream of

the crop from Florence's artistic circles to the Vatican. Thus, it was Lorenzo himself who unwittingly initiated the great exodus of creative talent from Florence to Rome, an exodus that would make the Papal See the new center of the High Renaissance, and leave Florence in its dust. Yet Leonardo wasn't among the delegation selected to go to Rome. He had been overlooked in favor of other, more established painters, such as Sandro Botticelli, Pietro Perugino, Domenico Ghirlandaio, and Luca Signorelli.

Vasari doesn't shed much light on why Leonardo decided to move to Milan, either. He claims that Leonardo was "summoned by the Duke, who took much delight in the sound of the lyre, and wanted Leonardo to play it." This is the first time we ever hear of Leonardo playing a lyre. What's more, we know for a fact that Duke Ludovico Sforza took no great interest in Leonardo, as an artist, musician, or otherwise, until many years later. Nicholl posits that Leonardo, understandably fed up with the city after the failure of the *Adoration* project, decided to join two distinguished lecturers, Bernardo Rucellai and Pier Francesco da San Miniato, on a journey to Milan in early 1482. But why he would have done so is not clear. Perhaps the real reason is the most obvious one: he was fed up with Florence and its politics, and longed for the stability and renown of a painter in the service of a powerful prince, as a court artist.

The desire for such a new source of patronage is clearly evident from the draft of a letter that he intended to send to the duke. And there was no reason to believe that Ludovico Sforza would not be receptive to such an overture.

As we noted earlier, Sforza was a usurper whose claim on the throne of Milan was uncertain at best and illegitimate at worst. In 1476, Ludovico's brother, the ruling duke Galeazzo Maria, had been assassinated, leaving his seven-year-old son, Gian Galeazzo Sforza, as the legitimate successor. This led to a bitter power struggle for control of the young heir, and in 1481, Ludovico emerged victorious. His rival, the young boy's mother, named Bona of Savoy, was ousted.

Following in the footsteps of many usurpers before him, Ludovico then

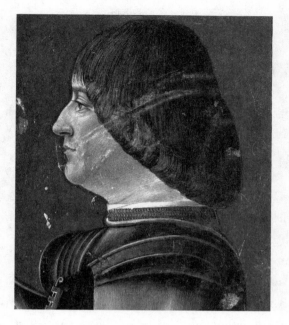

Ambrogio de Predis, *Ludovico Sforza, Duke of Milan,*
ca. 1490.

tried to camouflage his illegitimacy with the greatest possible pomp. Among others, he commissioned several propaganda projects to glorify the line of Sforza, which itself had been established by toppling the long-established dynasty of the Visconti. The idea that Ludovico would be in the market for new talent in a variety of artistic fields was therefore certainly plausible.

Leonardo thus drafted a letter to the duke that extolled his many talents, in the hope of securing a position at his court. The letter (if that's the right word, for the note may simply have been an aide-memoire in preparation for a presentation to the duke himself) reveals an uncanny understanding of the duke's priorities. Contrary to what one might expect, the note doesn't talk about Leonardo's artistic talents at all, other than as an afterthought, near the end of the missive.

Instead, Leonardo portrays himself as a military engineer, perhaps in the expectation that the duke would soon have to take to the field to defend his claim on Milan. Having "examined the inventions of all

Leonardo da Vinci, *Design for a Mortar*, ca. mid-1480s.

those who consider themselves masters of instruments of war," Leonardo began, "I therefore boldly offer my skills to Your Excellency." This was followed by a catalogue of special talents and inventions that Leonardo was prepared to execute, including "methods for making very light and easily portable bridges" as well as "scaling ladders"; "certain types of cannon, very easy to carry, which fire small stones"; and ways of "making underground tunnels and secret passages" for building "mortars" and "catapults," and even for designing "armored cars that are totally unassailable." It is only near the end of the letter that Leonardo remembers his skills as an artist, and concludes with the rather sycophantic offer to sculpt an equestrian statue "to the immortal glory and eternal honor of the Prince, your father's happy memory, and the famous House of Sforza."

This rather casual reference to the equestrian statue has prompted some historians to suggest that Leonardo had, in fact, already been in contact with the Sforza court about the project, and that the purpose of this letter was merely to emphasize his other talents, perhaps to increase the appeal of the "overall package." In fact, the desire of the Sforzas to build such a statue was well known; Ludovico's brother Duke Galeazzo Maria

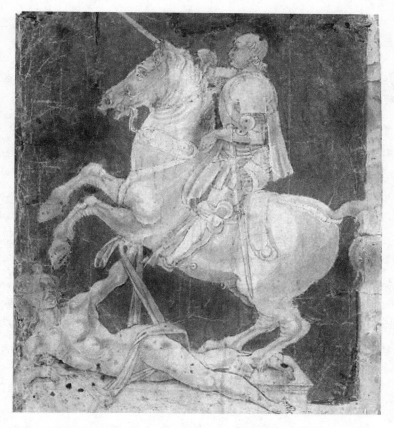

Antonio Pollaiuolo, *Design for the Sforza Equestrian Monument*, early 1480s.

had talked about a statue of his father "in bronze, and on horseback" as early as 1473, the year before his assassination.[3]

The Metropolitan Museum of Art in New York has a fine study of the monument, drawn by Antonio Pollaiuolo and dated to the early 1480s, although it is not clear if Pollaiuolo, or anyone else for that matter, actually had the skill to execute such a daring design, including the rearing horse.

After his installation as duke, Ludovico revived the project. Leonardo himself was later to claim that the "bronze horse" project was what had brought him to Milan, but evidence suggests otherwise: he was not engaged on the project until many years later, in the late 1480s. In any case,

the duke had other things to attend to, because shortly after his coup d'etat, he found himself at war with the Republic of Venice.

THE VIRGIN OF THE ROCKS

The truth of what happened when Leonardo arrived in Milan is rather more prosaic, and it had little or nothing to do with the duke of Milan. It was a commission to create an altarpiece featuring the Virgin Mary, which essentially was what he had been doing in Florence. The contract came about as a result of Leonardo's contacts with two well-established Milanese painters, Giovanni Ambrogio de Predis (ca. 1455–1510) and his brother Evangelista (died 1490/1). Ambrogio was on his way to developing a reputation at the Sforza court as a skilled portrait painter in a style that was heavily influenced by northern European artists. Leonardo even stayed at Ambrogio's home for a while, which may indicate that it was his friendship with this Milanese artist, rather than the prospect of working for the duke, that had prompted his departure for Milan.

The contract for the altarpiece had been tendered by a Franciscan lay group known as the Confraternity of the Immaculate Conception, and it envisioned a collaboration among all three artists: Leonardo, Ambrogio, and Evangelista. While this may sound strange, such collective contracts were quite common in Lombardy, where large projects were typically undertaken by either a family of artists or an ad hoc cooperative of sorts— perhaps to hedge one's bets against any one individual not being able to finish it on time. The Florentine cult of the individual "genius" had not yet managed to penetrate the Po Valley.

The resulting panel is Leonardo's earliest masterpiece from the Milan period: the enigmatic *Virgin of the Rocks*. It was an opportunity to show the city, and the duke, what he was capable of. And in this he certainly succeeded.

At the time, Lombardy art was still poised on the cusp between the Gothic and the early Renaissance—a Renaissance style, that is, that leaned

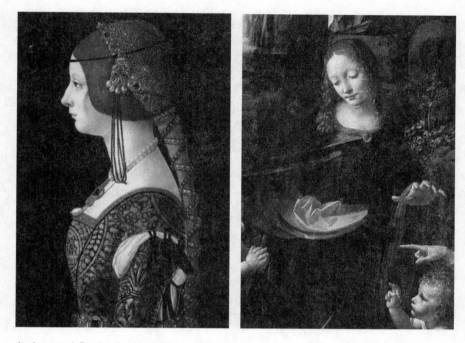

Ambrogio di Predis, *Portrait of Bianca Maria Sforza*, ca. 1490.

Leonardo da Vinci, *Virgin of the Rocks* (detail), Louvre version, ca. 1483.

more toward northern Europe than toward what was happening down south, in Tuscany. This may be one of the reasons the region of Lombardy had yet to produce any artist of real note. Instead, the art of Lombardy tended toward the depiction of figures in rather stiff and formulaic poses, which betrayed the tension between northern Gothic and the classicizing influences from the south. Ambrogio's portrait *Bianca Maria Sforza,* with its almost obsessive interest in textural detail rather than the personality of the sitter, could easily have been the product of a German studio.

To compare this work with *The Virgin of the Rocks* is to begin to understand the tremendous revolution that Leonardo brought to Milan. His Virgin Mary is not a two-dimensional stereotype, but a fully realized young woman, painted with delicacy and a naturalism that must have astonished the burghers of Milan. The soft interplay of light and shade on human skin and texture, the mysterious treatment of the cave's rocky

interior, and the overwhelming suggestion of depth, all products of Leonardo's scientific observations, conspired to give Milan a preview of what this remarkable artist was capable of.

While Mary's left hand hovers over her son Jesus, as if to shield him from evil, her right hand embraces the young John the Baptist, the figure destined to announce Jesus' inevitable path to his Passion. Thus the composition eloquently expresses Mary's dilemma: while devoted to her son's well-being, she knows she must submit to God's will and anticipate his future sacrifice. This is further affirmed in the gesture of the angel, who points to John so as to emphasize his role in God's plan for mankind. The infant Jesus, meanwhile, raises his hand to bless John, thus signifying that he has accepted his future Passion, and welcomes John's role in it.

This does not resolve all of the mysterious motifs surrounding *The Virgin of the Rocks*, given that the emphasis is clearly on the Virgin and the infant John. Jesus, strangely, is relegated to a lesser role at the very base of the triangular composition. This may explain why the agency that commissioned the work, the Confraternity of the Immaculate Conception in Milan, refused to pay the agreed price. Some modern authors believe that Leonardo was inspired by a pseudo-heretical text known as the *Apocalipsis Nova*, by the Franciscan theologian João Mendes da Silva, which depicts the Virgin and John at the core of the Passion story.[4]

We don't know if Ludovico ever saw the painting or, if he did, if he grasped the sheer originality of its design. Leonardo's panel was supposed to function as the "cover piece" of an elaborate wooden reliquary of sorts, which housed a venerable Madonna sculpture known as the *Immacolata*, symbol of the Immaculate Conception.

Contrary to popular perception, this Catholic doctrine does not pertain to Jesus' conception in Mary's womb, but rather to the conception of Mary herself. It holds that Mary was free from sin from the moment she was conceived in the womb of her mother, Saint Anne. This sin refers to the "Original Sin," mankind's perpetual sinful state since the Fall of Man in the Garden of Eden. The idea that Mary was "preserved free from

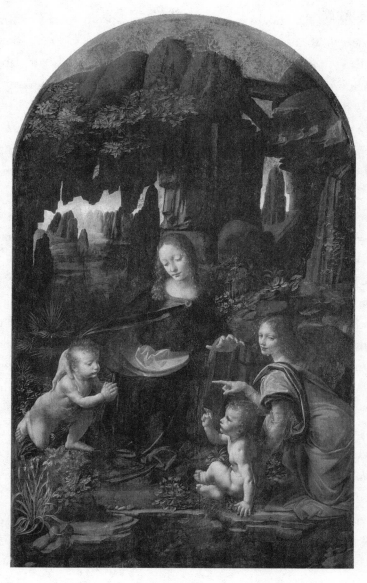

Leonardo da Vinci, *Virgin of the Rocks*, Louvre version, ca. 1483.

all stain of original sin" meant that she lived in the sanctifying grace of God from the very start.

In 1477, Pope Sixtus IV made the Immaculate Conception an official feast day on the Catholic liturgical calendar, and granted special

"indulgences" (essentially Church favors that expedited one's acceptance into heaven) to those who participated. Since Sixtus was a Franciscan, this may have prompted the Franciscan lay fraternity to build an elaborate shrine over the *Immacolata,* using a set of altar panels, known as a *retable,* as the screening device. Only once per year, on December 8 (the newly established feast day of the Immaculate Conception), was *The Virgin of the Rocks* to be removed to reveal the actual *Immacolata* sculpture underneath. Yet Leonardo's panel never got that far. As we saw earlier, a dispute between the artists and the fraternity over the price blocked the delivery of the panel. It probably sat in Leonardo's studio until its eventual acquisition, possibly by the French king, although this remains a topic of considerable debate.

What we do know is that, by 1485, the duke was at long last ready to take an interest in Leonardo. At that point, Leonardo was supporting himself with painting the type of devotional Madonna portraits he had made in Florence, while working in Verrocchio's studio. One of these may be the highly controversial *Madonna Litta,* now in the Hermitage in St. Petersburg. The subject is that of the *Madonna Lactans,* the "Nursing Madonna," a highly popular motif in the Middle Ages. That the chiaroscuro, Leonardo's delicate glazing of shadow and light on skin, is not as smoothly applied here as in *The Virgin of the Rocks* has prompted some historians to attribute the work to artists in Leonardo's immediate entourage. Frank Zöllner, for example, believes the work was painted by one of Leonardo's assistants, Giovanni Antonio Boltraffio (ca. 1466–1516). We believe, however, that the somewhat overpolished treatment of Mary's face could also be the result of repeated restorations during subsequent centuries.

More to the point, it is very doubtful than any of the *Leonardeschi* (artists who moved in Leonardo's orbit as pupils, assistants, or associates) would have been able to produce a portrait of such startling delicacy at this early stage of their engagement. The same is true for the silverpoint drawing, now in the Louvre, that is clearly intended as an advanced study for the *Madonna Litta.*

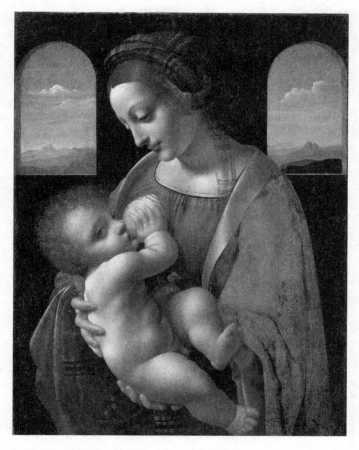

Leonardo da Vinci, *Madonna Litta*, ca. 1485.

One would be hard-pressed to accept that either Giovanni Boltraffo, Ambrogio de Predis, Marco d'Oggione or anyone else in Leonardo's entourage could have been capable of creating such a delicate drawing in the mid- to late 1480s. As M. A. Gukovskij rightfully points out, critics of the attribution to Leonardo "have not succeeded in putting forward the name of another artist to whom there are any convincing grounds for ascribing a picture of such great quality."[5]

In fact, the design of the *Madonna Litta* is a natural development of the *Benois Madonna,* with its growing sense of intimacy between Mary and the baby who suckles at her breast. To further strengthen the

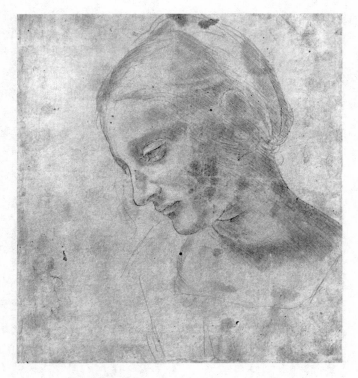

Study for the *Madonna Litta*, ca. 1485.

disarming naturalism of a loving young mother nursing her child, Leonardo dispenses with the medieval artifice of halos. The landscape, it is true, is rather perfunctory and lacks the panoramic sweep of his other Madonna portraits, but this could have been the work of one of his assistants. Some historians, notably Luke Syson, believe that the *Madonna Litta* belongs to a later date, particularly since it was executed in tempera paint, rather than oils. Syson argues that the delicate transition between light and shade on the Virgin's skin closely parallels similar attempts by Leonardo in the portraits of the Apostles in *The Last Supper*, executed in a blend of tempera and oils. If he is correct, then the *Madonna Litta* may have served as a test case of sorts, to determine how far tempera pigments could be pushed to produce the same glazing effect of oils.

4

THE SFORZA COMMISSIONS

Men of lofty genius are most active when they are
doing the least work.
—LEONARDO DA VINCI

As Leonardo's notebooks from the mid-1480s testify—the earliest surviving codices date from this period—his mind was drifting to subjects other than painting. It was spinning with new ideas and inventions, from architectural designs to all sorts of military contraptions, including a submarine, a steam-powered cannon, and the first of his "flying machines." Leonardo yearned to break out of the mold of painter and be recognized as an *engineer,* to be able to put his scientific empiricism into practice. He was consumed by trying to figure out how things work, and whether the technological fantasies of his frenetic mind could be turned into reality. One is tempted to think that it is by virtue of some of these designs that he came to the attention of Ludovico Sforza. For, by now, the duke must have realized that the grandiose ambition of the Sforza equestrian monument was well beyond the ability of any existing Lombard sculptor, and could be realized only by a truly exceptional artist. Perhaps Leonardo was that man.

That Leonardo nurtured a special love for the horse is well attested. Numerous of his sketches have survived that explore the perfect equine form from a variety of angles, including a beautiful study in metalpoint on blue paper, now at Windsor Castle. Never content to accept the norm

when a more daring proposition lay in the prospect, Leonardo initially ignored the conventional way of creating an equestrian statue, namely, with at least three of the horse's hooves firmly anchored on the base. That is how his master, Verrocchio, was casting his statue of the mounted Colleoni in Venice. Leonardo wanted something more daring, more spectacular: a horse rearing up on its two hind legs, even while carrying a full adult male on its back—not unlike Pollaiuolo's design of a decade earlier. While spectacular, such a design immediately raised the problem of how to bear the stupendous weight of a large bronze cast on just two of the horse's hooves, quite apart from the need to calculate *exactly* the balance of the work, lest it tip over or backward.

Unfortunately, Leonardo's enthusiasm was no substitute for experience. It is certainly true that at as part of his apprenticeship at Verrocchio's, he would have been trained in the various stages of casting a bronze sculpture, including the "lost wax" technique that enabled an artist to create a hollow bronze from a clay model. Yet, as far as we know, Leonardo had

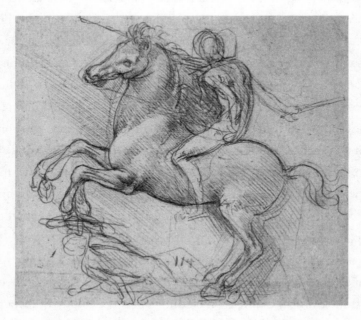

Leonardo da Vinci, *Study for the Sforza Monument*, ca. 1488–89.

never actually produced anything of the sort, certainly not in the gigantic dimensions that this particular project called for. The horse, the *cavallo,* alone was to be twenty-three feet (seven meters) tall! Would Leonardo be up to the task?

Ludovico wasn't so sure. On July 22, 1489, the Florentine ambassador in Milan, Piero Alamanno, wrote to Lorenzo de Medici that the duke wants "a very large bronze horse and on it the figure of Duke Francesco," and wondered whether Lorenzo could "send him one or two artists from Florence who are accomplished in this field." The reason, Alamanno added regretfully, is that "although the Duke has commissioned Leonardo da Vinci to do the work, it seems to me that he is not confident that he will succeed."[1] Either Leonardo had failed to convince Ludovico of his ability to execute the work, or the duke was merely looking for a second opinion from some experienced hands.

What we do know is that the work was temporarily halted while the duke weighed his options. Only in April 1490 did Leonardo confide to his notebook that he had "begun again on the horse." The enforced hiatus between 1489 and 1490 brought Leonardo somewhat back to earth, for after he "resumed" his work on the *cavallo,* it had changed to the more conventional design of a trotting horse—that is, with at least three hooves firmly on the ground. A note in the *Codex Atlanticus* suggests that a trip to Pavia, to see an equestrian statue from Late Antiquity called the *Regisole,* was a major factor in Leonardo's opting for the more conventional solution. "The imitation of antique works is more praiseworthy than modern ones," he scribbled to himself. The *Regisole* was unfortunately destroyed in 1796, in the aftermath of the French Revolution; the current version is a copy from 1937, and of uncertain fidelity.

Three years later, in 1493, Leonardo did complete a massive horse, just in time for the dynastic celebrations of the marriage of Bianca Maria Sforza, Ludovico's niece, to Emperor Maximilian I. But the horse was only a life-size model in clay, not yet in bronze. Nevertheless, the model astounded everyone who saw it in the courtyard of the Corte Vecchia, the

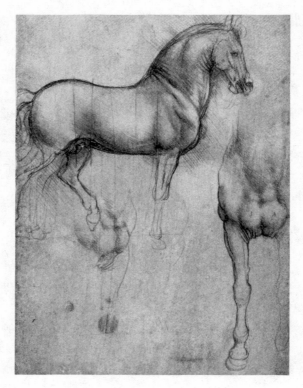

Leonardo da Vinci, *Study of a Horse*, ca. 1490.

old Visconti castle where Leonardo had established his studio. "Vedi che in corte fa far di metallo," Ludovico's court poet Baldassare Taccone intoned,

> *See what has been made in the Corte of bronze*
> *in memory of the father, a colossal horse.*
> *I firmly believe that no greater work*
> *was ever seen in Greece or Rome.*[2]

The word *colosso* ran like wildfire through Milan and was picked up by several other writers, notably Francisco Tantio and Giovanni Tolentino. The idea that a contemporary artist had matched the famed colossal

Design for the Casting of a Horse's Head, ca. 1493.

statues of Antiquity, such as the *Colossus* of Nero or the colossal statue of Constantine the Great, seemed to seal the duke's ambition, and that of the era as a whole, not only to match, but also to surpass the glory of Rome.

Unfortunately, the project never moved beyond this point. "It was conceived on so vast a scale," Vasari opined, "that it could never be completed." It was estimated that some seventy tons of bronze would be needed to cast the horse. The technical difficulties of the casting technique itself would occupy Leonardo for the remainder of that year. Yet it all came to naught when the vast stocks of bronze were unceremoniously appropriated in 1494. Ludovico's erstwhile ally, the French king Charles VIII, had become his enemy. Therefore, the bronze was needed to cast cannon rather than art. The clay model remained in the courtyard, slowly disintegrating in the elements, until, in 1499, the city fell into the hands of the French army. According to a famous story, perhaps apocryphal, French mercenaries used the horse as target practice for their crossbows, until it lay in pieces on the ground.

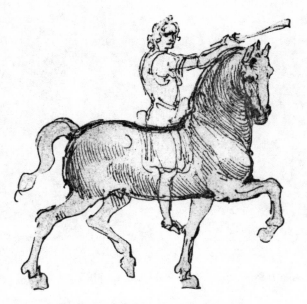

Sketch for the Sforza Equestrian Statue, ca. 1493.

A PORTRAIT OF A LADY

By the early 1490s, however, Leonardo had become engaged in a task that brought him closer to his core competency: the depiction of feminine grace. He was asked by Ludovico Sforza to create the portrait of a lady. The subject was Cecilia Gallerani, who had been born in 1473, when Leonardo was already working in Verrochio's studio. When she was thirteen or fourteen years old, Cecilia was betrothed to a certain Giovanni Stefano Visconti. This was the custom in those days; girls were prepared for their nuptials as soon as their menses started. In the case of Cecilia, however, the need for marriage was urgent. Her father, the Milanese ambassador to Florence, had died when she was seven, leaving most of his inheritance in the hands of her six brothers. Marrying into the Visconti family, who despite their loss of power remained a prominent one, would very likely have put an end to her financial problems.

Then, in June 1487, her marriage contract was suddenly annulled. The reason was never documented, but one plausible explanation is that she

had caught the eye of the notoriously amorous Duke Ludovico himself. That she became the duke's mistress not long after is a matter of record. There was only one problem: Ludovico had just been pledged to a marriage contract himself, to a lady named Beatrice, daughter of one of Italy's most renowned dynastic families, the House of d'Este. Her father was Ercole I, Duke of Ferrara, and ruler over a magnificent Renaissance court. The marriage was calculated to elevate Ludovico's prestige significantly, and thus increase his chances of being recognized as the legitimate duke of Milan.

Under normal circumstances, the betrothal would not have prevented Ludovico from indulging in an affair with a lovely young commoner. In the Renaissance, prominent men were expected to have both a wife and a mistress, or even several mistresses. In those days, romance and marriage were not necessarily synonymous. Marital unions were usually the product of careful political and financial negotiations, not the outcome of love or courtship. If it was romance one wanted, the more obvious venue was to pursue a liaison with one or several young ladies, provided one used discretion.

Yet here was another problem: Ludovico was anything but discreet. In fact, he had become thoroughly besotted with the girl. By 1490, Cecilia had gained such prominence as Ludovico's *maîtresse-en-titre* ("official mistress") that Ferrara's ambassador in Milan, Jacopo Trotti, wrote home with the alarming news that the engagement with Beatrice might be in danger. "He is head over heels in love with her," the ambassador wrote despairingly, referring to Cecila; "she is pregnant, and as beautiful as a flower, and he often takes me along when he wants to visit her."

Well before then, Ludovico's consuming passion for Cecilia had prompted him to commission a portrait of her. For this, he decided not to turn to his stable of reliable Lombard artists but to his Florentine guest, Master Leonardo. In this, Ludovico knew, Leonardo would not disappoint him. And he was right.

The result is the famous *Lady with an Ermine,* another landmark in the development of Leonardo's highly personal style. Set against a dark

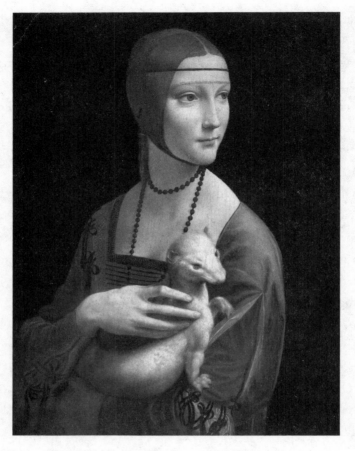

Leonardo da Vinci, *Lady with an Ermine*, ca. 1490.

background so as to draw the viewer's attention to the delicate glazing of Cecilia's flawless skin, the most striking feature of the portrait is the subject's pose. It is perhaps the first example of Leonardo's deep interest in the suggestion of movement—as if the sitter were caught in the midst of shifting her gaze, thus enhancing her natural poise and grace.

Leonardo did not arrive at this solution overnight. The queen's collection of his work at Windsor Castle includes a wonderful worksheet where the artist explores some twenty different ways in which a woman's head, neck, and torso could be positioned, often seen from a variety of angles. The worksheet is a textbook example of *contrapposto,* the classical ideal of

Leonardo da Vinci, *Study of a Young Woman in Various Poses*, ca. 1490.

moving the head, torso, and limbs of a human body in different positions from its center axis. "From varied viewpoints," Leonardo wrote in his *Treatise on Painting,* which was painstakingly put together by his pupil Francesco Melzi, "each human action is displayed as infinite in itself."[3]

Leonardo's chiaroscuro, the delicate transition from light to shadow to suggest the shape and texture of the human body, would become the hallmark of his style. "I must remind you," he wrote for his planned *Treatise on Painting,* "to take care that every portion of a body, and every smallest detail which is ever so little in relief, must be given its proper importance as to light and shade."

Familiarity has worn away our appreciation of *Lady with an Ermine,* but that certainly wasn't the case for Leonardo's contemporaries, who must have been astonished to see such a lifelike and arresting portrait. For the first time in the Italian Renaissance, an artist had created a portrait of a woman that captured not only her likeness, but her very *soul.* Leonardo was very much aware of this. In his *Treatise,* he writes, "A figure is most praiseworthy when it expresses the passion of its mind." Of the lady depicted, a poet at the Sforza court, Bernardo Bellincioni, wrote that Leonardo "made her seem so lifelike that she appears to be listening, and not speaking just now." Or, in the words of John Pope-Hennessy, the *Lady with an Ermine* is the first portrait in European art to show that a painting could express the sitter's *thoughts* simply through a combination of posture and gesture.[4] Indeed, Leonardo wrote that to capture the elusive thoughts of a sitter, a painter had to use the "gestures and movements of the limbs."[5]

In *Lady with an Ermine,* gesture is indeed a key element, not only stylistically but also allegorically. Upon close inspection, the slender fingers are slightly elongated, to make them appear more graceful—a conceit Leonardo undoubtedly learned from his master, Verrocchio. As our gaze is drawn toward these beautiful hands, we see that the lady's right hand is absentmindedly caressing the neck of an ermine, thus enhancing the pensive, almost intellectual air of the portrait. The ermine, a weasel-like animal, also provides a key to deciphering the sitter's identification. The ermine was a favorite pet of the aristocracy, and one of the emblems of Duke Ludovico Sforza of Milan; known as a stoat, inspired by the Dutch word *stout,* it was believed to be "bold and courageous." Others, including Leonardo himself, equated the animal with "immaculate purity," a quality that was both admired and expected from a female courtier at the time. What these allusions tell us is that we must be dealing with an important lady from the court of Milan.

Another clue is hidden in the Greek name for "ermine." By this time, Greek had once again become part of the educational curriculum for high-

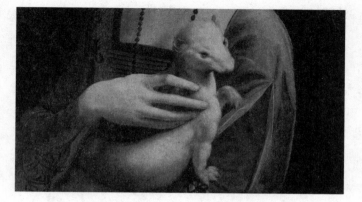

Lady with an Ermine, detail of the hands holding an ermine, ca. 1490.

born children, so that courtiers were expected to have some familiarity with Greek authors and poetry. As it happened, the Greek name for an ermine is *gale* or *galay*. Taken together, the clues all seem to point toward Cecilia Gallerani, a young woman whom the duke took as his lover when she was sixteen.

The portrait was probably executed between 1489, when Cecilia began her affair with Ludovico, and later in 1490, when she became pregnant; she then bore the duke's son in January 1491. Alas, regardless of his love for his young mistress, the wedding to Beatrice d'Este went ahead. It was celebrated, with all the requisite pomp, on January 16, 1491. This naturally called for an official state portrait of the new Duchess of Milan. Curiously, it was not Leonardo but Ambrogio de Predis, the artist who worked with Leonardo on *The Virgin of the Rocks,* who was chosen for the task. This is, once again, an example of the duke favoring native artists from Lombardy for politically significant works over his guest artist from Florence, who apparently could be trusted only with less sensitive subjects, such as the duke's mistresses. Not surprisingly, Ambrogio's portrait of Beatrice follows the standard Lombard model of showing the lady in profile, even though the delicate patterns of her dress clearly reveal the influence of Leonardo. Some historians have even detected Leonardo's hand in the execution of the face.

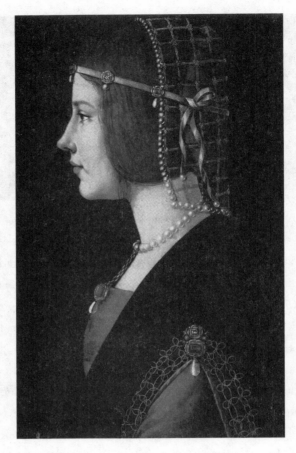

Ambrogio de Predis, *Portrait of a Young Woman*, possibly Beatrice d'Este, ca. 1490.

The obvious conclusion is that Ambrogio had continued to work closely with Leonardo. Despite the scarcity of commissions, Leonardo had attracted a number of "associates." These, such as Giovanni Boltraffio and Marco d'Oggiono, weren't "pupils" in the traditional sense of the word, but trained painters from Lombardy who were eager to learn (and appropriate) the astonishingly realistic effects pioneered by Leonardo. Many of them would later gain considerable fame as *Leonardeschi,* painters who had absorbed the Leonardesque magic firsthand, and applied it with relish in their own paintings. Eventually the studio grew to a total of six

"dependents" (as Leonardo described them), including his companion Salaì; a painter named Tommaso Masini, or Zoroastro; a German artist known simply as Giulio; and a bevy of other pupils, including those variously identified as Gianmaria, Galeazzo, Bartolomeo, and Benedetto.

LA BELLE FERRONNIÈRE

Though over time he became quite fond of Beatrice, secretly Ludovico continued to yearn for his young mistress Cecilia more than he desired the conjugal bed. Several weeks after the wedding, the duke confided to the long-suffering ambassador of Ferrara that he "wanted to make love to Cecilia," and that this was fine by his new wife, for "she did not want to submit to him." It seems that Beatrice, a high-born princess of the same age as Cecilia, simply refused to sleep with the duke until he got rid of "that girl," as a wife would put it nowadays. Threatened with a scandal and the loss of Ferrara's support, on March 21 Ludovico finally sent Cecilia away, justifying the decision with the comment that "she is now too big for him to have relations with her." Two months later, Cecilia gave birth to a son, Cesare Sforza Visconti.

Shortly after New Year's Day 1497, Beatrice went into labor herself, but as so often happened in the Middle Ages, the birth was not without complications, and on January 3 she died. Renowned for her beauty, intellect, and political acumen, she was only twenty-one years old.

Ludovico was inconsolable, even though by this time he had acquired another mistress. Her name was Lucrezia Crivelli, a lady-in-waiting to Beatrice. By 1495 she had succeeded Cecilia Gallerani as the duke's *maîtresse-en-titre*. In March 1497, just two months after Beatrice's death in childbirth, Lucrezia bore the duke a son; he was named Giovanni Paolo, the later Marquess of Caravaggio.

While the identification is disputed, several historians believe that Lucrezia is the sitter in another portrait by Leonardo from this time, commonly referred to as *La Belle Ferronnière*. The attribution to Leonardo has

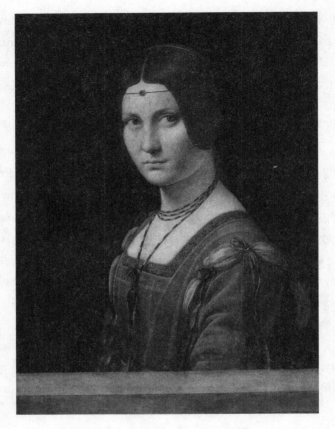

Leonardo da Vinci, *La belle Ferronnière*, ca. 1495.

not been without controversy, but a scholarly consensus has emerged that, in its most important details, the portrait is indeed an autograph work. The almost photographic realism of the portrait, achieved through a subtle chiaroscuro against the black limbo of the background—note, for example, the luminous passage on the subject's lower cheek, lit by the reflection of her bare shoulder—is certainly a continuation of the theme of *Lady with an Ermine*. The understated jewelry is another feature that this painting shares with the Gallerani portrait.

It is only when our gaze travels downward that disappointment follows. The plain wooden balustrade is almost certainly the work of pupils. As Pietro da Novellara would write several years later, Leonardo preferred

to delegate the tedium of portraits to "associates," except for obviously critical areas of the face and hands.[6]

The meaning of the title *La Belle Ferronnière* (meaning the wife or daughter of an ironmonger, a *ferronnier*), which first appears in a 1709 inventory of the French royal collection, has been the subject of extensive speculation. One of the mistresses of King Francis I of France was married to a man named Le Ferron; it is possible that the inventory simply confused our Milanese lady with a portrait of the king's *maîtresse*. Another, even earlier inventory, drawn up in 1642, correctly ascribes the painting to Leonardo, but calls it a "portrait of a Duchess of Mantua," thus adding to the confusion. To complicate matters further, the portrait of the *Lady with an Ermine* was also at one point described as *La Belle Ferronnière,* given that the small chain worn on the lady's forehead was called a *ferronnière* in fifteenth-century France.

Stylistically, both portraits are closely linked to what would become Leonardo's masterpiece in Milan, the fresco for the Convent of Santa Maria delle Grazie in Milan, *The Last Supper.* As several historians have pointed out, the drama of posture and expression on the faces of the Apostles is in many ways anticipated by the portraits of Cecilia Gallerani and Lucrezia Crivelli, each brimming with beauty, intelligence, and purpose.

THE *PALA SFORZESCA*

Every action needs to be prompted by a motive.
—LEONARDO DA VINCI

Buoyed by his marriage to the prestigious House of d'Este, Ludovico now focused on the single greatest objective of his rule: his elevation to, indeed his *vindication* as, the legitimate duke of Milan. Only the Holy Roman emperor could bestow this title. So the challenge that confronted Ludovico was how to motivate the ruling emperor, Maximilian I, to grant him his wish.

Of course, the position of Holy Roman emperor itself was an anomaly, a hopeless medieval anachronism at the dawn of Europe's early modern age. The title had been invented in 800, when the French king Charles was finally able to bring all of France and parts of Germany under his sway. For his efforts, the king (thereafter known as Charles the Great, or Charlemagne) was crowned emperor of all of Western Christendom. The title was not only a deliberate attempt to recapture the glory of Rome. It was also a not-so-subtle riposte to the Byzantine emperor and his Orthodox realm in the East. Even as the idea of a Christian "empire" dissolved in a political sense, the title was still avidly pursued by a string of European monarchs with ambition on their minds. As the protector of a growing number of principalities across the Continent, the emperor became the most important counterweight to the still-formidable power of the Church.

In 962 the imperial title passed from the French to a series of German dynastic lines, beginning with King Otto the Great and culminating in the reign of Wenceslaus IV of the House of Luxembourg. It was Wenceslaus who in 1395 anointed Gian Galeazzo Visconti, a scion of a long line of Visconti rulers in Lombardy, as the first legitimate duke of Milan. Unfortunately, the Visconti hegemony was brief; the untimely death of Filippo Maria Visconti in 1447 brought an abrupt end to the Visconti dynasty. Milan then briefly became a republic, before its government was overthrown by Filippo's son-in-law Francesco I Sforza, who happened to be Ludovico's father. The fact that Francesco's wife was actually Filippo's *illegitimate* daughter, without any legal claim to Visconti rule whatsoever, was conveniently overlooked. The House of Sforza then firmly remained in control, even though the new emperor, Frederick III, didn't like the family and never officially affirmed its ducal ambitions.

Maximilian I of the House of Habsburg was a different quantity altogether. Elected to the title of emperor in 1486, just five years after Ludovico's triumphant coup d'état, Maximilian was a man who could be persuaded to see reason, preferably in exchange for a handsome bribe.

Bolstered by the considerable prestige that his 1491 marriage to Beatrice d'Este had brought to the Sforza claim, Ludovico launched a charm offensive to bring the emperor into his camp. In 1494 he scored his first success, persuading the emperor to accept the hand of his niece Bianca Maria Sforza in marriage. As it happened, Bianca was less known for her beauty (as her portrait on page 67 attests) than for her rather startling domestic habits, such as her inclination for eating her meals on the floor. Fortunately, this did not seem to be an insurmountable obstacle once it became clear that Ludovico was prepared to grant Maximilian a dowry of 400,000 ducats (around $32 million in today's currency). This gigantic sum was raised by the expedient of sharply increased taxes on the hapless populace of the Duchy of Milan.

There were, however, also political reasons that the Hapsburgs and the Sforzas needed to be aligned, however temporarily. In early 1494, King

Ferdinand I of Naples had died, vacating the throne in favor of his rather unstable son Alfonso. Alfonso wasted no time in also claiming the Duchy of Milan, based on the not unreasonable assumption that his daughter, the wife of young Gian Galeazzo Sforza, who was now pining away in a castle in Pavia, was the legitimate duchess of Milan. As we saw, Alfonso therefore planned to march on Naples, depose the pretender Ludovico, and install Gian Galeazzo and Isabella as the rightful rulers—all as part of a greater kingdom of Naples, of course.

In response, Ludovico turned to the French king Charles VIII for help. He encouraged the king to enter Italy with his armies, which were renowned for their artillery, and to enforce a *French* claim on *Naples* instead. And just to be safe, Ludovico also decided to appropriate the seventy tons of bronze that had been earmarked for Leonardo's horse and send it to the foundries of Ferrara with the order to have it cast into three large cannons "in the French manner."

At first, the idea of recruiting Charles VIII to intervene in Italy's squabbles looked like an inspired decision. After crossing the Alps, the French king ate and feasted his way down the Italian peninsula, pausing just long enough in Florence and Rome to augment his already groaning train of loot. He then marched on Naples and took the city with an ease that stunned all of Italy. The people's shock turned into alarm, however, when it appeared that the French king was in no hurry to leave.

In fact, Ludovico's plan had already begun to backfire. Rumors began to circulate that Charles had been in touch with the young Gian Galeazzo Sforza, the duke's rival for the Milanese throne. Clearly, the French king was up to no good. Ludovico's worst fears were realized when Charles suddenly decided to lay claim to Milan *himself.* He justified his claim on the rather complicated pretext that his cousin Louis of Orléans was the grandson of Valentina Visconti, daughter of the same Gian Galeazzo Visconti who had been anointed duke by Emperor Sigismund. That Gian Galeazzo Visconti had at one point threatened to declare war on France was not seen as a particular obstacle to the claim by the House of Orléans.

The abrupt turnabout by the French king, the duke's erstwhile ally, made the issue of Ludovico's legitimacy suddenly very urgent. Ludovico was well aware that the only reason that people all over Europe were coming out of the woodwork to claim the Duchy of Milan was that, *officially* at least, the position was vacant. Ludovico was merely a regent, a caretaker, keeping the throne warm until such time that his nephew Gian Galeazzo Sforza was old and wise enough to take it (an event that, naturally, Ludovico strove mightily to delay or prevent). And in the bizarre tapestry of European politics, that made a Sforza alliance with the emperor very attractive, for the House of Hapsburg had long since recognized France as its principal rival in European affairs. As France's enemy, Ludovico suddenly became much more appealing to Maximilian, especially if this attraction was sweetened with a dowry guaranteed to improve the rather deplorable state of the imperial coffers.

Thus, in that fateful year of 1494, Ludovico Sforza finally realized his greatest ambition. He was formally invested as the duke of Milan by imperial fiat. Lavish ceremonies were celebrated throughout the city of Milan, some of which were orchestrated by Leonardo, though the outlying towns and villages were less enthralled, knowing that they would have to pay for all the revelry with their taxes.

THE ART OF SFORZA PROPAGANDA

With his position as duke secure at last, Ludovico could begin to devote his energies to extolling his dynastic line as the ruling house of Milan. The first action in this propaganda effort was, naturally, a state portrait that would show him as the enlightened prince that he was, and as the pious father of his people. This meant that the portrait would have to be displayed in a socially prominent place, where all of Milan would be able to see it. Fortunately, a perfect place presented itself. This was the Sant'Ambrogio ad Nemus, one of the oldest and most revered churches in Milan. Saint Ambrose (ca. 340–97), Aurelius Ambrosius in Latin, had

served as the consular prefect of Milan some fifty years after Emperor Constantine made Christianity a tolerated religion within the Roman Empire. By 371, however, the nascent Christian Church was being torn apart by the conflict between Catholicism and Arianism, two different philosophies regarding the dual nature of Christ as both God and man. In this tense climate, Ambrosius emerged as a peacemaker of sorts because of his reputation for piety and conciliation, and was rewarded with the see of Archbishop of Milan. Ever since, Ambrosius ("Ambrogio" in Italian) would be revered as the patron saint of the city. According to tradition, the Sant'Ambrogio church was founded by Ambrose himself in the year 379, to mark the spot where numerous martyrs of Roman persecution were buried. The church was therefore one of the preeminent sacred spaces of the city, deeply woven into Milan's social fabric.

Ludovico and his artist had also settled on a motif for his official state portrait. The painting would be a *sacra conversazione,* a "sacred conversation," between the enthroned Madonna and a group of saints of particular relevance to the donor, the person who paid for the work. Throughout the early Renaissance this had become a popular motif for many wealthy families in Europe: the idea of creating a devotional picture of the Madonna that included the patron saints of their house and other religious figures who were politically or socially important to their estate. An example is the *Annalena Altarpiece,* painted in Florence by the Late Gothic artist Fra Angelico around 1435.

Despite the obvious incongruity of seeing a contemporary benefactor with his wife and children in the traditional setting of a Nativity or Crucifixion, the idea was a big hit on both sides of the Alps. For example, in the *Portinari Altarpiece,* by the Flemish artist Hugo van der Goes, which arrived in Florence in 1483, the donor's wife and her daughter (painted on a smaller scale) are "introduced" to the scene by Mary Magdalene and Saint Margaret.

Ludovico envisioned something similar, a *sacra conversazione* with the Madonna and saints who were closely associated with Milan: Saints

Ambrose, Gregory, Augustine, and Jerome, four of the most revered Church fathers in the late Middle Ages. In the foreground of this ensemble, Ludovico saw the votive portraits of himself and his wife, the renowned Beatrice d'Este.

The year was 1494. Leonardo had already finished the inimitable *Lady with an Ermine* and would soon begin work on a portrait of another Sforza mistress, Lucrezia Crivelli. Yet, once again, Ludovico chose *not* to charge Leonardo with this commission, the most important painting of his rule to date, his official state portrait. Or did he?

The question is an important one. Some historians, including Luke Syson, detect some influence of Leonardo in the work. They point to the artist's attempt to imitate Leonardo's fine glazing technique in the face of Mary, and to the heavy chiaroscuro of the rather oddly positioned Jesus. Syson even wonders if the work could have been a product of Leonardo's workshop, for perfectly valid reasons, as we soon shall see. Yet, in every other respect, this rather uninspired composition is typical of the stodgy and somewhat Germanic approach of Lombard artists in the mid-Quattrocento.

The four saints, as well as the Madonna and Child, are crammed into a tiny space whose dimensions are delineated by the gilded architectural features of a *baldacchino*. Mary herself, holding the child Jesus on her lap, is seated on a throne conforming to the iconographic conventions of Italian medieval art. The rich detail of the wardrobe of the four saints, moreover, betrays the influence of northern European artists, such as Rogier van der Weyden and Robert Campin.

Politically, the most important element of the painting, and indeed the raison d'être of its genesis, is what happens at the far left. Here, Saint Ambrose lays his hand on Ludovico's right shoulder, while simultaneously the child Jesus turns on the Virgin's lap to raise his right hand and bless the duke. Invoking the endorsement of a saint such as Ambrose, who by this simple gesture assures the Milanese faithful that they should trust and obey the duke, follows a precedent that has its roots in Gothic art. But

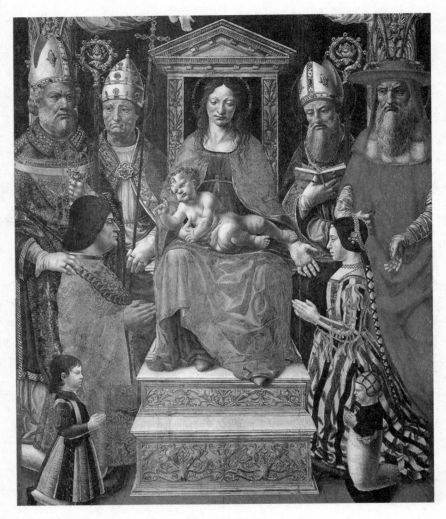

Master of the Pala Sforzesca, *Pala Sforzesca*, 1494.

co-opting even Christ himself in the glorification of Sforza rule is a rather unprecedented and, some would say, even sacrilegious feature. It betrays a duke at the apex of his power, secure in his position, and confident in the dynastic rule of his house for many years to come.

That dynastic future is further guaranteed by two smaller figures, which may have been added to the foreground at a later date. Here we see, on the left, Ludovico's eldest son, Massimiliano, born in 1493; and

on the right, his newborn baby Francesco, still in swaddling clothes, kneeling next to his mother, Beatrice d'Este. The painting was commissioned in 1494, but Francesco was not born until February 1495, and therefore must have been added when the composition was already in place. The pledge implicit in Ambrose's gesture is a promise of political rule for at least one generation in the future.

THE MASTER OF THE PALA SFORZESCA

Why, then, would Ludovico not choose his finest court artist to paint the first official portrait of him as a legitimate duke, in the company of the city's most revered saint, for the city's most prestigious religious house? Did he not trust Leonardo to execute it in a timely fashion? Was Leonardo on probation, following the collapse of the great Sforza *Cavallo,* the equestrian monument? To put it more succinctly, was Ludovico angry with Leonardo?

There is some indication that this last suggestion, bizarre though it may seem, could not be far from the truth. To begin with, Leonardo was certainly furious with Ludovico for having taken away the bronze for his clay horse. His notebook features a series of angry scribbles in which he gives full vent to his anger, perhaps as a therapeutic device or perhaps to rehearse what he would say when he next saw the duke. In these notes, Leonardo faults Ludovico for all sorts of problems, including the fact that his compensation was two years in arrears, forcing him to pay his assistants out of his own pocket. The possibility of a confrontation between the headstrong artist and the even more headstrong duke is not out of the question.

One of the notes, mostly fragments now, refers to a "commission to paint the rooms." Perhaps Ludovico exacted revenge on his artist by condemning him to work as a wall decorator, painting Sforza heraldic portraits in the Castello Sforzesco of Milan. In Lombardy, painters had not yet shaken the stigma of being considered essentially glorified artisans, quite in contrast to the cult of the genius that was being nurtured in

Florence. Ludovico would therefore have had no compunction about ordering his court artist to paint some of the walls in the sprawling castle, just as he would later "reward" Leonardo for painting *The Last Supper* by having him decorate the ceiling of a large hall, known as the Sala delle Asse. A painter was a painter, period. And for creating something as politically significant as the altar panel for the Sant'Ambrogio, Ludovico may have relied on an artist he could *trust,* in contrast to that volatile Florentine.

But who was this artist? No one knows for sure. For lack of a better term, and following a convention often used in art history, the artist is now named after his most important work: thus, the "Master of the Pala Sforzesca," *pala* meaning "altarpiece." While we don't know his identity, we do know some of his other works, based on a comparison of stylistic telltales. One of these paintings is *The Virgin and Child with Four Saints and Twelve Devotees,* now in the National Gallery in London.

This is another *sacra conversazione,* with a composition that is strikingly similar to that in the *Pala*; the position of Jesus is almost identical. The individual who is being favored by Christ's blessing has never been identified; nor have the other characters in the foreground, who most likely are members of the favored man's (extended) family. But the saints who "introduce" the donors are most likely James the Greater and Saint Lawrence on the left, and San Bernardino (in habit) on the right; the identity of the other saint is a mystery. The similarity to the *Pala* would indicate a date around 1495. Most important, however, the influence of Leonardo is here even more pronounced. The position of the Virgin is more natural and more monumental, while the gentle inclination of her face and the treatment of her skin clearly betrays the influence of *The Virgin of the Rocks.*

Does this give us a clue about who the artist might be? That he had access to Leonardo's studio, and perhaps worked as one of Leonardo's assistants, is very likely. The British Museum has a metalpoint drawing with white highlights on gray paper that clearly appears to be a copy of Mary from *The Virgin of the Rocks.* The drawing is not without skill, particularly in the treatment of the shading on the Virgin's left cheek,

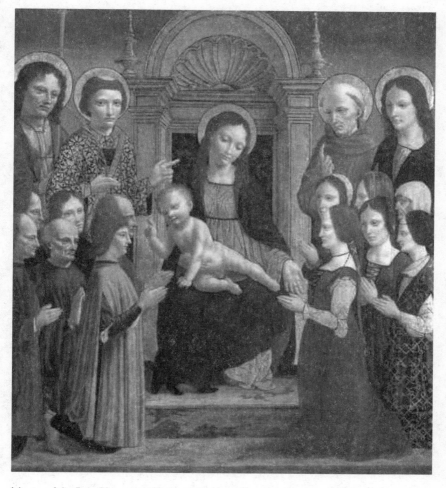

Master of the Pala Sforzesca, *Virgin and Child with Four Saints and Twelve Devotees*, ca. 1495.

although, as Luke Syson points out, "[the artist] clearly does not possess Leonardo's anatomical knowledge."

It seems plausible that this drawing formed the principal study for the head of the Virgin in the *Pala Sforzesca*. But we know that *The Virgin of the Rocks* was not on public display, because of a disagreement between the artists and the confraternity that commissioned the painting. Therefore, the artist must have had access to Leonardo's studio, or to the place used by Leonardo to store the panel.

Two distinguishing elements of the drawing are the curiously heavy-lidded, protruding eyes and the pronounced lips. These features are typical of several Lombard painters, particularly Giovanni Boltraffio. But Boltraffio, one of Leonardo's most prominent Milanese *Leonardeschi,* was a far more accomplished painter than the *Pala* suggests.

Syson believes that the *Pala* artist was trained in the studio of Ambrogio Bergognone (also known as Ambrogio da Fossano, ca. 1470s–1523/24) because of the curious way in which the gold leaf is overpainted with black paint. A com-

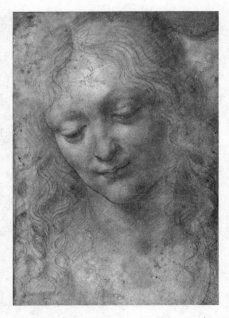

Master of the Pala Sforzesca, *Head of a Young Woman,* ca. 1490.

parison between the *Pala* and another altarpiece by Bergognone, *St. Ambrose and Saints* for the Certosa di Pavia monastery complex, is particularly revealing. For one, the Certosa was a major beneficiary of Ludovico's patronage, which could indicate that the duke was aware of the artist and favored him. Second, the composition of *St. Ambrose and Saints* is almost identical to the one employed in the *Pala.*

Another school of thought suggests that the panel could have been the work of one of two sixteenth-century Spanish artists, both named "Fernando" in Italian: Hernando de Llanos, and Hernando Yáñez de la Almedina. It is possible that either Fernando appears in Leonardo's notebooks as Fernando Spagnolo, or "Ferdinand the Spaniard." Spagnolo is believed to have been one of Leonardo's assistants on the large *Battle of Anghiari* fresco in Florence, begun around 1504, but it is not impossible that he first met Leonardo during his sojourn in Milan. Of

the two painters, Yáñez would prove to be the most faithful and accomplished *Leonardesco,* as evidenced by several works inspired by Leonardo's *Madonna of the Yarn-winder* (ca. 1501). If so, then it is possible that the artist of the *Pala Sforzesca* may in fact have been Spanish in origin.

THE MYSTERY OF THE VOTIVE PORTRAITS

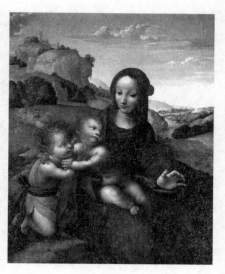

Hernando Yáñez de la Almedina, *Madonna and Child with Infant John,* ca. 1505.

The reason we have lingered on this Sforza propaganda piece involves the votive portraits of Ludovico and Beatrice flanking the throne of the Virgin. Even the untrained eye will be able to discern that the execution of the duke's portrait, and that of his consort Beatrice, is notably different, and indeed more skillful, than that of the other figures. An even more astonishing discovery is the fact that these figures *are nearly identical* to the donor portraits that were added to the *other* fresco in the refectory of the Santa Maria delle Grazie—(the *Crucifixion with Donors,* by Giovanni di Donato di Montorfano) by none other than Leonardo himself.

What does this mean? Did Ludovico have a change of heart? Did he prevail on Leonardo to intervene, or to "assist" the Master of the Pala Sforzesca on the most important detail of this altarpiece, namely, his own portrait? Could this explain why the delicate treatment of the blue fabric on Ludovico's costume betrays the hand of a more capable artist—someone from Leonardo's studio, or perhaps Leonardo himself?

As we will see, it is likely that by the time this panel was nearing

Master of the Sforzesca Panel, *Pala Sforzesca*, 1494; detail of Ludovico Sforza.

completion in early 1495, Leonardo may have served his "probation" period. The duke, now basking in the glow of the emperor's protection and freed from the danger of his French foe, was ready to charge Leonardo with his largest painting yet: to create a fresco in the refectory of the Santa Maria delle Grazie.

THE SANTA MARIA DELLE GRAZIE

*Experience does not err. Only your judgments err
by expecting from her what is not in her power.*
—LEONARDO DA VINCI

Shortly after his investiture as the first official duke of Milan in 1395, Gian Galeazzo Visconti had decided to endow a large monastery. Such was expected of medieval rulers upon their being anointed by the grace of God; their temporal power went hand in hand with the religious power of the Church. Gian Galeazzo chose a spot near a large hunting preserve that, as it happened, was owned by the Visconti family. As a Carthusian monastery, it became known as the Certosa di Pavia (*Certosa* being the Italian root of *Carthusian,* itself derived from the Chartreuse Mountains). Gian Galeazzo wanted it to be the most magnificent religious complex in all of Italy, and a worthy pantheon for the Visconti dynasty.

Designed by Marco Solari, an architect who had previously worked on the Milan Cathedral, the Certosa rose as a curious mixture of Italian Romanesque with Gothic trimmings, later enhanced with extensions in the Renaissance style. As such, it was a perfect kaleidoscope of the fluent architectural styles that Milan had absorbed over the centuries, and was busy absorbing still.

After Gian Galeazzo himself lay the foundation stone on August 27, 1396, the construction proceeded in fits and starts, not in the least because of Gian Galeazzo's untimely death in 1402 from the plague.

The Certosa di Pavia Monastery (*courtesy Pantheon Studios, Inc.*).

With Ludovico's rise to power in the 1480s, the project gained renewed impetus. A new architect was commissioned, Gian Giacomo Dolcebuono, even though the master was rather overstretched at the time, with responsibility for extensive work on the cathedral of Pavia and the dome of the Milan Cathedral.

Leonardo had nurtured fervent hopes to be chosen for any one of these projects, particularly the design of the dome in Milan, but as we will see shortly, his designs were rejected. So Ludovico's decision to give all three commissions to Dolcebuono, who was already so busy that he had to outsource part of his workload to another architect, Giovanni Antonio Amadeo, must have come as a bitter disappointment. Adding insult to injury, Ludovico also sent an agent to Florence to order altarpieces from Filippino Lippi and Pietro Perugino, rather than commissioning such from his own Florentine "court artist!"[1] This, at the very least, should prompt us to question whether Leonardo was considered Ludovico's "court artist" or simply a foreign painter at the periphery of Sforza's creative circle.

Indeed, it was Ambrogio Borgognone, a thoroughly conventional artist whose style blended Lombard and Renaissance influences (and who

may have been the teacher of the *Pala Sforzesca* painter), who was picked to paint a number of important frescoes in the church of the monastery. This included one of Ludovico's other propaganda pieces, the *Coronation of the Virgin with Francesco and Ludovico Sforza*. Similarly, Ludovico hired a sculptor to create an imposing funeral monument to Gian Galeazzo, the man who had founded the monastery to begin with. Ludovico felt either that Leonardo had his hands full with his colossal horse or that he simply couldn't be trusted to deliver a work on time.

By 1490, however, the duke began to harbor doubts about the suitability of the monastery as a dynastic mausoleum of Milanese rulers. Perhaps the location was too closely associated with the Visconti name to be a worthy resting place of the House of Sforza. The distance from Milan, some twenty-seven miles, may have been another factor. What was the point of lavishing such monumental glory on a building so far removed from the capital that no one would come to see it?

THE SANTA MARIA DELLE GRAZIE

Instead, Ludovico's choice fell on the church of the Santa Maria delle Grazie, the church of "Holy Mary of Grace." It was a handsome but otherwise unremarkable convent, built in the late 1460s by Guiniforte Solari, an architect who stubbornly hewed to the Gothic tradition even as the rest of Italy gingerly embraced Renaissance influences. Why Ludovico chose this parish church as the burial place of the Sforza dynasty is not entirely clear. The convent had first been constituted in 1463, when a condottiere of one of Francesco Sforza's troops, Gaspare Vimercato, donated a piece of land to the Dominican order—perhaps in an act of expiation. Construction began in 1463, and the convent itself was largely finished by 1468, although the church was not completed until 1482.

The convent was certainly close by, no more than a fifteen-minute walk from the Castello Sforza. More important, however, the Dominicans were by then one of the most influential monastic institutions in Italy. The

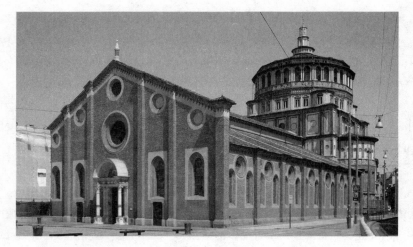

The Santa Maria delle Grazie with the later addition of the octagonal choir section (*courtesy Pantheon Studios, Inc.*).

order had been founded in 1215 by Dominic Guzmán (1170–1221), a Spanish priest and diplomat who traveled widely before settling in Toulouse. Appalled by the ignorance and laxity of the clergy he met along the way, Dominic decided to create a new monastic organization dedicated to preaching the Gospel to the masses. This aim dovetailed perfectly with the call by Pope Innocent III for greater enlightenment of the Christian faithful. Dominic's movement was rapidly granted its papal patent under the name Ordo Praedicatorum ("Order of Preachers"), although it very soon became known simply as the Dominican Order. A parallel order of Dominican nuns soon followed.

In the years to come, the Dominicans would begin to provide basic education to thousands of poor and illiterate children, while also popularizing simple prayer exercises such as the Rosary. At the same time, the Dominicans were vigilant for any form of heresy. Some scholars see the Dominican movement as a major factor in the emergence of the Inquisition, which, significantly enough, was first established in Lombardy in 1231, some ten years after Dominic's death.

The very prominent role that the Dominicans played in the education

of children and the religious enlightenment of adults must surely have figured in Ludovico's decision to adopt the Santa Maria delle Grazie as his family church. The Dominicans (sometimes called the *Domini canes,* or "hounds of the Lord") were a thoroughly indoctrinated movement that understood the power of propaganda. An alignment between this order and the Sforza dynasty could undoubtedly yield great benefits for both.

Apart from extending the original convent with several new facilities, including a newly designed refectory, Ludovico also bequeathed his new religious home with a radically redesigned choir and apse. Even Ludovico could see that Solari's Gothic style was no longer in sync with the proud new thrust of the Renaissance, which deliberately fashioned itself after the grandeur of ancient Rome. Thus, on March 29, 1492, Archbishop Guido d'Antonio laid the foundation stone for an all-new, octagonal-shaped choir in the Renaissance style, to be surmounted by a large dome. This would not be the end to the Sforza enhancements, for Ludovico was also calling for a new Renaissance façade.[2]

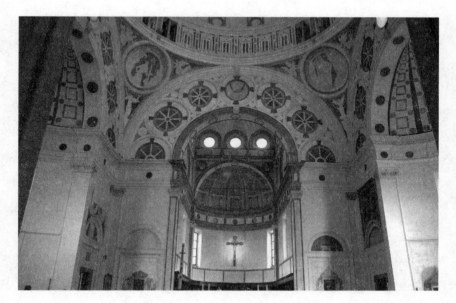

Santa Maria delle Grazie, Renaissance choir and dome, reportedly designed by Bramante, ca. 1492–95 (*courtesy Pantheon Studios, Inc.*).

Tradition (actively abetted by Milan's tourism authority today) has attached the name of the renowned Donato Bramante to this undertaking. Bramante, one of the leading architects of the High Renaissance, was indeed in the service of the duchy at the time, although he would shortly become involved in another, far more ambitious project, the design of the new St. Peter's Basilica in Rome. Leonardo counted him as one of his dear friends.

Yet the rather clumsy design of the octagonal apse, and the equally unsatisfying dome (which, rather than a real dome, is actually an octagonal pitched roof) make it highly unlikely that Bramante himself was the chief designer. Nor is there any real evidence that he was ever commissioned for the job. The documents that do exist refer to the name "Amadeo," probably Giovanni Amadeo, the partner of Ludovico's star architect Dolcebuono. While it is possible that Bramante may have been consulted on the project, it is far more likely that this extension is another example of the curiously hybrid style of Dolcebuono's workshop. The name of "Bramante," which is inscribed in one of the marble passages of the vault, may have been added later, after the architect shot to worldwide fame with his design for the new St. Peter's.

THE REFECTORY

The new choir was not the only addition to the Dominican convent. As another consequence of Ludovico's sponsorship, the complex was to be graced with a new refectory, the place where they would take their meals. This new hall was a rectangular space, measuring some 115 feet by 30 feet, to accommodate the long dining tables used by the friars. Dimly lit by a row of clerestory windows on top, it was completed in 1495, the year used by most historians as the beginning of Leonardo's *Last Supper*.

Why Ludovico finally decided to favor Leonardo with a significant commission is debatable. The horse project, now abandoned, lay a year in the past. If there had been an altercation between Leonardo and the duke,

as we previously surmised, then surely tempers had cooled by now. Then again, the choice may not have been Ludovico's. While the duke was probably expected to bear the cost of the work, direct responsibility for the painting (its subject matter, its iconography, its *program,* in short) would most definitely have been in the hands of the most senior clerical figure present, namely, the prior of the monastery.

That such was common in Italy is attested by the agreement that the Fraternity of Santa Maria della Misericordia contracted with Piero della Francesca on July 11, 1445, for a panel for their church. The contract specified that the painting should be executed "with those images, figures and ornaments as stated and agreed with the above-said Prior and advisor or successors in office."[3] After all, propagating religious instruction is what the Dominicans *did* for a living.

This fact is often overlooked by art historians. The fresco to adorn the freshly plastered walls was not supposed to be another of Sforza's propaganda pieces; a refectory, unlike a basilica, was not a place open to the public. This hall was for the exclusive use of Dominican friars and their guests. Therefore, whatever was going to be painted on the wall had one principal purpose: to instruct and inspire the friars, both young and old, as they sat down to have their modest repast.

Since the Middle Ages, the most obvious theme for a refectory fresco was the Last Supper, the final meal that Jesus shared with his Apostles before his arrest on the Mount of Olives, and the beginning of his Passion. The use of this theme in convent dining halls became so common that, over time, the Last Supper motif became known as the *cenacolo*—literally, the "refectory." It gave the monks and nuns the illusion that they were taking their meal with Christ and his disciples in their presence. Of course, for the intellectually minded Dominicans, heirs to Thomas Aquinas, such a simple allusion did not suffice. One example was the doctrine of transubstantiation, which posits that during the consecration of the Eucharist, the substance of bread and wine is *transformed* into not a mere symbol of Christ, but Christ's *actual* body and blood—thus re-creating,

Fra Angelico, *The Last Supper (Christ Presenting the Communion to his Apostles)*, ca. 1441.

during every Mass, a miracle not unlike the miracles that Jesus performed in his lifetime.

From the Dominican perspective, this gave the Last Supper motif an entirely new and important meaning. For the Dominicans, a *cenacolo* painting was not merely a pleasant image of Jesus supping with his followers. It celebrated the institution of the most fundamental sacrament of the Catholic Church: the Eucharist. It was by virtue of this sacrament that the millions of faithful were allowed to be in communion with God every time they attended Mass.

In his fresco for the Dominican convent of San Marco in Florence, for example, the artist Fra Angelico, a Dominican friar himself, depicted the Last Supper as a scene in which Christ actually presents the Communion host to his Apostles.

Our conclusion is therefore that the choice for Leonardo to paint *The Last Supper* in the *cenacolo* of the Santa Maria delle Grazie may not have

been Ludovico's, but rather, that of the Dominican prior, even if Ludovico would ultimately foot the bill—as he would for all other works involving the monastery.

Nor was Leonardo the only artist to be commissioned for the decoration of the refectory. Simultaneously with the contract for *The Last Supper,* the friars also charged another artist to paint a fresco opposite the wall where Leonardo would be working. This artist was known as Giovanni Donato da Montorfano, and his task was to produce a monumental depiction of the Crucifixion of Christ.

MONTORFANO'S *CRUCIFIXION WITH DONORS*

The poet ranks far below the painter in the representation of visible things, and far below the musician in that of invisible things.
—LEONARDO DA VINCI

Curiously, the authors of most books about Leonardo's Milan period omit an important point. They write about the Sforza monuments, masques, and propaganda pieces, but they forget that throughout the fifteenth century, the most important cultural endeavor in Milan was the construction of its cathedral.

That this cathedral, built largely in the Renaissance, is actually a rather anachronistic monument in the Gothic style is due to a variety of factors. On the one hand, most leading cities in Italy had already built a prominent cathedral in the thirteenth or early fourteenth centuries, the heyday of medieval prosperity, when European Christianity stood at its apex. Every self-respecting town, regardless of its size, wanted to have a Christian basilica in the most up-to-date fashion of the day—which, in the *Trecento,* was the new Italian Gothic style. Thus, the Duomo of Florence, by Arnolfo di Cambio, was begun in 1296; the Siena Cathedral dates from 1215; and the basilica of Bologna was rebuilt from the ground up after a devastating fire in 1141. Only Milan lacked a prominent church that properly bespoke of its wealth and power. Once again, it was only with the accession of Gian Galeazzo Visconti, the first properly anointed duke of Milan, that the initiative to build a major cathedral

Façade of the *Duomo* of Milan, thirteenth–seventeenth century (*courtesy Pantheon Studios, Inc.*).

began to gather steam. Perhaps to make up for the late start, Visconti ordained that the building should be bigger and taller than any other cathedral in Italy.

Unfortunately, this vast project was initiated just as the influence of the International Gothic style began to wane and the first impulses of an architectural movement in imitation of Roman architecture, the Renaissance style, began to make itself felt. The builders paid this new style no heed. Even as Renaissance architecture began to radiate all over Europe from its source in Florence, buoyed by the success of Brunelleschi's Dome and his revolutionary designs for the San Lorenzo and the Santo Spirito, the architects of the Milan Cathedral stubbornly persevered in what others were disparagingly calling the *moda antica,* the "old style."

This should not have come as a surprise. Given its close proximity to Germany and France, the Milan Cathedral had been conceived in a Late Gothic style known as Rayonnant, more in tune with the cathedrals of Chartres or Amiens than with Italian Gothic, which in truth was

Duomo, detail of the crown of the flying buttresses, including its rich Gothic ornamentation (*courtesy Pantheon Studios, Inc.*).

actually an updated form of Tuscan Romanesque with some Gothic trimmings. In fact, one of the original designers of the Milan Cathedral was French, not Italian. His name was Nicolas de Bonaventure, a man more renowned for engineering skills than artistry, which is perhaps reflected in the massive hulk of the cathedral as it broods today over the Piazza del Duomo.

According to one source, de Bonaventure's European successors resisted the colossal size envisioned by Gian Galeazzo in favor of the soaring vertical thrust so typical of French and German cathedrals. They were dismissed, and replaced with a series of more pliable Italian masters, including Giovanni Grassi, Beltramo da Conigo, and Giovanni Solari.

Nevertheless, the vast majority of masons and artisans on the cathedral were of either French or German origin, simply because no one else possessed the knowledge to build such an edifice. Perhaps they knew, as they slaved on the massive structure, that this might be the last time their

skills in the Gothic vernacular would be needed—as indeed would be the case. After Milan, no other Gothic cathedral of comparable size or scope would be built in Europe until the nineteenth century, and the advent of the neo-Gothic movement.

Predictably, the demise of Gian Galeazzo led to a temporary suspension of the building activity, even though nearly half the church was finished. Construction proceeded in fits and starts in the 1430s and '40s, until the arrival of the Sforza dynasty. Francesco Sforza plunged into the project and ensured that by mid-century, both the nave and the aisles had been completed up to the sixth bay. His son Ludovico, eager to cement the Sforza claim on the duchy, embraced the project soon after having seized power. Like his father, he realized that of all the monuments and artworks of Milan, none would project the city's prestige more than the Milan Duomo, which at that time was already the biggest church edifice on Italian soil. Thus, the cathedral inevitably became the principal hub of Sforza artistic endeavor, led by architects we've encountered before: Gian Giacomo Dolcebuono, who worked on the octagonal choir and dome; and Giovanni Antonio Amadeo, who set to work on the exterior decoration, as the building was still largely unadorned on the outside. (To this day, one of the spires is called Gugliotto dell'Amadeo, the "Little Spire of Amadeo.")

As soon as the nave and aisles were covered, a massive effort began to decorate the interior with frescoes. In keeping with the Gothic imprint of the church, Ludovico relied on a group of northern European and Lombard artists who remained firmly anchored to the medieval tradition of the International Gothic style, with only occasional nods to the revolutionary changes that were taking place in Florence. So, when we talk about projects such as the refectory of the Santa Maria delle Grazie, or the refurbishing of the Castello Sforza, it's important to remember that all these were dwarfed by the massive expenditures being lavished on the completion and decoration of the Duomo.

That project, more than anything else, is what loomed large on Sforza's

Duomo of Milan, detail of the spires (*courtesy Pantheon Studios, Inc.*).

cultural horizon, and this may go a long way toward explaining why Leonardo, at least in our opinion, remained a mostly secondary character in Ludovico's artistic pantheon. While da Vinci was certainly a brilliant and talented designer, he was too much of an outlier, too individualistic and unconventional, to gain entry into the duke's inner creative circle. That Leonardo was aware of the paramount importance of the Duomo is beyond doubt. While living in the Corte Vecchia, the old Visconti castle located directly opposite the Duomo, Leonardo could see Dolcebuono's team of masons slaving on the central crossing on a daily basis.

Yet the problem of covering such a vast space with a central dome remained. One consultant brought in by Ludovico warned that because the building was "lacking in framework and measurements, this would not be easy."[1] Ludovico then invited several architects, including Leonardo and the venerable Bramante, to submit competitive designs. Leonardo's design was sufficiently intriguing to be awarded sixteen imperial lire

Leonardo da Vinci, *Designs for a Central Church and One Based on a Latin Cross*, 1490s.

(roughly three hundred fifty dollars) for the purpose of building a model, which was completed in the summer of 1487.

Leonardo's "pitch" to the architectural committee responsible for judging the designs, which has miraculously survived, reveals the artist's recognition that, politically, he was up against considerable odds. Many on the panel may have harbored suspicions against a Florentine who obviously had had little or no actual experience in the design and engineering of complex structures, let alone the unusual form of Milanese Gothic, so deeply influenced by French and German models. "Do not allow yourselves to be influenced by any passion," Leonardo's presentation warns, "but choose either me or someone who has succeeded better than I in demonstrating what a building is, and what the rules of correct building are." Pointing to the model and the accompanying drawings, Leonardo argued that "my model possesses this symmetry, concordance,

and compliance [*conformità*] that is entirely appropriate to the building in question."

Looking at Leonardo's sketches, there is indeed some resemblance to the structure of the great dome of Brunelleschi, which Leonardo must have known intimately; during his apprenticeship with Verrocchio, the old master had completed the large bronze ball now perched on top of the cupola. But this insider information was to no avail; Leonardo's design was rejected. The winners, not surprisingly, were Ludovico's two Lombard stalwarts, Giovanni Amadeo and Gian Giacomo Dolcebuono.

THE MONTORFANO FAMILY

Throughout the fifteenth century, vast numbers of stonemasons, sculptors, and painters were drawn from places as far as France and Germany to build the massive building. Because, in medieval Italy, sons usually followed in the footsteps of their fathers, this meant that entire families over several generations could be involved in a cathedral project. One of these was the Lombard Montorfano family, beginning with Paolino da Montorfano (1402–30), who was employed at the Milan Cathedral as a painter and an artist in stained glass. The family must have originally hailed from the town of Montorfano, located some three miles south of Lake Como, at a distance of some twenty-five miles from Milan. Three generations followed him in this trade. His son Abramo (di Alberto) da Montorfano (1430–38) rose to become one of the court artists of the ruling house of Visconti, while a certain Giovanni da Montorfano (1452–70) worked in the Milan Cathedral between 1452 and 1454, before moving to Genoa, where he painted, among others, a signed *Saint Martin and the Beggar*. Abramo's son Alberto (di Abraam) da Montorfano (1450–81) likewise followed in the family business, as did *his* offspring, the brothers Vincenzo (dates uncertain) and Giovanni.

About Giovanni Donato da Montorfano (ca. 1460–ca. 1503), there is

Giovanni Donato di Montorfano, *Altarpiece of the Madonna Enthroned,* San Pietro in Gessate, Milan, ca. 1490.

surprisingly little documentation. Giovanni probably began his career in the 1470s. Several frescoes in the chapels of Saint Anthony, Saint John the Baptist, and the Virgin in the Milan church of San Pietro in Gessate are attributed to him, although it is difficult to arrive at an exact assessment since the work involved several painters, as was the custom in Lombardy.

Giovanni was then commissioned to paint a number of saints on the pillars of the Santa Maria delle Grazie, shortly after its completion in the late 1480s. The portraits of these saints vividly establish Montorfano as an artist in the traditional Lombard mold: a painter who is au courant with the basis of linear perspective and the three-dimensional modeling of figures, while remaining faithful to the medieval Lombard penchant for solid, static figures. The fresco of *St. Peter Martyr* in the Santa Maria delle Grazie is a clear example; the somewhat awkward turn of the saint's head would presage that of the impenitent thief in Montorfano's *Crucifixion* at the Santa Maria delle Grazie.

Giovanni Donato di Montorfano, *St Peter Martyr*, Santa Maria delle Grazie, ca. 1487.

The artist was also credited with the fresco of scenes from *The Life of St. Catherine,* although this attribution has now been challenged.

Be that as it may, the Dominican prior must have been pleased with Montorfano's work on the pillars of the nave of the monastery's church. It is also possible that in executing the portraits of the saints, Montorfano established himself as an artist experienced in fresco painting, who

delivered his work on time, and whose art was entirely in line with the work his family had produced for the most prestigious ecclesiastical building in the city, the cathedral. Artists (or their families) associated with the cathedral were still considered the crème de la crème of Milanese artistic society. All these factors must have played a role in the decision to commission Montorfano to create a monumental Crucifixion on the south wall of the refectory, at the same time that Leonardo was charged to paint a Last Supper on the northern wall.

The idea of two polar paintings in a refectory was another well-established practice. Opposite a Last Supper, painters were often asked to paint a Crucifixion. The reason for this theme was once again grounded in medieval theology. While the Last Supper, and the institution of the Eucharist, held forth the promise of universal salvation, that promise was fulfilled only by Jesus' suffering and death on the Cross. Thus, Andrea del Castagno was charged with painting a Crucifixion and a Resurrection directly above his *Last Supper* in the refectory of the convent of Sant'Apollonia. When these frescoes were removed for restoration in 1953, restorers found a detailed set of *sinopie,* or drawings on the plaster, that give a fascinating insight into the way the artist created his composition.

Ross King has speculated that the Dominican prior contracted simultaneously with both Montorfano and Leonardo because Montorfano was the type of Lombard cathedral painter who could be relied upon to deliver his work properly, and on time—in contrast to Leonardo, who, as everyone knew by then, either took too long or left things unfinished.[2] Perhaps the abbot thought that the shining example of an artist who did as he was told would shame the Florentine into a more pliable attitude. Another motive for the double commission may have been the desire to foster a certain rivalry between the two, in the hope that a competitive atmosphere might raise the quality of the work and speed its completion. As we saw previously, the tendency to let a project to a group of painters, rather than one individual artist, was a peculiar feature of artistic endeavor in Lombardy. Here, again, the influence of the cathedral enterprise may

be at work, where decoration had for generations been the responsibility of multiple families of artists. It is also reflected in the nave of the Santa Maria delle Grazie proper, where Montorfano labored on the fresco decorations side by side with at least two other Milanese artists. Thus it did not come as a surprise when the commission for decorating the refectory, a task that in Florence would undoubtedly have been charged to a single artist (as in the case of Daddi, Ghirlandaio, or del Castagno) was charged to two separate artists, working on opposite walls from each other.

As it happened, this would not be the only time Leonardo was pitted against another artist. In 1503 he won the contract to paint a large fresco of *The Battle of Anghiari* in the Grand Council Chamber of the Palazzo della Signoria in Florence, only to discover that his great rival Michelangelo would be working right across from him, depicting another great victory from Florence's past, *The Battle of Cascina*.

Thus, for many months, Leonardo and Montorfano (and their assistants) would be sharing the same space, running into each other on a daily basis. But, as King points out, in one respect Montorfano had one great advantage over Leonardo. He was a highly experienced artist in fresco, whereas Leonardo was not.

THE *CRUCIFIXION WITH DONORS*

For some strange reason, Montorfano's fresco of the *Crucifixion* has escaped serious scholarly attention. Not a single book or journal article has ever endeavored to examine the work in detail. The reason, most likely, is that with all the excitement focused on Leonardo's fresco, it was easily overlooked. That the work appears to be a thoroughly conventional Calvary scene by a rather mediocre Lombard painter didn't help matters. Still, the fresco is very important for our understanding of the context for *The Last Supper,* not only because of Leonardo's putative influence on the *Crucifixion,* but also because Montorfano's work vividly illustrates the creative control that the Dominicans exercised over what would appear on the walls of

their refectory. Even Vasari, who visited the refectory in the 1530s, suspected that there was more to this fresco than met the eye. He wrote,

> *In the same refectory, while he was working at the Last Supper, on the end wall where is a Passion in the old manner, Leonardo portrayed the said Lodovico, with Massimiliano, his eldest son; and, on the other side, the Duchess Beatrice, with Francesco, their other son, both of whom afterwards became Dukes of Milan; and all are portrayed divinely well.*

In other words, Vasari confirms that Leonardo was involved in this painting, done "in the old manner" (Vasari's euphemism for passé artists and styles). Why would Leonardo, of all people, have been called upon to paint the donor portraits in Montorfano's fresco? And why is there such an obvious similarity between the donor portraits in the *Pala Sforzesca* and those in the *Crucifixion?*

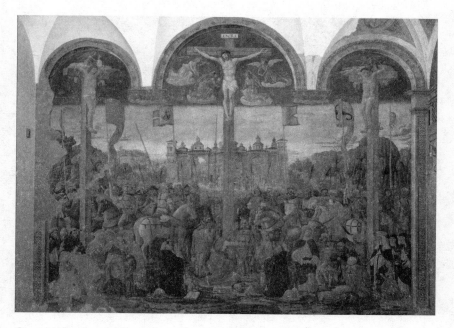

Giovanni Donato di Montorfano, *Crucifixion with Donors*, 1495.

Stylistically, Giovanni's *Crucifixion* is an ambitious work in a conventional mold. More than fifty figures crowd around the three soaring crosses on Golgotha, with a fortress-like Jerusalem set in the distance, framed by two rocky passages signifying the hills of Jerusalem. According to medieval legend, the place of execution, "Skull Hill" (*Golgotha* in Aramaic, *Calvaria* in Latin), was a bleak open area, "stony, forbidding, and lifeless." The crosses have been deliberately raised high above the attending crowd in order to exploit the presence of the three lunettes, formed by the arches of the refectory. Thus each of the three condemned men's suffering is framed, halo-like, by the semicircular arch of the predella, with that of Christ being the most prominent in size. As a result, the composition is arranged around three crosses rising high into the Jerusalem sky, anchored by an unusually packed crowd in the middle ground, with the principal mourners placed in the foreground. We can detect some influence of Mantegna's *Crucifixion* (completed in 1459), not only in the rendering of

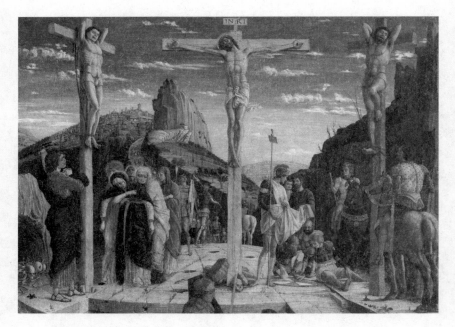

Andrea Mantegna, *Crucifixion*, 1457–59, from the San Zeno Altarpiece, Verona.

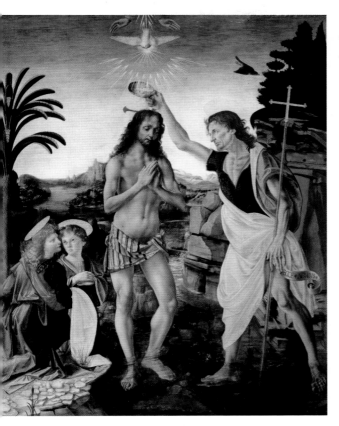

Andrea del Verrocchio, *Baptism of Christ*, 1472-1475.

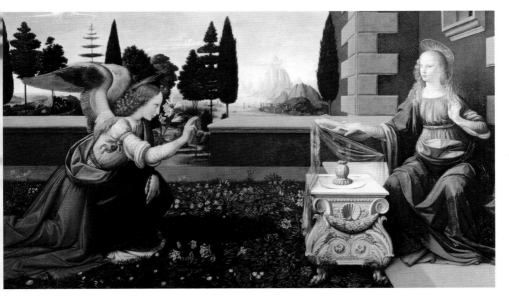

Verrocchio workshop, including Leonardo da Vinci, *The Annunciation,* ca. 1474.

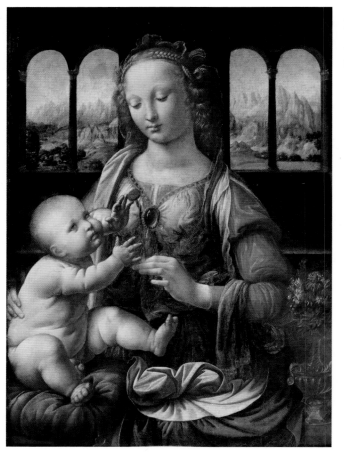

Leonardo da Vinci,
Madonna of the Carnation,
ca. 1478.

Leonardo da Vinci, *Portrait of
Ginevra de' Benci,* ca. 1474.

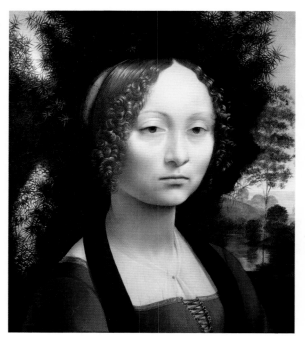

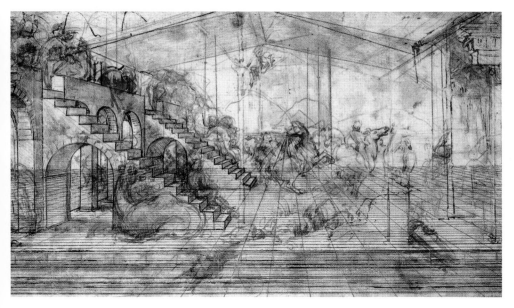

Leonardo da Vinci, *The Adoration of the Magi,* 1481-1482.

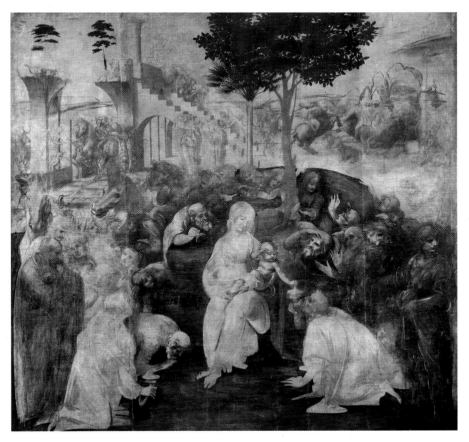

Leonardo da Vinci, *Study for the Adoration of the Magi,* ca. 1481.

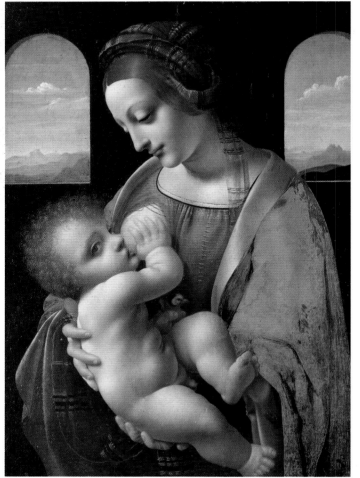

Leonardo da Vinci,
Madonna Litta, ca. 1485.

Study for *the Madonna
Litta,* ca. 1485.

Leonardo da Vinci, *Lady with an Ermine,* ca. 1490

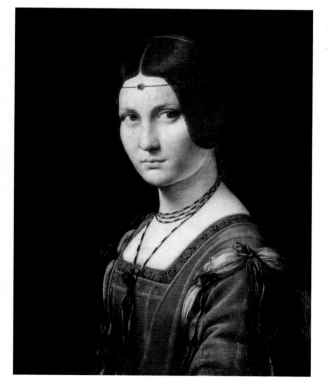

Leonardo da Vinci, *La belle Ferronnière,* ca. 1495.

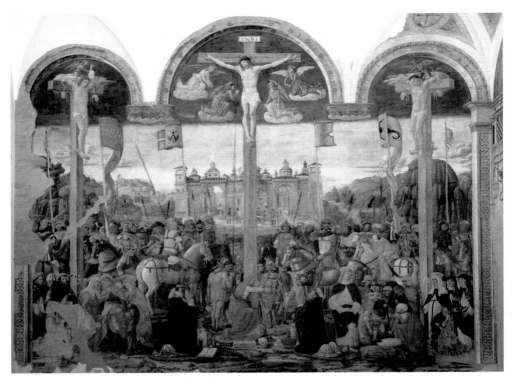

Giovanni Donato di Montorfano, *Crucifixion with Donors,* 1495.

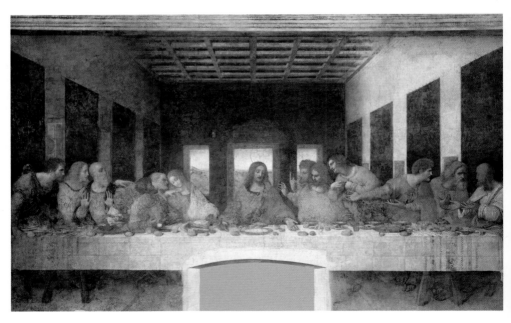

Leonardo da Vinci, *Last Supper,* ca. 1494-1498.

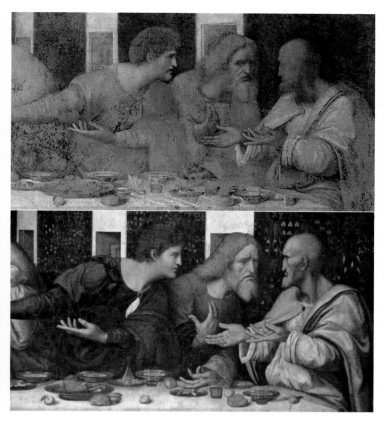

Matthew, Thaddeus, and Simon, from Leonardo's original and Solario's copy.

Bartholomew, James the Younger, and Andrew, from Leonardo's original and Solario's copy.

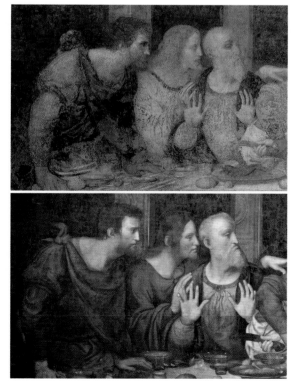

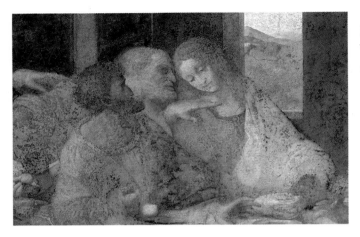

Leonardo da Vinci, *Last Supper,* detail of John.

Andrea Solario, *The Last Supper after Leonardo,* detail of John.

the figures and the elongated treatment of the crosses, but also in the detail of the landscape.

The link between Mantegna, whose work over the preceding decades was concentrated in and around Mantua, and Giovanni da Montorfano was quite possibly an artist named Vincenzo Foppa (ca. 1430–ca. 1515). Based in Pavia, some twenty-two miles south of Milan, Foppa belonged to the circle of Lombard artists whom the dukes of Milan relied on to decorate their manifold secular and religious projects throughout the duchy. Significantly, Vasari wrote that Foppa was apprenticed in Padua, at a time when Mantegna's influence was paramount.

Foppa's panel of the *Crucifixion,* executed around the same time as Mantegna's *San Zeno Altarpiece,* shows the same hallmarks that would reappear in Montorfano's work: the elevated position of the crosses and the distant view of Jerusalem in the background. The peculiar way in which the two condemned on either side of Christ are crucified, with their arms tied behind the crossbar (so as to deny them the same position as Christ), would later be followed by Montorfano.

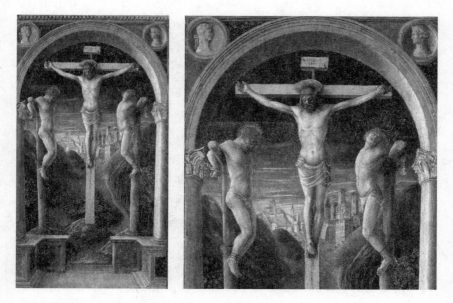

Vincenzo Foppa, *Crucifixion,* ca. 1456.

Nevertheless, the stock expressions of the figures, as well as the hobbyhorse quality of the mounted Roman detail, mark Montorfano's *Crucifixion* as one firmly rooted in the transitional style from Late Gothic to Early Renaissance, which is typical of the art of Lombardy in the late fifteenth century. The fresco features all the key protagonists of the Crucifixion according to its medieval canon: Christ and the two thieves (or "bandits") who were crucified with him, the Virgin Mary (dressed in aquamarine robes, as per fifteenth-century custom), Mary Magdalene and Salome, the centurion and the lance bearer, and the soldiers casting lots.

At the same time, however, the Dominican friars demanded that many more figures be called upon to populate the vast space, including Thomas of Aquinas and Dominic, the two principals of the Dominican Order. Among the clutch of saints to the left are two prominent figures in local Milanese lore, Saint Vincent and Saint Peter Martyr. Lastly, the area around the crosses proper is packed with a large group of people, including numerous Roman officers, foot soldiers, and a number of spectators, including several local worthies.

No doubt, this desire to populate the composition with many more figures than the Passion story calls for was prompted by the sheer size of the wall that Montorfano had to cover. Whereas Leonardo resolved this problem by the sheer monumentality of his figures, Montorfano fell back on the device that Gaddi had previously employed in his frescoes in Florence: by crowding the space with lots of characters and enlivening this crowd with a variety of color, pose, and orientation.

A striking figure has detached himself from the crowd to look straight at the beholder. Arguably, this is John, the beloved disciple who, according to Christian tradition, was also identified with John the Evangelist; his penetrating gaze, directed straight at us, suggests that he is the narrator of the tragic events taking place in the fresco.

Immediately to his right is a group of soldiers throwing dice over Jesus' garments, as described in the Gospel of John: "They divided my clothes among themselves, and for my clothing they cast lots" (Psalm

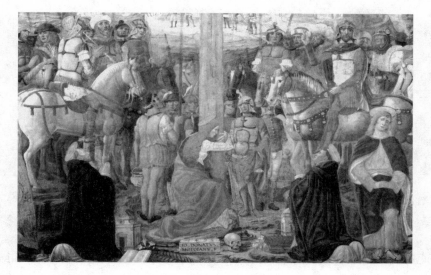

Giovanni Donato di Montorfano, *Crucifixion with Donors*, detail of center with John the Evangelist on the far right, gazing at the beholder.

22:18; John 19:24). The dice show the numbers 1, 6, and 4, which may refer to John 16:4: "I did not say these things to you from the beginning, because I was with you. But now I am going to him who sent me."

Another soldier, standing to the immediate left of Jesus' Cross, is holding what appears to a *pilum,* a long Roman spear, even though the upper part of the lance has faded. There are two possible interpretations for this figure. On the one hand, he could be the soldier who "put a sponge full of the wine on a branch of hyssop" and gave it to Jesus to drink (John 19:29). In medieval art, this sponge is usually placed at the tip of a long spear, so that the soldier can reach Jesus' mouth. This interpretation is bolstered by the fact that in Montorfano's fresco, the soldier is carrying a vessel in his left hand, presumably containing the sour wine.

On the other hand, John also refers to a soldier who pierced Christ's side with a lance, so as to verify that he was dead, "and at once blood and water came out" (John 19:34). This interpretation appears to be validated by the fact that blood is indeed flowing from Jesus' torso. According to a Christian legend (the fourth-century "Gospel of Nicodemus"), the

Giovanni Donato di Montorfano, *Crucifixion with Donors*, detail of the crucified Christ.

lance bearer was named Longinus. In later legends, he was sometimes conflated with the centurion who cried out at the moment of Christ's death, "truly this man was the Son of God" (Mark 15:39). Some legends state that Longinus eventually converted to Christianity. In fact, he is venerated as a saint in both the Catholic and Eastern Orthodox Churches to this day.

In Montorfano's treatment, however, the lance bearer is merely depicted as a Roman legionnaire. By contrast, the centurion described in Mark's Gospel is easily identified. He is the mounted figure to the right of the center cross, wearing a purple cloak and riding a pale gray horse. He is pointing to Christ, as if to acknowledge that "truly this man was the Son of God." Another mounted officer, to the left of the Cross, has pressed his hands together as if in a gesture of prayer. This may have signaled to the beholder that the centurion's faith was shared by other officers, in a foreshadowing of the way that Christianity would ultimately engulf and conquer the Roman Empire.

The Gospel of John also refers to the fact that, at the end of the day, Roman soldiers moved from cross to cross to smash the legs of the victims. This was done to accelerate a prisoner's death: once his legs were broken, he could no longer raise himself up to breathe. In this painting, though, that moment has not yet occurred—the legs on all three crosses appear anatomically correct, and are not yet mutilated.

A sign above the Cross of Christ bears the initials I.N.R.I., which stands for the Latin phrase Iesus Nazarenus, Rex Iudaeorum—or "Jesus of Nazareth, King of the Jews." This refers to the passage in the

Gospel of Mark wherein one of the soldiers posted a sign over Jesus' Cross that read, mockingly, "The King of the Jews" (Mark 15:26). John's Gospel says that the chief priests had suggested a different text: "This man said, I am King of the Jews." But Pilate had overruled them and replied, in his typical oblique fashion, "What I have written I have written" (John 19:21–22).

THE ORIENTATION OF THE THIEVES

What is interesting about the depiction of the thieves on either side of Jesus is that they are merely bound to their crosses with ropes, rather than having their hands and feet nailed, as in the case of Christ. This was meant to distinguish their punishment from the extreme agony of Christ, which is therewith made even more unique and significant. In the Gospel of Luke, moreover, one of the thieves mocks Jesus, whereas the other expresses remorse: "We indeed have been condemned justly, for we are getting what we deserve for our deeds, but this man has done nothing wrong" (Luke 23:41).

In Montorfano's version, the "penitent" and the "impenitent" thieves are clearly identified. While the good bandit is placed in a prominent position to Jesus' right, the bad bandit is to his left. They are shown in the act of dying, and here Montorfano reverts to an awkward medieval motif: the soul is shown as a miniature replica of the dead man, emerging from his body. At left, the soul of the penitent thief is carried by an angel, while, at right, it is the devil who prepares to pull the bad thief's soul from his body. Such an explicit portrayal, which obviously clashes with the Renaissance dictate of realism, is another reflection of the Dominicans' penchant for clarity in the instructional quality of their art, even at the expense of naturalism.

The orientation of this composition is extremely important, because by turning Christ to his right, toward the penitent thief and the group around Mary, Montorfano established the principal division between

Giovanni Donato di Montorfano, *Crucifixion with Donors,* detail of the crucified bandits.

good and evil, or between sacred and secular space within the refectory—a division that, as we shall see, Leonardo was bound to follow.

As Leo Steinberg has pointed out, this orientation was toward the *East,* traditionally the direction of all Latin churches, and in this case, an orientation toward the Santa Maria delle Grazie altar within the monastery complex.[3] This, too, would have been stipulated by the prior.

Perhaps the most important Dominican "signature" in the fresco is the prominent placement in the foreground of Thomas of Aquinas and Saint Dominic, the two most important figures in the history of the Dominican Order, officially known as the Order of Preachers to underscore its primary mission as an evangelizing agency. In the years to follow, the Dominicans would provide elementary education to thousands of the poor and illiterate—as illustrated by the open book lying at the feet of the saint. However, the Dominicans were also charged with enforcing Catholic orthodoxy, and were instrumental in the rise of the Inquisition, which, significantly, was first established in Lombardy in 1231, some ten years after Dominic's death. This is why Dominican monks, with their black cloaks, were often feared in many liberal-thinking circles of Renaissance Italy. Many began to refer to them as *Domini canes,* or "Hounds of the Lord."

At the same time, Thomas Aquinas became the order's leading intellectual. Aquinas, a pupil of the renowned teacher Albertus Magnus, sought to reconcile Aristotle's philosophy with the tenets of Christianity by arguing that Aristotelian thought and Christian doctrine were essentially

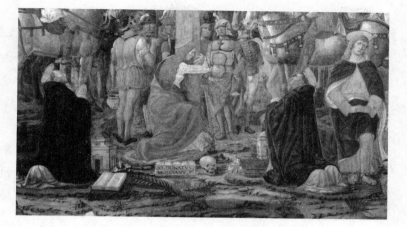

Giovanni Donato di Montorfano, *Crucifixion with Donors*, detail of St. Dominic and Thomas Aquinas.

complementary rather than contradictory. A leading thinker of the medieval movement known as Scholasticism, Aquinas produced a vast corpus of learned works, including his famous *Summa Theologiae*, a comprehensive compendium that explained Christian theology for the average clergyman. Aquinas, too, is shown in Montorfano's fresco with a book, which is probably intended to be a copy of *Summa Theologiae*.

In between Aquinas and Dominic, in the center of the composition, is another leading figure in the Dominican canon: Mary Magdalene, shown embracing the Cross. This embrace is actually a foreshadowing of the Resurrection. In the Gospel of John, Jesus appears first to Mary Magdalene. But as she moves to embrace Jesus, he stops her, telling her "not to hold on to me, because I have not yet ascended to the Father" (John 20:17). Significantly, Mary Magdalene is shown with long blonde hair falling down her shoulders and back—unlike the other women, whose hair is covered. In the Middle Ages, wearing one's hair loose and without a covering was considered an attribute of prostitutes. There is no evidence in the Gospels to suggest that Mary Magdalene was indeed a prostitute, but early Church tradition—possibly in reaction to Gnostic Christian writings, which revered Mary as an Apostle—conflated her with the

unnamed woman in Luke, "a sinner" who bathes Jesus' feet with her tears and dries them with her hair (Luke 7:38). In the sixth century, Pope Gregory I actually declared Mary Magdalene to be a "fallen woman" guilty of "forbidden acts." Not until 1969 did Pope Paul VI explicitly separate the figure of Mary Magdalene from the "sinful woman" character.

Since the eighth century, it was believed that Mary's remains were interred in the Benedictine church in Vézelay, France, having been brought there by none other than the French king Charlemagne. Since then, Vézelay had become one of the most important pilgrimage destinations in France. But near the end of the thirteenth century, a Dominican convent in Aix-en-Provence, farther south, announced that it was actually in possession of her relics, based on the sensational discovery of an ancient sarcophagus in the crypt of its church. The discovery was particularly auspicious because Dominic Guzmán had received his first vision while visiting a shrine to Mary Magdalene near the village of Prouille. In 1297, Dominicans elevated Mary Magdalene to the exalted status of patron saint of the order, and made her feast day one of the most important dates on their liturgical calendar. Therefore, Montorfano's decision to place Mary at the center of his fresco was certainly no accident.

Behind these saints and the Cross, our eye is drawn to a large number of mounted spectators, some twelve riders in all. Interestingly, these twelve figures are located at the same height as the twelve Apostles in *The Last Supper*. What's more, while many of these horsemen appear to be Roman officers, as evidenced by their helmets and breastplates, others appear to be Jewish officials to judge by their beards and Oriental turbans. None of the Gospels indicates that any chief priests or other Jewish dignitaries was present at the execution site (which they would have considered defiled and unclean ground). In medieval art, however, these figures were often added to scenes of the Crucifixion so as to underscore their perceived complicity in the murder of Christ—a theme that, unfortunately, is very strong in the Gospel of John and that would subsequently be perpetuated by the Dominican Inquisition.

Giovanni Donato di Montorfano, *Crucifixion with Donors*, detail of Jerusalem in the background.

Beyond this crowd of spectators looms the city of Jerusalem. It is depicted as a castle complex somewhat reminiscent of the Castello Sforzesco itself, with its heavy brick archways and circular corner towers from which pennants flutter in the wind. Through the archway at right, we can glimpse a prominent structure topped by a rounded dome. A similar structure appears as the Second Temple in many fourteenth- and fifteenth-century "maps" of ancient Jerusalem, at least in the shape that the medieval mind imagined it. In this fresco, the presence of the Temple carries a theological meaning as well. For after Jesus "gave a loud cry and breathed his last," says Mark, "the curtain of the temple was torn in two, from top to bottom" (Mark 15:38).

Another symbol that would have been recognizable to most medieval viewers is the skull at the foot of the Cross. This is not only a reference to the place of execution, Skull Hill, but also to Adam, since according to one medieval tradition, Jesus was crucified on the site of Adam's grave. This strengthened the allegorical link between Adam and Jesus: through his sacrifice on the Cross, Jesus redeemed mankind from the original sin committed by Adam and Eve in paradise.

Lastly, Montorfano framed his fresco with simulated pilasters, which

Giovanni Donato di Montorfano,
Crucifixion with Donors, from a
nineteenth-century photograph.

support painted arches inside the three lunettes. As we saw previously, such painted architectural details helped negotiate the transition from real space into imagined space. Unfortunately, during World War II the fresco suffered considerable damage, particularly on the left side. Only the pilaster on the right and the illusion of three-dimensional arches inside the lunettes still exist. A nineteenth-century photograph gives us an idea of what the fresco originally looked like, including the rich decorative elements in the rib vaults of the ceiling.

Though ambitious in size, Montorfano's fresco work is typical of the late medieval style in which every detail is rendered with the same sharpness and detail, and lit with the same intensity of light, without any regard for the optical effects of atmosphere and depth. What's more, virtually all the figures are drawn in identical size, with little regard for foreshortening or perspective. For example, the mounted Roman officer in a purple harness at the extreme right of the fresco, standing well back behind the cross of the impenitent bandit, appears to be just as tall as Saint Catherine of Siena, standing in the foreground, well in front of the Cross. In Dominican art, the need for clarifying the identity and role of each figure in the sacred drama was more important than fostering the illusion of space and depth.

Montorfano was evidently pleased with his work, not in the least because he appeared to have executed it in record time. At the foot of the Cross, undoubtedly with the consent of the Dominicans, he proudly added a painted inscription that proclaims, GIO. DONATUS MONTORFANUS, with the year 1495. If accurate, this means that Montorfano must have finished the work in less than a year—quite an impressive achievement.

TRAGEDY IN THE HOUSE OF SFORZA

In 1496 a tragedy befell the duke's court. Ludovico's daughter by an early mistress, Bernardina de Corradis, died on November 22. Even though the girl, named Bianca Giovanna, was illegitimate, Ludovico was very fond of her and had legitimized her as a Sforza. In 1496, when Bianca was no more than thirteen, she was married to a young nobleman named Galeazzo Sanseverino, but several months later she developed a stomach ailment (or perhaps an ectopic pregnancy) that ultimately led to her death.

Some authors, notably Martin Kemp, believe that Bianca is the subject of a controversial portrait in colored chalk and ink on vellum, known as the *Portrait of a Young Fiancée,* or *La Bella Principessa.* Kemp and Carlo Pedretti both believe that the portrait was executed by Leonardo, perhaps at the occasion of Bianca's betrothal or marriage to Sanseverino, though this suggestion has not found majority acceptance.

Just six weeks after Bianca's death, Ludovico suffered another blow. His wife and consort, Beatrice d'Este, died in childbirth. Her son was stillborn. The whole court was plunged into grief. As a Venetian observer wrote, "[F]rom that time the duke became sore troubled, and suffered great woes, having lived very happily up to that time."[4] Beatrice's body was taken to the Santa Maria delle Grazie and interred next to the fresh grave of Bianca, with whom she had been on excellent terms.

By all accounts, the duke was genuinely grief-stricken. Ross King relates how the twin deaths prompted Ludovico to direct all his attention to the Santa Maria convent, lavishing all sorts of decorations and precious gifts on the church. This, we believe, is the moment when Ludovico chose to commemorate his wife in the Santa Maria delle Grazie in the form of a donor portrait. Since she was no longer among the living, no new portrait could be made of her from life. But a good likeness did exist—in the form of her profile portrait in the *Pala Sforzesca,* as a kneeling donor, together with her son. It was only natural that she should be depicted in the same manner in the Santa Maria delle Grazie, using the *Pala* as the model.

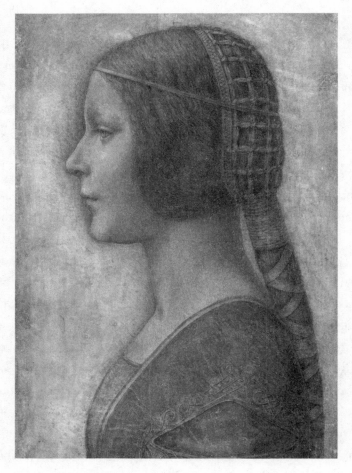

Portrait of a Young Fiancée or *La Bella Principessa*, nineteenth-century German School. Some historians believe it is a portrait of Bianca Giovanna Sforza, drawn by Leonardo.

What's more, a perfect opportunity to create such a donor portrait already existed: Montorfano's *Crucifixion,* which was not only finished (quite unlike the work of the artist laboring on the opposite wall) but also very large in size—large enough, in fact, to accommodate the donor figures from the *Pala* almost to scale. What's more, the theme of the Crucifixion, the death of Christ, made it an appropriate setting for a posthumous portrait.

Traditionally, such donor portraits were placed at the extreme right

and left of the work, so as not to interfere with the sacred events taking place at the center. In Montorfano's fresco, this was certainly feasible. But who was to paint these portraits? The most obvious answer was the artist Montorfano himself. Yet, as Vasari writes, that was not the case. Perhaps Montorfano was no longer available, having accepted a commission outside Milan. Or perhaps he was already ill, given that he died, at the relatively young age of forty-two, in 1502. Instead, says Vasari, it was Leonardo who "portrayed the said Lodovico, with Massimiliano, his eldest son; and, on the other side, the Duchess Beatrice, with Francesco, their other son."

This further strengthens our hypothesis, described in chapter 4, that there is more to the *Pala Sforzesca* than meets the eye. If indeed the *Pala* was painted by an artist who moved in Leonardo's entourage and who had absorbed the lessons of *The Virgin of the Rocks* (which was not on public display at the time), and if indeed the much superior figures of the duke and duchess in this painting were painted under Leonardo's supervision, then the choice for Leonardo to duplicate these figures on the *Crucifixion,* right opposite *The Last Supper,* then still in gestation, becomes rather plausible.

Unfortunately, very little remains of these portraits, notwithstanding their very close resemblance to what we must assume are the originals from the *Pala.* Quite possibly, Leonardo used the same mixture of oil and tempera that would doom *The Last Supper;* when applied on the tempera ground of Montorfano's original fresco, the results would certainly have been disastrous. A more likely possibility, though, is that the portraits were never finished; indeed, their current state suggests that the paintings may never have matured beyond the principal underpainting.

The reason for this is buried deep in the extensive Sforza state papers, which were published by L. Beltrami at the beginning of the twentieth century. Among the large volume of letters is a little-noticed memorandum from Ludovico Sforza to his court marshal, Marchesino Stanga. Dated June 29, 1497, it instructs Stanga to ask Leonardo why he has still not finished his "principal work in the refectory of the delle Gratie [*sic*]," meaning, *The Last Supper,* and to see if he could "turn his attention to the

Leonardo da Vinci, *Donor Portraits of Montorfano's Crucifixion*, in comparison to the donor portraits of the *Pala Sforzesca*.

other wall" ("ad altra Fazada d'esso Refettorio").[5] Ludwig Heydenreich interpreted this note to mean that Ludovico "was considering stripping Montorfano's fresco of the Crucifixion off the opposite wall . . . and having it replaced by a painting by Leonardo, possibly another crucifixion."[6]

The suggestion is not without merit. By the spring of 1497, much of Leonardo's composition on the northern wall was already in place. Even Ludovico, despite his obvious preference for homegrown, Lombard art, must have recognized that this monumental *Last Supper* was a major turning point—a work of such genius that it made Montorfano's fresco pale in comparison. Just imagine, as the letter to Marchesino Stanga suggests, what the overall effect of the refectory would have been if the fresco on the southern wall depicted the Crucifixion of Christ with the same sense of power and drama as seen in *The Last Supper*?

And yet, if that interpretation is correct, there would have been no point in continuing the donor portraits on the lower panel of Montorfano's fresco. Why indeed would Leonardo have done so when, very soon, the whole thing would have been scrubbed away to make room for another masterpiece of his: a Crucifixion with the portrait of Beatrice kneeling at the foot of the Cross of Christ? Indeed, there is no documentation for this hypothesis. And no known study for a Crucifixion by Leonardo's hand has survived.

THE *CRUCIFIXION OF CHRIST* BY DI BARTOLO

Was this Ludovico's final verdict on Montorfano's fresco? We might never know. If indeed it was the duke's intention to replace the *Crucifixion* with a fresco by Leonardo, he was never in a position to make that vision come true. In 1498 the new French king, Louis XII, suddenly turned on France's erstwhile ally and marched south to enforce his claim on the Duchy of Milan. Ludovico had no choice but to flee.

There is, however, one interesting coda to the story of Montorfano's fresco. When, four years later, a Milanese artist named Andrea di Bartolo (ca. 1465–ca. 1524) was commissioned to paint a Crucifixion, he evidently studied Montorfano's work in detail. Significantly, di Bartolo had traveled to Venice in 1494, where he absorbed the work of Bellini and Mantegna. The result of these experiences is his panel of the *Crucifixion* of 1503. The painting perfectly blends his Venetian impressions with some features of Montorfano's fresco, including the high position of the Cross, the presence of mounted officials in Jewish dress, and the deep panorama in the background.

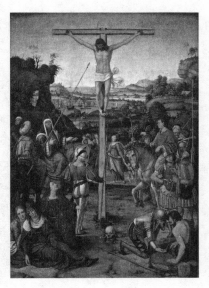

Andrea di Bartolo, dit. Solario, *Crucifixion of Christ,* ca. 1494.

An intriguing footnote to the story is that di Bartolo was better known as Solario—the same Solario would become an important associate of Leonardo's studio during the development of *The Last Supper,* to which we will now turn our attention.

THE THEME OF *THE LAST SUPPER*

He who is fixed to a star does not change his mind.
—LEONARDO DA VINCI

We tend to see *The Last Supper* as the inevitable outcome of Leonardo's single-minded talent. In this, as in so many other ways, we are the product of our modern age and its obsession with the artist as a *solitary* genius. But in the late fifteenth century, things were considerably different. Leonardo did not, and *could* not, conceive his painting in a vacuum. Being asked to paint a large Last Supper fresco was not like being asked to paint a secular portrait of a ducal mistress, where one had the freedom to do as one liked—provided, of course, that the portrait was an acceptable likeness of the sitter. The Last Supper was a *sacred* subject, to be executed at one of the most prestigious religious organizations in Milan. Also, as we noted before, such art was governed by well-known attributes. Therefore, artists were expected to adhere to such conventions in a consistent manner.

It is difficult for us, in our modern times, to recognize this crucial aspect of late medieval art. We are used to seeing paintings, even sacred paintings, in carefully lit museums, in secular spaces that encourage us to appreciate the work as a pure form of art, *l'art pour l'art,* an artifact to be valued for its creative skill. We cannot be faulted for that, because in our world, we are surrounded by the verisimilitude of imagery, by pho-

tography, graphic art, commercial art, television, and the countless forms of other media that modern technology can conjure. We are no longer surprised or astonished by verisimilitude. It has become an integral part of our visual landscape.

Yet that is not how men and women in the Middle Ages would have experienced these works. There was no photography of any kind; no prints, commercial ads, posters, or any other form of simulated nature other than *paintings*. Consequently, the medieval beholder looked at a painting with a sense of wonder that is difficult for us to imagine. Seeing an illusion of people in three-dimensional space on a flat wall or a piece of wood would have been a magical experience, which was closely bound up with the reverence due to the sacred matter on display. Indeed, this magic would become a powerful driving force for the adoption of the new realism of the Renaissance. That included the modeling of figures on a basic understanding of human anatomy, and the projection of those figures on a perspective grid that accurately calculated their foreshortening and attenuation in space. The more realistic the visual experience, or so the Church believed, the deeper the spiritual contemplation of these sacred events by the beholder, and the more he could identify with them.

At the same time, however, the vast majority of the Italian population, including in Milan, was illiterate. That meant that sacred art should not

An *agape* banquet as depicted in an early fourth-century catacomb fresco in Rome.

only imbue the beholder with awe and reverence, but also teach him about the purpose and meaning of the scene being depicted. To do so, each artistic tradition, including Northern Italian art, gradually developed an ecclesiastical program of poses and attributes that could easily be decoded by the average beholder. In other words, each sacred subject had its own iconographical vocabulary that artists were expected to understand and deploy, lest their work fail in its primary mission of instructing the public. For the Dominican Order and its stated mission of educating the European populace about the Gospel and Catholic doctrine, this was a concern that trumped all others. In 1492, just three years before Leonardo's *Last Supper* commission, the Dominican friar Michele da Carcano summarized the primary reasons for the use of sacred art in the Church as follows:

> First, *on account of the ignorance of simple people, so that those who are not able to read the scriptures can yet learn by seeing the sacraments of our salvation and faith in pictures* . . .
>
> Second, *on account of our emotional complacency; so that men who are not aroused to devotion when they hear about this histories of the Saints may at least be moved when they see them, as if actually present, in pictures. For our feelings are aroused by things seen, more than by things heard.*
>
> Third, *on account of our unreliable memories . . . Many people cannot remember in their memories what they hear, but they do remember if they see images.*[1]

In the friar's view, therefore, the more that a painter could summon the power of visual illusion, the more effective the painting would be in meeting its spiritual objectives of instruction, devotion, and remembrance.

The point of this brief segue is to stress that an artist such as Leonardo couldn't simply be guided by his imagination—or *invention,* as the Renaissance called it—as a modern artist would today. In our modern era, we expect art to be the sole expression of an artist's creative ideas, and

nothing else. The situation in the Middle Ages was exactly the opposite. An artist was to follow the instructions of his commissioning agency—in the case of sacred art, a clergyman deeply familiar with religious texts—and to do so to the best of his availability, while striving for the greatest possible realism and impact within the visual canon of the subject.

This may explain why *cenacolo* (or "Last Supper") depictions in fifteenth-century Italy, including both Tuscany and Lombardy, are so strikingly similar. The idea of depicting the Last Supper originated as early as the third century in Roman catacombs, in the form of the *agape* banquet. Usually these wall paintings show a group reclining around a table set with bread and fishes, probably inspired by actual practice in Early Christian communities of the time. The composition also reflected the custom in Antiquity of eating a meal while reclining on a bed or couch. The diner rested his head on one elbow while he took food with his other hand. These couches would be arranged around a semicircular table, so that the opposite side remained open for servants to serve the food and take away empty dishes. Although obviously sketched within the limitations of catacomb art, this painting set a formula that would remain surprisingly consistent through the subsequent centuries of Byzantine rule.

In a famous mosaic from the Sant'Apollinare Nuovo in Ravenna, we see a Last Supper scene that is remarkably similar, except for the prominence accorded to Christ.

Again according to custom, Jesus is shown in what in Antiquity was considered the most important place at the table, namely, the right-most position.

Last Supper, sixth century, San Apollinaire Nuevo in Ravenna.

From the ninth century onward, Christianity in the West sought to develop an authentic Latin culture that distanced itself from Byzantine models in the East. Among others, this brought changes to the Last

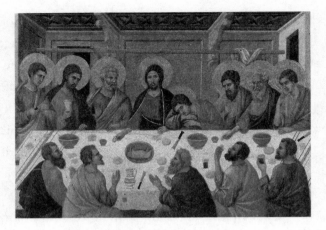

Duccio di Buoninsegna, *Last Supper*, ca. 1308.

Supper motif. The semicircular table became rectangular, which caused the Apostles to be arranged around the table, with Christ in the center. This arrangement forced the artist to take a high, "top-down" viewpoint, since the Apostles in front would otherwise have obscured those in back. Given the highly stylized uniformity of pose, it is difficult to determine if these depictions illustrate a specific event in the Last Supper story, or if they follow the general *agape* format; some historians have even tried to present the Sant'Apollinare Nuovo mosaic as a "direct precedent" for Leonardo's fresco.[2]

As the Last Supper motif became more popular in Western Europe, two new elements were added. Judas, the disciple who plotted to betray Jesus, was made to stand out, usually by wearing a garment of a different color (such as brown or black) or being isolated from the rest. And the Apostle John, who in the Gospel of John is described as Jesus' "beloved disciple," was invariably placed next to Jesus; their affection for each other is illustrated by John reclining on Jesus' shoulder or lap, as shown in Duccio's panel of 1308.

The rapid growth of monastic life, and the attendant construction of convents from the thirteenth century onward, made the Last Supper a natural subject for the room where the monks shared their meals, in the

form of a large-size fresco. The term *al fresco* reflects the technique whereby tempera paint (essentially, hand-ground pigments bonded with egg yolk) were applied on wet plaster covering the wall surface, so that the two could create a permanent bond. That meant that the artist had to work in haste, usually by painting a particular section of his composition from start to finish, in a single sitting, before moving on to the next.

Most important, however, the task of creating a large painting on a wall, in a church or refectory, meant that the artist could no longer ignore the architectural context. The mosaic artist in Ravenna, or the Byzantine painter of an icon, knew no such demands; he created his composition as his training and talent informed him. But the fresco artist needed to take account of the immediate architectural features, the spatial reality in which his painting would be seen. As we saw with Agnolo Gaddi's fresco in the Santa Croce, a fresco demands some form of reconciliation between the painted illusion and the architectural frame that surrounds it.

Thus, the early fourteenth-century artist Vitale da Bologna still depicts the Apostles as a group seated around a circular table, seen from a high vantage point according to the Latin convention, but the scene is framed by simulated pillars topped by a frieze, in an early attempt to "anchor" the scene in space. Giotto di Bondone takes the next step by lowering the vantage point to one that more or less corresponds to the eye line of the viewer. Accordingly, the row of heads in the back is just visible over the figures sitting in front.

Giotto's "intuitive" approach to modeling space was then superseded by the adoption of linear perspective. Using a scientific approach to create a three-dimensional illusion inevitably forced artists to abandon the circular composition. Unless the artist chose a high vantage point, which was no longer plausible in the pursuit of realism, he would see his front row blocking the row of Apostles in the back. Therefore, artists had no choice but to line up the figures *in one row,* seated at a long table perpendicular to the beholder.

A vivid example of this solution is the *Last Supper* that Andrea del

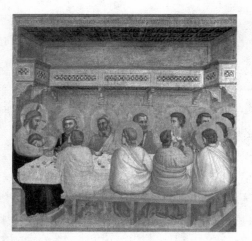

Giotto di Bondone, *Last Supper*, ca. 1306.

Castagno painted in 1447 in the Church of Sant'Apollonia in Florence. Having arranged his figures along one long rectangular table, Andrea adopted Giotto's solution of placing the scene in a tightly spaced room, albeit with the full force of "true" linear perspective. The artist may have calculated that the monotony of lining up twelve figures behind a long table could be assuaged by the highly convincing realism of his illusionary space, especially in the way the tiles on the floor and the beams of the ceiling all appear to recede convincingly toward a common vantage point. We must remind ourselves that for Castagno's contemporaries, such visual effects were still quite novel. We are used to looking at a photograph, relying on our brain to visually *decode* things in proper perspective, but people in fifteenth-century Florence were not. They must have been astonished by such a convincing optical illusion. Even though they *knew* they were looking at a flat wall, it still *looked* like a window into a real room.

At the same time, however, Castagno was careful to retain the key elements of conventional Last Supper iconography, such as the separation of Judas from the group and the depiction of John as a young man who rests or sleeps close to Jesus. With all Apostles seated behind the table, Castagno placed Judas *in front* of it, a solution that Taddeo Gaddi had

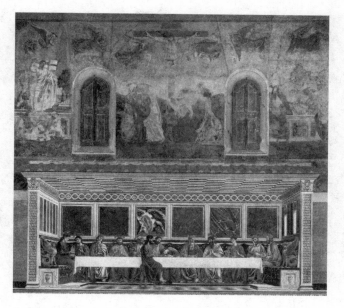

Andrea del Castagno, *Last Supper,* 1445–50, Church of
Sant'Apollonia, Florence.

already used in his *Last Supper* in the Santa Croce of 1340. Castagno also
used Gaddi's conceit of differentiating Judas by the color of his wardrobe;
whereas Gaddi gave him a dark purple robe, Castagno decided to clad
him in menacing brown and gray. Lastly, Castagno follows the convention
of giving Judas a "sop," a piece of bread dipped in oil. According to the
Gospel of Mark, Jesus revealed the identity of the traitor to the Apostles
by declaring that "It is one of the twelve, one who is dipping bread into
the bowl with me" (Mark 14:20). In medieval art, therefore, the person
who held such a piece of bread was instantly recognizable as the traitor
whom Christ was talking about.

Leonardo may also have been familiar with the fresco that Domenico
Ghirlandaio painted in the Church of Ognissanti in Florence around
1480, at least one or two years before Leonardo's departure for Milan. As
we saw, Ghirlandaio was considered one of the leading artists in Florence,
with a workshop that rivaled Verrocchio's *bottega* in its sheer output of
work. Ghirlandaio's *Last Supper* is particularly important for our story,

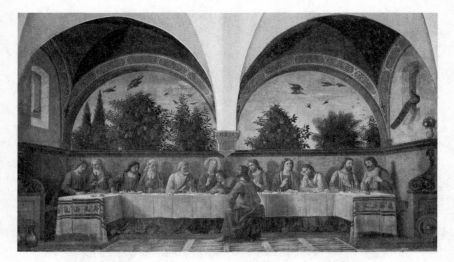

Domenico Ghirlandaio, *Last Supper,* 1480, Church of Ognissanti, Florence.

since it added a number of refinements that may have influenced Leonardo's design.

The first and most important of these is his exploitation of the structural features of the wall as an integral part of the composition. Thus, the two flat arches supporting the groined vault are repeated in the *painted* space beyond the room. In the Baroque period, this would become known as a *trompe l'oeil,* or "deceive the eye," effect: the intermingling of actual and painted space to such a degree that the viewer no longer knows where the architecture ends and the painted illusion begins. Ghirlandaio's brilliant solution is further made plausible by the addition of a corner table at each end, which encourages the eye to interpret the scene as a three-dimensional space.

In other aspects, Ghirlandaio was careful to follow Castagno's precedent. Both painters realized that the success of their spatial illusion would depend to a considerable degree on the position of the viewer in the room. If, for example, the visitor stood in the "sweet spot" right opposite the vantage point used in the painting, at the far end of the hall, the effect would be far more persuasive than if he stood either on the far left or right,

well outside the optical projection of converging lines. The obvious solution, then, was to *collapse* the depth projection as much as possible, by keeping the receding lines very short. In both paintings, the "room" in which the Apostles are gathered is very shallow, about the depth of the table itself. Instead, both artists emphasize the vertical planes (the marble mosaics in Castagno's case, and the wide sky in Ghirlandaio's work). These clever devices distract the eye from the fact that *linear* perspective, of the type used in the Early Renaissance, is effective only within a narrow cone of visibility.

In an iconographic sense, however, Ghirlandaio hewed closely to traditional convention. Once again, Judas is separated from the group by sitting in *front* of the table. John, the beloved disciple, is asleep, leaning close to the bosom of Christ. And despite attempts to alleviate the monotony of the seated figures with such charming details as birds flying in the sky and a peacock perched on the window ledge at right, the composition is essentially static.

In sum, Ghirlandaio's work perfectly captures the state of Florentine art at the close of the Quattrocento. In every element (the convincing perspective, the robust modeling of the figures, the fine detail of the plants and trees, or the bowls and glassware on the table), the fresco summarizes Florentine art at its zenith. But the painting also marks the end of an era. From this point on, the next leap would be taken in Milan.

CHOOSING THE MOMENT

What is interesting about these Last Supper versions is that the narrative moment is actually quite ambiguous. This in itself was typical of the Early Renaissance. Artists were often too focused on rendering individual figures in a realistic, three-dimensional manner to tackle the challenges of realistic movement and action as well. This is true for almost all the great Quattrocento artists, including Masaccio, Mantegna, and Ghirlandaio, and with the possible exception of Botticelli. Their paintings

look like tableaux, like staged set pieces, with each figure carefully positioned on the perspective grid. There is a certain stiltedness about these works, an effect enhanced by the fact that every figure, every object, indeed every square inch of the painting is illuminated with light of the same intensity.

Consequently, it is very difficult to determine what is actually going on in these frescoes. Usually, as in the works of both Ghirlandaio and Castagno, the Apostles are cast in various poses of contemplation. Some observe the actions of Christ in awe, whereas others raise their eyes heavenward, or mutter to those seated closest to them. As we saw, that's because most Last Supper paintings mark the moment when Jesus broke bread and blessed his cup, saying, "This is my blood of the covenant, which is poured out for many. Do this in memory of me" (Mark 14:23–24). The problem with this motif is that it gives the Apostles very little to do. The obvious way to alleviate this problem is to give Christ's disciples a certain individuality in their poses and gestures, but that is difficult to do when you have twelve figures sitting in almost identical positions of preprandial repose, doing nothing but watching.

This, then, is the challenge that Leonardo confronted when setting out to design his fresco for the convent of Santa Maria delle Grazie: how to develop a new and innovative solution to the problems that Ghirlandaio, Castagno, and countless other artists had faced, while still remaining true to the iconographic conventions as his Dominican clients expected him to do. But Leonardo had been there before. He had faced the same challenge of creating a complex, monumental narrative with the design for *The Adoration of the Magi* in Florence. In essence, the problem came down to this: how could he create a composition that not only conveyed the principal story and message, but also engaged the beholder on an emotional level?

We have a rare glimpse of his earliest thoughts on the subject in the form of a drawing, now in the Royal Library at Windsor Castle, which was probably sketched some three to five years *before* the earliest docu-

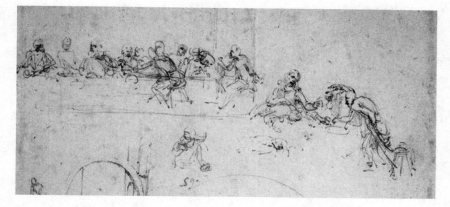

Sketch for a Last Supper, ca. 1490–92.

mentation of the refectory project in the Santa Maria delle Grazie. This worksheet shows the twelve Apostles seated at a table, together with Christ, based on the paradigm established in Florence by Castagno and Ghirlandaio.

Accordingly, Judas is seated by himself, on the other side of the table, facing Christ, with his back toward the beholder and his head in profile. Since this part is clearly the narrative core of the composition, Leonardo decided to execute a more detailed study of this small group, a "close-up" as it were, at the far right of the drawing. Here we see that Judas is reaching forward to dip the piece of bread in the dish, thus fulfilling Jesus' prophesy that "the one who has dipped his hand into the bowl with me will betray me" (Matthew 26:23). Jesus has turned toward Judas, with his hand hovering over the same dish.

What makes this drawing quite unique is that, in Carlo Pedretti's words, it "hints at the architectural setting of the scene"—the only sketch by Leonardo actually to do so. We see a hint of arches, which may correspond to the lunettes in the refectory. Perhaps, as Pedretti suggests, Leonardo was thinking of a "space of a portico or loggia," similar to Ghirlandaio's solution, so as to blend the triple-arched ceiling of the refectory wall with simulated space and depth.[3] If that is true, then the refectory space in the Santa Maria delle Grazie must have been completed *earlier*

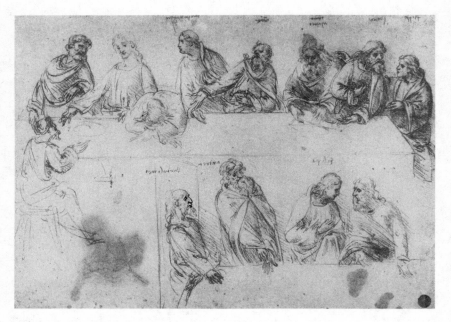

Leonardo da Vinci, *Study for the Last Supper,* ca. 1495.

than 1495. It is even conceivable that the fresco commission emerged around that time as well.

As Leonardo continued to investigate the motif, new ideas began to emerge. A study of around 1495 still shows Judas on the opposite side of the table, with both his and Christ's hands hovering near the dish. Jesus' beloved disciple John is likewise still shown as a young man sleeping with his head on the table.

Yet everything else has changed. Suddenly, the quiet reverie of the Apostles has been disrupted by an event that upsets them greatly. In fact, most disciples have now turned *away* from Christ and seem to be engaged in a deeply emotional debate with their neighbors. What is going on?

What's happened is that Leonardo clearly seized on a very different interpretation of the Last Supper theme. Rather than a traditional interpretation of the motif as the quintessential Eucharist, he has shifted to the account in the Gospel of John, which provides a far more detailed sequence of events. Interestingly, that same Gospel (a favored text in

Dominican sermons) also informs Montorfano's *Crucifixion,* as we saw earlier. For example, in John's Gospel, Judas is identified as the "treasurer" of the group, in charge of the money bag. What's more, John recounts how Jesus washes his disciples' feet. Then, when they are all seated, Jesus makes a shocking announcement. "Not all of you are clean," he says by way of a preamble. The Apostles are stunned. And Jesus continues:

"Very truly, I tell you, one of you will betray me." The disciples looked at one another, uncertain of whom he was speaking. One of his disciples—the one whom Jesus loved—was reclining next to him; Simon Peter therefore motioned to him to ask Jesus of whom he was speaking. So while reclining next to Jesus, he asked him, "Lord, who is it?" Jesus answered, "It is the one to whom I give this piece of bread when I have dipped it in the dish." So when he had dipped the piece of bread, he gave it to Judas son of Simon Iscariot. After he received the piece of bread, Satan entered into him. Jesus said to him, "Do quickly what you are going to do." (John 13:21–27)

This account, imbued with a dramatic tension that is lacking in other Gospels, would become the catalyst for Leonardo's new design. In his vision, the shock of Jesus' declaration explodes outward from the center and provokes the men around Christ to erupt in indignant denials and debate. This concept, which is such a radical departure from the traditional depiction of the Last Supper, would give Leonardo the opportunity to do exactly what he had first attempted to do with *The Adoration of the Magi:* to depict the full repertoire of human emotions in response to the message of Christ.

The true impact of this new idea is even more obvious when we take both parts of the drawing, which were obviously split because of size limitations, and restore them in one single drawing. The effect is remarkable. Suddenly we see a design that is very close to the final composition in the Santa Maria delle Grazie.

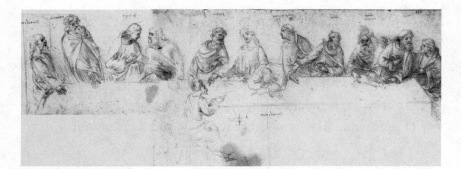

Reconstruction of the *Study for the Last Supper*, ca. 1495.

Several specific gestures and expressions, first pioneered in the somber, ochre-tinted panel of *The Adoration of the Magi,* are resurrected in this captivating drawing. In fact, Leonardo's notebooks are filled with all sorts of ideas on how to express the dismay of the Apostles in their gestures and facial expressions—"the motions of the mind," as Leonardo called them:

> *Emotions move the face of man in different ways, for as one laughs, another weeps; as one is cheerful, another turns sad; others show anger and pity, while others still are amazed, afraid, distracted, thoughtful or reflective. The hands and indeed the whole person should follow the expression of the face.*[4]

Yet how to achieve this vision in a painting that not only conveys the full depth of the human drama, using gesture and expression, but also deploys the revolutionary optical effects Leonardo developed in his Milanese portraits—all within the geometric framework of linear perspective? It seemed, in all, an almost insurmountable task, but a task that, if successful, could change the course of Renaissance painting.

PAINTING *THE LAST SUPPER*

*Perspective is of such a nature that it makes what is
flat appear in relief, and what is in relief flat.*
—LEONARDO DA VINCI

To resolve the awesome challenge of depicting a Last Supper on a wall measuring twenty-eight and a half feet by fifteen feet, Leonardo essentially returned to the solution he had pioneered in *The Adoration of the Magi* some fifteen years earlier. To manage a large ensemble of figures, he first organized them in individual groupings; and within those groupings, he then used the full force of his creative vocabulary to express individual motives through mime and gesture. In the case of the *Adoration,* as we saw previously, Leonardo was never able to complete this ambitious concept. What we have today is only a glimpse of what the ultimate work may have looked like. It is perhaps the greatest tragedy of Leonardo's oeuvre that, in the second (and last) of his surviving monumental endeavors, he succeeded in realizing his ideas only to have the corrosive influence of his pigments destroy his work. Today, the Milan fresco of the *Last Supper* is almost as opaque and inscrutable as the *Adoration* panel in Florence.

Yet succeed he did. While the depth of his *Adoration* painting enabled him to disperse his figures across three planes (foreground, center, and background), the traditional treatment of the motif in *The Last Supper* did not give him the freedom to do the same. The established convention of depicting Jesus and his Apostles as seated at a long table, perpendicular

to the viewer, essentially forced him to plan his composition along a two-dimensional axis. Even within these constraints, though, Leonardo seized on the brilliant solution of disrupting the monotony of twelve seated men by creating intimate clusters of three figures each. Within each of these clusters, the shocking announcement of treason produces a very unique response, driven by the particular personalities within each group. The result is an almost *episodic* treatment of human emotional response, in much the same way that Leonardo sought to create a broad scale of human emotion around the birth of Christ in the *Adoration*.

To embrace these four groups within the integrity of the composition, Leonardo exploits the spatial delineation of the three arches in the vaulted ceiling—in much the same way that Montorfano used them to create three lunettes around the crucified figures. The outermost clusters are framed by the lateral lunettes on either side, while the larger, center lunette encompasses the two inner groups with Christ at their center. The deliberate use of these lunettes in the overall composition is underscored by the presence of Sforza and d'Este heraldic coats of arms, painted by Leonardo himself.

It is within each of these clusters that the great human drama of *The Last Supper* unfolds. Here, with infinite care, Leonardo tries to portray the full range of human emotions, cued to the unique personality and physiognomy of each Apostle. Shock, disbelief, indignation, fear, sadness, submission—all these sentiments are performed right in front of us, as if we were witnessing a play onstage with live actors.

Yet how to "script" these thirteen roles, and how to *cast* the proper characters to play them persuasively? This was the task that consumed most of the four-odd years that Leonardo worked on the fresco, much to the despair of both the duke and the Dominican prior.

A young monk named Matteo Bandello, who happened to be the nephew of the prior and who would later become a novelist of some renown, observed how Leonardo struggled with this challenge. He later wrote, "Many a time, I have seen Leonardo go early in the morning to

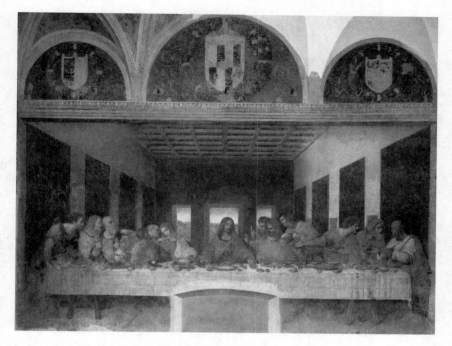

Leonardo da Vinci, *Last Supper*, ca. 1494–98.

work on the platform before *The Last Supper*; and there he would stay from sunrise till darkness, never laying down the brush, but continuing to paint without eating or drinking." Then days would go by in which nothing happened, while Leonardo fought inwardly, considering and discarding all sorts of solutions for what he had in mind. During these intervals, the days would pass "without his touching the work, yet each day he would spend several hours examining it and criticizing the figures to himself."

Then, out of the blue, inspiration would seize him. "I have also seen him," Bandello continued, "when the fancy took him, leave the Corte Vecchia"—the castle in the center of town that was his home and studio—"and come straight to the Grazie. There, climbing on the platform, he would take a brush and give a few touches to one of the figures: and then suddenly he would leave and go elsewhere."[1] Bandello probably reported this strange behavior to his uncle, the prior Vicenzo Bandello.

As it was, the prior was greatly vexed by the rather subversive attitude

Leonardo da Vinci, *Studies of St. Peter for the Last Supper,* ca. 1494–97.

of this Florentine artist, which stood in sharp contrast to reliable Lombard artists such as Montorfano. Native painters did as they were told and delivered their paintings on time and on budget, and without any of the newfangled innovations from down south. So, says Vasari, "the Prior of that place kept pressing Leonardo, in a most importunate manner, to finish the work; for it seemed strange to him to see Leonardo sometimes stand half a day at a time, lost in contemplation, and he would have liked him to go on like the laborers hoeing in his garden, without ever stopping his brush." Eventually, the Dominican stormed off to the Castello of the Duke, and complained bitterly to Ludovico himself."

This story clearly shows that whereas Ludovico Sforza paid for the project, it was the prior who was responsible for its execution. The duke had no choice but to listen to the exasperated cleric, and then to summon the wayward artist himself. Leonardo arrived and was interrogated about his intentions, even though Ludovico was apologetic, and emphasized that he was merely asking these questions in response to the prior's complaints. Here, too, we get a glimpse of the delicate and often tense relationship

between Sforza and his rather importune "guest artist." Had Leonardo been a local painter, there would have been no debate; Ludovico would simply have told him to finish or get out. Yet Leonardo obviously needed more delicate handling. So, Vasari claims, he wormed his way out of the situation by arguing that "men of lofty genius sometimes accomplish the most when they work the least, seeking out inventions with the mind, and forming those perfect ideas which the hands afterwards express and reproduce from the images already conceived in the brain." This sounds like Vasari putting words in Leonardo's mouth, because it is highly doubtful that Ludovico would have understood, let alone *tolerated,* such arrogant language from one of his retainers.

Still, Leonardo was well aware of the stakes involved in this commission. Coming so soon on the heels of the collapse of the *Cavallo* project, here was a perfect opportunity to redeem himself, and to show the duke, the prior, and all of Milan what this mercurial, single-minded Florentine artist was truly capable of. He had, as we saw, assembled a retinue of assistants who helped him to tackle some of the technical challenges of what he had in mind: building the scaffold, preparing the gesso, grinding the pigments, prepping the ground. Yet, in the end, the work would be the product of *his* vision and his vision alone. He now realized that the years of turning out portraits (first in Florence, painting the Madonna; and then in Milan, working on the likenesses of Ludovico's lovers) had actually prepared him well for this ambitious task.

To realize a psychological portrait of each Apostle in his moment of shock and denial, Leonardo would have to call on all the things he had learned about depicting a human face as the mirror of the *soul,* the character of the individual. This process is documented in a series of fascinating portrait studies related to *The Last Supper.* All these appear to have been drawn from life, using characters that Leonardo would have met in the streets and alleys of Milan. What makes each study unique, however, is that it shows the sitter in a moment of intense emotional or intellectual

Leonardo da Vinci, *Studies of heads for the Last Supper,* ca. 1494–97.

concentration—unlike the bland, formulaic type of portraiture that had been the hallmark of Verrocchio's studio. At the same time, the drawings also reveal a keen desire to seek a sharp contrast in age, character, and personality.

Some of the models Leonardo used we know by name. They include Giovannina in the Santa Caterina hospital ("a beautiful face") and Cristofano di Castiglione ("a beautiful head"). But Leonardo's head-hunting expeditions weren't confined to the streets of Milan. He also drew the head of Count Giovanni, of the house of Cardinal Mortaro. Indeed, as Antonio de Beatis later wrote, "the persons in that *Last Supper* are portraits, drawn from life, of several personages at Court and of Milanese citizens of the time, painted life-size."[2]

To grasp the truly revolutionary quality of this concept, we only have to remind ourselves that Pietro Perugino who, like Leonardo, was a pupil of Verrocchio's workshop, was at this time busy using stencils to copy his stock figures across the breadth of his panel. This is why almost all Perugino's figures look so painfully alike, as in the *Fano Altarpiece,* painted at the same time as *The Last Supper.*

Pietro Perugino, *Fano Altarpiece*, 1497.

ANATOMICAL AND GEOMETRIC STUDIES

Yet, as Leonardo would later argue in his *Treatise on Painting*, studying the facial features of his sitters was not enough. A painter, he wrote, must also "be familiar with the anatomy of the tendons, bones, muscles and bundles of muscles." Only then will he "know exactly how many and which tendons have brought about the movement of a limb, which muscle has swelled up in order to shorten the tendon, and which strands, now transformed into delicate cartilage, envelope the relevant muscle and hold it together."[3] Thus it is in Milan that Leonardo first began his studies into human anatomy, not only by examining human skin and muscle tissue in live subjects, but also by dissecting corpses, as some of his detailed studies of muscle groups suggest.

Leonardo da Vinci, *Study of a Human Skull,* ca. 1489–92.

In this Leonardo was certainly not alone. Back in Florence in the 1470s, Antonio del Pollaiuolo and his brother Piero were among the first artists to carry out dissections for the specific purpose of improving their rendering of the human body, even though, in their case, it sometimes led to rather bizarre results. Twenty years later, in 1492, the young Michelangelo Buonarotti also began to dissect cadavers, in the hospital of the Santo Spirito, and even carved an anatomically correct wooden figure of the crucified Christ, as a thank-you to the friars for their indulgence. And as Vasari indicated, Leonardo had already received the basics of geometry and linear perspective during his apprenticeship in the studio of Andrea del Verrocchio. "He made so much progress," Vasari wrote in his unceasing efforts to portray Leonardo as a prodigy, "that, by continually suggesting doubts and difficulties to the master who was teaching him, he would very often bewilder him."

Yet Leonardo's studies went beyond the mere observation of form, of

mere *appearance*. He was interested in how the human body functioned, how it moved, how it propelled itself, and how its muscles contracted and expanded as its limbs and facial expressions changed. "Observe," he urges his reader in his *Treatise,* "how the limbs and their movements change, because when the arms and shoulders move, the shoulder blades greatly alter the position of the spine."

Leonardo's interest, however, was primarily aesthetic, rather than biological. He wanted to know if it was true that all of nature was ruled by a fundamental set of proportions, and if this system could somehow be detected in the structure of a human body. Of course, this idea has its roots in Greek and Roman metaphysics, which held that the most perfect geometric figure in nature is the rectangle, as defined by π, or *phi*. First coined by the Greek mathematician Pythagoras (570–495 BCE) as the "golden ratio" or the "golden rule," this idea states that a rectangle of the length-to-width ratio of 1:1.618 can be replicated ad infinitum in a series of the exact same proportion. The thirteenth-century mathematician Leonardo Fibonacci used the Pythagorean theorem to develop the so-called Fibonacci series, whereby each number is the sum of the previous two (for example, 1, 1, 2, 3, 5, 8, 13, 21, 34 . . .).[4] The ratio of this sequence (arrived at by dividing the second term by the first in any given pair) varies around 1.62, but after a dozen calculations, *phi* is firmly established: 1.618056. Creating a series of tiles based on the Fibonacci sequence, and then drawing a circular arc connecting the opposite corners of these tiles, will produce a Fibonacci spiral. As Bülent Atalay has shown, nature is full of such logarithmic spirals, from a simple nautilus seashell to the massive Whirlpool Galaxy, one of the largest star constellations in our universe.[5]

The Romans adopted the Pythagorean theorem as the guiding principle for their monumental architecture. As such, it appears in the third volume of the *Ten Books of Architecture,* written by the Roman architect Vitruvius (ca. 70 BCE–15 CE). Leonardo was aware of this treatise, for he copied the following excerpt from Vitruvius above his famous drawing

of a man with outstretched arms in two superimposed positions, which form both a perfect circle and a perfect square:

> *Vitruvius, the architect, has it in his work on architecture that the measurements of man are arranged by nature in the following manner: four fingers make one palm and four palms make one foot; six palms make a cubit; four cubits make a man, and four cubits make one pace; and twenty-four palms make a man; and these measures are those of his building.*[6]

Some authors believe that Leonardo's interest in the proportional system of the human body was sparked by the arrival in Milan of a friar and

Leonardo da Vinci, *Studies of a Man with Outstretched Hands,*
also known as *"Vitruvian Man,"* ca. 1494–97.

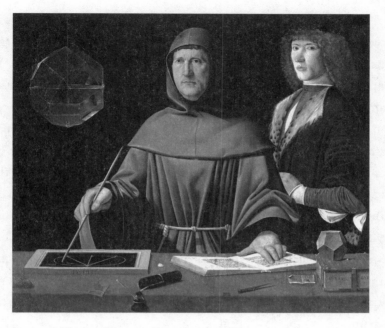

Jacopo de' Barberi, *Portrait of Luca Pacioli,* 1495.

mathematician by the name of Luca Pacioli. Pacioli was known for his publication *Summa de arithmetica geometria proportioni et proportionalita,* a treatise that Leonardo would later often refer to in his notebooks. The book was published in Venice in 1495, and it is quite possible that Leonardo was able to acquire an early copy.

The famous portrait of Pacioli, painted by Jacopo de' Barberi, was probably commissioned on the occasion of the book's release, for it is prominently displayed, in its red cover, at the far right of the table with the inscription LI.RI.LUC.BUR. (*Liber reverendi Luca Burgensis,* or "Book of the Reverent Luca di Borgo," in reference to his place of birth, Borgo Sansepolcro). What's more, Barbari dated and titled the work, in the form of a paper snip placed directly to the left of the book. That snip reads, ACO[PO] BAR[BARI] VIGENNIS P[IXIT] 1495 ("Jacopo Barbari from Venice painted this in 1495"). A little impudent fly has landed right on top of this little scribble. In Late Renaissance and Baroque art, a fly was often featured as a popular vanitas motif, a reference to

the fleeting quality of life. Many sitters, and particularly religious ones, asked for such a motif to temper the "vanity" of their having a portrait done, by reminding themselves that man's physical presence is only temporary. This would certainly have appealed to Pacioli, a Franciscan friar.

It has sometimes been suggested that the handsome young man standing next to Pacioli, dressed in the rich garments of the well-to-do, is Leonardo da Vinci himself. But in 1495, Leonardo was already forty-three years old, and most likely wore a beard. More to the point, he was in Milan at the time, not Venice. It is more likely that the young man is simply one of Pacioli's wealthy Venetian pupils or associates who commissioned the painting, and who insisted on having his donor portrait placed next to the image of the master. Having said that, the depiction of the geometric figure known as a rhombicuboctahedron, in the upper left area of the painting, is quite exceptional.

A rhombicuboctahedron is an Archimedean shape with eight triangular and eighteen square faces. With twenty-four identical vertices, it is a very difficult shape to draw, let alone paint. And in the case of the Pacioli portrait, the representation is even more complicated by the fact that the

Jacopo de' Barberi, *Portrait of Luca Pacioli,* detail of a rhombicuboctahedron.

shape is apparently made of glass, and half-filled with water! Note, for example, how the reflection from the window, with its glimpse of a blue sky and the street below, is perfectly reflected in one of the bottom faces. This suggests a superior knowledge of optics that, as we know, Leonardo was certainly capable of. It is questionable whether Jacopo de' Barberi, a competent but by no means exceptional artist, would have possessed the same skill. It is more likely, in our opinion, that it was Leonardo who added this tour de force to the painting after Luca arrived in Milan in 1497.

Indeed, from that point on, Luca and Leonardo became close friends, and even collaborated on a book, *De divina proportione,* whereby Leonardo furnished the illustrations while Pacioli wrote the text. In this book, Pacioli argues that *phi* is a "divine proportion," because it appeared to be a fundamental rule used by God in the Creation. It therefore followed that the same "golden rule" would be manifest in God's most perfect, most *ideal* creation: a human being.

Few authors, however, have found evidence that Pacioli's books had any tangible impact on Leonardo's paintings, including *The Last Supper.* It is more plausible that Leonardo arrived at his ideas about the proportions of human anatomy based on observation, as shown in a study for Christ's foot in *The Last Supper,* now in the Windsor Castle collection. Featuring parallel lines to denote the principal relationships between the bones and joints, the sketch is clearly drawn from life. Nor was Leonardo particularly adept in mathematics, despite his protestations to the contrary, as the frequent miscalculations of expenses in his notebooks reveal.

"The first step of painting is to put down its scientific and true principles," he writes in his *Treatise.* "That is, darkness, light, color, body, figure, position, distance, nearness, motion, and rest . . . this is the science of painting." The term *geometry* is conspicuously missing from this recital. It is more likely, then, that Leonardo's collaboration with Pacioli, and his own studies on the subject, merely developed his *intuitive* grasp of proportionate modeling.

CREATING THE SPACE

Apart from identifying thirteen distinct models to capture the individual personalities of the Apostles and Christ, Leonardo also faced the problem of how to arrange these figures in a convincing tableau—in a space that would enhance the emotional charge of the composition. This, as we saw previously, was a problem confronted by all his Italian predecessors. Many of these artists, from Duccio to Castagno, found the solution in simply keeping the space as small as possible. The medieval artist was not particularly concerned with a realistic depiction of space, beyond the need to place the thirteen figures at their dinner in a proper setting. The Early Renaissance artists were exactly the opposite: they were so constrained by the rigors of linear perspective that they saw no alternative but to place the figures against a flat wall. To try to create a realistic suggestion of depth for so large a space, across so large a surface, simply went beyond their powers of imagination.

So the problem was solved by *denying* space, by making it appear that the Apostles were sitting against a flat stage set, as it were.

Leonardo recognized the near-impossible task of creating a wide visibility cone within the refectory, at the eye level of the viewer, from where one could experience a convincing illusion of three-dimensional space. Whatever vanishing point he chose, it was bound to look very different for a person standing in the refectory at the far right than for one at the far left. So Leonardo came up with a unique solution: rather than denying space, as his predecessors had done, he decided to *cheat* it. As he would later write in his *Treatise,* "If you wish to represent a thing near, which should produce the effect of natural things, it is impossible for your perspective not to appear false, by reason of all the illusionary appearances and errors in proportion."

Instead, Leonardo counseled his reader to "take your viewpoint at a distance of at least twenty times the maximum width and height of the

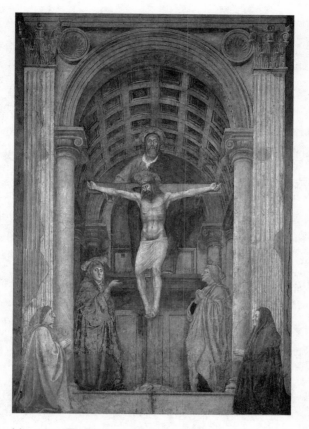

Masaccio, *The Trinity*, 1456. In this fresco, generally
believed to be the first example of linear perspective,
Masaccio placed the vanishing point at the eye level,
near the bottom of the cross.

thing that you represent; and this will satisfy every beholder who places
himself in front of the work at any angle whatsoever." The irony is that
Leonardo's solution for *The Last Supper* violated the core principle of linear
perspective that had governed Quattrocento art since the days of Masaccio:
that the eye of the person looking at a fresco should be the origination point
in reverse for the linear projection of the painting, the vanishing point.

This idea, that linear perspective should always be cast from the eye
level of the beholder so as to establish full correspondence between the

center of projection and the spectator's vantage point, had always been an article of faith—even in the workshop of Verrocchio, as the silver bas-relief on page 13 attests. The reason, the Quattrocento artist would argue, is that that's how nature presents itself to the human eye. As Leonardo himself wrote, "when you go along a land ploughed in straight furrows, the ends of which start from the path where you are walking, you will see that continually each pair of furrows seem to approach each other and join at their ends."

The problem was that with a mural as large as the northern wall of the refectory, and with a space as deep as the refectory itself, *there was no single point* that could convincingly appear as the vanishing point at eye level. Leonardo therefore did something astonishing: he chose to ignore that law. Instead, he arrived at a brilliant solution: to place the vanishing point some fourteen feet *above* the natural eye level of a human being. This is even more astonishing when we remember that the floor of the refectory was originally four feet *lower* than it is today. As a result, the

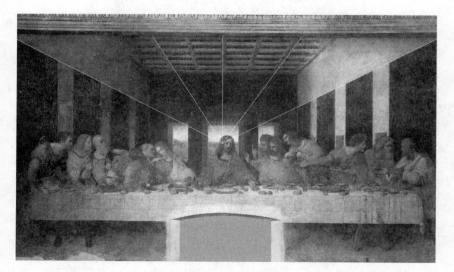

The vanishing point of the linear perspective in *The Last Supper* is placed twenty feet above the original floor, so as to make the spatial illusion seem plausible from all points in the refectory.

vanishing point actually *rose* to a height of twenty feet above the original floor level, to be placed near Christ's right ear.

As a result, the base of the *Last Supper* mural is much higher than that of Montorfano's *Crucifixion*—something that did not escape the discerning eye of the young Bandello, who remarks on it in his memoir.

This daring gambit succeeded beyond all expectations. The deep projection of the room in which the Apostles share their Passover meal now appears as a natural and entirely plausible suggestion of depth, no matter where one stands in the refectory—even though it has no actual relationship with the eye level of the viewer. This elevated point of view also allows us to see the surface of the table and all the objects placed on top of it, which would have been invisible to us if Leonardo had used the conventional solution of a vanishing point at eye level.

As a result of this rather unorthodox solution, the painting truly acts as a spatial extension of the refectory—a goal sought by artists since the earliest days of the Renaissance. It would have given the monks, sitting at long benches perpendicular to the painting wall, the illusion that they were dining *with* Jesus and his Apostles, no matter where they sat. From 1497 onward, this often included Ludovico himself. After the death of Beatrice, he made it a point to visit the refectory twice a week and share a meal with the Dominican friars. Thus, as the mural approached its completion, the duke would undoubtedly have been impressed by the astonishing verisimilitude of Leonardo's composition, and the awe-inspiring sense of breaking bread with Christ.

THE REVOLUTION REALIZED

In the final analysis, what Leonardo produced on the north wall of the refectory was nothing short of a revolution in art. For the first time, an artist used not only linear perspective, but also the dramatic exploitation of light, the delicate modeling of skin and shadow, and the suggestion of

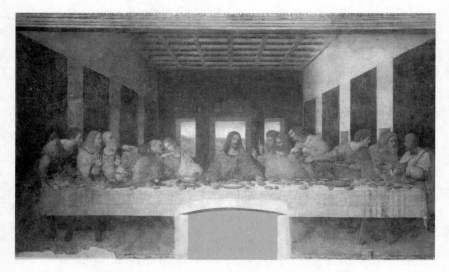

Leonardo da Vinci, *Last Supper*, full view after the latest restoration.

true depth to create an imitation of reality never before achieved by man on a painted surface.

Previously, we used the word *episodic* to describe the unique narrative value that unfolds in each of the clusters seated at the table. With the painting fully realized within its space, the term *cinematic* comes to mind. What Leonardo did was create a scene as a modern motion picture director would: with each actor performing his assigned role in the ensemble, and the scene projected on a vast monumental screen, larger than life. This monumentality is magnified by the background; the sharply receding lines of the walls and ceiling add grandeur and gravitas to the composition.

Yet, as we draw closer to this magnificent tableau, we immediately recognize a problem. The mural as it exists today is horribly mutilated, a condition that the twenty-year restoration project has only served to expose more clearly than ever before. Is it still possible to see all the things that Leonardo had in mind? How much of Leonardo's brilliant scenario is still visible to us?

Last Supper, Detail of Jesus.

A DISASTROUS EXPERIMENT

As we saw before, Leonardo had little experience in painting large murals. Almost all his portraits were painted on a modest scale, and in oils, for oils were patient. They allowed him to work slowly and deliberately, using each new glaze to add another layer of light and shadow, of relievo and chiaroscuro, until the portrait shone as the reflection of real, living flesh. But frescoes could not be painted in oils. As the name *fresco,* or *affresco,* implies, a mural had to be painted with quick-drying tempera paint on fresh, wet lime plaster, so that the two elements, pigment and wall surface, could dry simultaneously. Only then would both elements fuse into a bond that could withstand the test of time. This is why, as the young monk observed, Leonardo had to think two or three steps ahead and spend much time calculating the overall effect of what he had in mind before putting his brush, irretrievably, on the wall.

Yet this method of working—with an "intense intellectual concentration but a hesitant manner of execution"[7]—was not enough to satisfy him. His restless mind drove him further, always looking for ways in which the naturalism of oils could be extended to the medium of a mural.

He was impatient with the immediate and definitive quality of tempera. He wanted to layer things, to add and subtract, to change his mind.

Leonardo thus embarked on a fateful experiment: to try to create a new form of tempera. He wondered if it was possible to develop a process that would enable him to use the same effects of his oil technique while still producing a strong bond between pigment and plaster. And in fact, he thought he had found a solution. Instead of using wet plaster, he decided to prepare a dry wall surface, using a seal of pitch and gesso, a binding agent consisting of chalk, gypsum, and lead white pigment. On top of that, he applied a thick layer of egg tempera. The idea was to create a surface that would patiently tolerate multiple layering in the same way a wooden panel does. Only in this way could he apply the necessary glazes to create a true, psychological portrait of each of the Apostles.

Unfortunately, the attempt failed. The pigments refused to bind with the surface, and as early as 1517 the painting began to flake. The reason, as Lorenzo Matteoli has pointed out, is that the northern wall faced the kitchen, and therefore absorbed a lot of condensation. Under normal circumstances, this condensation would have been naturally absorbed in the air through ventilation, but Leonardo's unique dry-wall primer kept the moisture trapped inside the wall. Thus, over time, condensed water began to build up beneath the priming layer, which led to the growth of mold and, ultimately, decay.[8]

Antonio de Beatis, who visited the refectory that same year of 1517, wrote that the painting was "most excellent although it is beginning to be spoilt"—*cominciava ad guastarse*—"either by dampness oozing from the wall, or from some other negligence." While Montorfano's fresco on the south wall, competently produced in tempera, would maintain its integrity in the centuries to come, Leonardo's mural slowly began to disintegrate. When Vasari visited the refectory in Milan in 1556, he declared that the painting was all but "ruined." Paolo Lomazzo, who made a copy of the fresco some ten years later, wrote that "the painting is in a state of total

ruin." Giorgio Vasari pronounced it to be "nothing but a blurred stain." And things went downhill from there.

In 1652 the friars of the monastery decided to cut a door in the north wall, thus destroying part of the fresco around the area of Christ's feet. From the eighteenth century onward, various "restorers" were put to work to try to resuscitate the moribund painting. To make matters worse, in 1796, during the Napoleonic Wars, one of the French generals used the refectory as a stable for his horses. As legend tells us, his soldiers then used Leonardo's mural as target practice with whatever projectile they could find, including bricks. Lastly, on August 16, 1943, an RAF bomber dropped a bomb on the Santa Maria delle Grazie. The explosion demolished the building but left the walls of the Leonardo and Montorfano frescoes relatively intact (in the case of *The Last Supper,* the wall had been reinforced and protected with sandbags). So it is nothing short of a miracle that there is anything left at all.

There followed several attempts to restore *The Last Supper,* until, in 1977, the painting disappeared behind scaffolding and canvas for what turned out to be the longest restoration effort ever: a project of twenty-two years. Only in 1999 was the fresco once again made available to the public, but with its unveiling came a rather sobering conclusion: only about 20 percent of Leonardo's original mural is still visible.

Is this, then, the last word on *The Last Supper*? Is Leonardo's vision irreparably lost? Or is there another way to recapture what his contemporaries saw?

SEEING *THE LAST SUPPER* WITH NEW EYES

Blinding ignorance does mislead us.
Wretched mortals, open your eyes!
—LEONARDO DA VINCI

In Vasari's lengthy treatment of *The Last Supper,* there is an intriguing reference that has been largely overlooked by modern scholarship. Vasari writes that "the excellence of this picture, both in composition and incomparable finish of execution, made the King of France desire to carry it into his kingdom." Vasari, of course, is talking about Louis XII, who, as we saw earlier, believed he had a claim on Milan (as did his predecessor, Charles VIII) and proceeded to act on that claim as soon as he was crowned king in 1498.

The king promptly marched down to the duchy and conquered Milan in 1499, forcing Ludovico Sforza to flee. Leonardo, too, decided to leave, and embarked on a journey that brought him, in a roundabout way, back to Florence by 1500.

But the French king was not satisfied with the title of Duke of Milan. Eight years later, he launched the Third Italian War, which lasted until 1516 and ultimately embroiled just about every Italian state between Venice and Rome, with often disastrous results.

In between his martial pursuits, however, the king had not failed to visit the Santa Maria delle Grazie. *The Last Supper* made a deep impression on him. As Vasari writes, he was so enthralled by the painting that he wanted to "carry it into his kingdom." King Louis had good reasons

Jean Perréal, *Portrait of King Louis XII*, ca. 1514.

to do so. Though it is difficult to imagine today, France, and particularly the royal court at Amboise, was actually a cultural backwater at that time. France had experienced its greatest artistic flowering during the fourteenth and fifteenth centuries, when the court of Burgundy was a leading center of the High Gothic style with painters such as Jean Fouquet, Enguerrand Quarton, and the Limbourg brothers. But the sudden onset of the Florentine Renaissance, which took Europe by storm in the latter part of the fifteenth century, had toppled France from its artistic pedestal.

Louis, who was raised at the Château de Blois on the Loire, was keenly aware of France's sudden regression in matters of art. Like his eventual successor, François I, he believed that his nation could restore its artistic preeminence only by using Italian art as a model—including such masterpieces as Leonardo's *Last Supper*. Yet, how to transport this huge

mural to France? The technology needed to transfer a mural painting to canvas or any other form of moveable support was developed only in the nineteenth century; one of the first murals to be preserved in this manner was the series of *Pinturas negras,* or "Black Paintings," painted by the Spanish artist Francisco Goya, which were transferred to canvas in 1874. Still, that technique lay far in the future when the French king demanded to know if there was a way to ship *The Last Supper* to France "safely, and without any regards for expense." Indeed, "he tried by any possible means to discover whether there were architects who, with cross-stays of wood and iron, might have been able to make it so secure that it might be transported safely," Vasari writes; "but the fact that it was painted on a wall robbed his Majesty of his desire, and so the picture remained with the Milanese."

Yes, but not quite. The king couldn't ship the original to France, but there was another, far more practical way to take it with him. He could have a copy made, on canvas, and as much to scale as the size of the canvas would allow.

This hypothesis is very important for our story, and for one simple reason. There are scores of copies of Leonardo's *Last Supper* in museums all over the world, some dating as far back as the sixteenth century. At one point, in the beginning of the twentieth century, the refectory itself had a dozen copies on display. But the idea of a copy for the French king Louis XII himself would have been a very different proposition. It is highly unlikely that the king would have been satisfied with a copy by a local artist, certainly given the wide gap between Leonardo's transformative work and the quality of the work of most Milanese artists. We therefore believe it is plausible that King Louis commissioned a copy *directly from Leonardo,* and that this copy was executed in Milan under Leonardo's direct supervision. Even more astonishing perhaps is our suggestion that this copy may still be in existence today.

The evidence for such a claim is compelling. We know that Ludovico Sforza fled Milan on September 2, 1499, and that after the French forces

captured the city, Louis made a triumphant entry into Milan on October 6 of that year. At that time, the king appointed a man named Georges d'Amboise to serve as the permanent governor of Milan. D'Amboise was a French cardinal whose family had served in several prominent positions in the previous government of King Charles VIII. Among others, his father, Pierre d'Amboise, was a chamberlain to Charles VIII, while his brother Charles d'Amboise had been a governor of various regions for Louis XI. Georges himself became a bishop at age fourteen. This was not unusual in a time when such positions were prized for their political rather than spiritual value, and many bishoprics were bought or sold for the considerable influence that they could wield, regardless of the spiritual abilities of the individual involved.

Despite the great enmity between Charles VIII and the Orléans branch of the House of Valois, the d'Amboise family was able to retain the royal favor after Louis XII, previously known as Louis d'Orléans, came to the throne in 1498. Georges was instantly elevated to cardinal, and then performed the same service to his sovereign that the newly elevated archbishop in England, Thomas Cramner, would execute for Henry VIII some thirty-five years later: he annulled the king's marriage to his consort, Jeanne de Valois, who unfortunately happened to be infertile. Thus released, the king married Anne of Bretagne in January 1499. In October of that year, he made his triumphant entry into Milan.

King Louis's patronage of Leonardo must have begun very soon after that. Leonardo's painting of the *Madonna of the Yarnwinder*, begun around 1500, was commissioned by Florimond Robertet, a senior adviser to Louis XII who undoubtedly acted on the king's instructions. This suggests that Robertet probably charged Leonardo with the *Yarnwinder* project while the artist was still in Milan. Leonardo then completed the painting after his return to Florence.

In 1502, Leonardo's old partner in Milan, Ambrogio de Predis, delivered the second version of *The Virgin of the Rocks* (now in the National Gallery in London) that he and Leonardo had collaborated on. But when

Andrea Solario, *Portrait of Charles II d'Amboise, Governor of Milan*, ca. 1507.

the Confraternity of the Immaculate Conception refused to pay, de Predis lodged an official complaint with the Milanese government, which at this time happened to be the king of France, Louis XII, in his capacity as the new duke of Milan. In practice, it was probably Georges d'Amboise who received the petition. The new French government duly ordered a judicial hearing on the case, but the Confraternity held considerable political sway in Milan and, as it happened, Leonardo himself was in Florence at that time. Perhaps as a result, the judge's ruling went against the

artists and sided with the Confraternity, which claimed that the painting was still "unfinished." Translated properly, this meant that the Confraternity believed the painting was more Ambrogio than Leonardo; the magic touch of the *real* master, or so it was felt, was clearly missing. As a result, Leonardo had to return to Milan and do whatever it took to see the client satisfied, and get himself and his partner paid.

Thus began an epic tug-of-war between Piero Soderini, the *gonfaloniere,* or president, of the Signoria, and the French royal government in Milan. The problem was that, by 1504, Leonardo was not free to jump up and leave Florence for Milan. He was under contract to paint a massive fresco in the Great Council Hall of the Palazzo della Signoria, the seat of the Florentine government. And that project was not going very well, because Leonardo had once again been experimenting with various pigments that would allow him to create the optical effects of oils on a plaster wall.

There now followed an increasingly acrimonious exchange of letters between the *gonfaloniere* and the new governor of Milan, who was none other than the nephew of Georges d'Amboise. In 1500, Ludovico Sforza had launched a daring raid to retake Milan, taking the French forces by surprise. It then fell to Cardinal d'Amboise, now promoted by Louis XII to lieutenant general, to lead the French troops in recapturing the city. This d'Amboise proceeded to do with such force and speed that he was even able to take Ludovico himself prisoner.

The king's gratitude was boundless. As a result, Georges d'Amboise became prime minister of France, and was ennobled as the Count of Lomello. He left Milan, but not before installing his nephew Charles d'Amboise as the new governor. It thus fell upon this new governor to execute the king's wishes in his capacity as the duke of Milan, and one of these tasks involved getting Leonardo back to Milan, by hook or by crook.

Pressed by the French, Florence grudgingly issued Leonardo a permit on May 30, 1506, with the understanding that the furlough not exceed three months, and that he would have to leave a deposit of one hundred

fifty florins to guarantee his return. If he failed to do so, he would forfeit the escrow and, needless to say, forever incur the enmity of the Republic of Florence. And so Leonardo duly left for Milan in the first weeks of June, and was received with open arms. In sharp contrast to the acerbic Florentines, Charles d'Amboise treated him like a celebrity. And unlike the Signoria, which had always considered Leonardo a talented but rather unreliable painter, d'Amboise proved to be generous. Whereas Gonfaloniere Soderini had once stooped so low as to pay Leonardo's monthly fee in pennies,[1] the French accorded him a rich retainer, leaving him free to organize his time as he saw fit.

The weeks flew by, and when Leonardo showed no inclination to return to Florence at the end of the agreed three-month furlough period, d'Amboise wrote a courteous letter to the Signoria, asking for an extension until September. Soderini replied with a thunderous volley on October 9, all but accusing Leonardo of bad faith. "He received a large sum of money and has only made a small beginning on the great work he was commissioned to carry out," the *gonfaloniere* charged, adding that "we do not wish further delays to be asked for on his behalf, for his work is supposed to satisfy the citizens of this city." Any more delay, he charged, would "expose ourselves to serious damage."

Ever the suave French *gentilhomme*, d'Amboise tried to reduce the escalating tensions by writing a conciliatory letter on December 16, 1506. "The excellent works accomplished in Italy and especially in Milan by Master Leonardo da Vinci, your fellow citizen, have made all those who see them singularly love their author," he wrote, by implication rebuking Soderini for the lack of respect that *he* had shown Leonardo. Then d'Amboise continued: "Now that we have been in his company and can speak from experience of his varied talents, we see in truth that his name, already famous for painting, remains comparatively unknown when one thinks of the praises he merits for the other gifts he possesses, which are of extraordinary power." Nevertheless, the governor of Milan pledged

that Leonardo would indeed return to Florence shortly. That seemed to have settled the matter.

But then, surprisingly, the king himself decided to intervene. He summoned the Florentine ambassador at the French court, Francesco Pandolfini, and made a formal, royal request to retain Leonardo's services in Milan—perhaps the first instance in modern history in which a king intervened with a fellow head of state for the services of a humble painter. "His Majesty summoned me to Him," Pandolfini duly reported to his masters at the Signoria after the audience, and then quoted the king's words verbatim: "Tell them that I need your painter, Master Leonardo, who is living in Milan, because I wish him to make some things for me. See that your Signoria charge him with this task and command him to place himself immediately at my service, and that he does not leave Milan before my arrival. He is a good master, and I would like to have a number of things by his hand."

Louis was remarkably circumspect about the "things by his hand" that he wanted Leonardo to execute. If the need for this artist was so urgent, why not tell the Signoria the reason? Pandolfini was actually wondering the same thing, so he boldly asked the king "what sort of works he wanted from Leonardo." But the king had no intention of divulging his plans to the Florentine republic. "Oh," the king replied airily, according to Pandolfini's letter, "a number of small pictures of our Lady, and other things, depending on what springs to mind."

The truth, in our opinion, is that the king knew very well what he was going to charge Leonardo with. Since he couldn't take the *Last Supper* fresco to Milan, he was going to order a faithful copy executed under the supervision of the master himself. Such an enterprise would, of course, take many months. This is why the king chose not to make his intentions known to the Signoria, because such would undoubtedly have unleashed another storm of protest.

As an indication of the great importance that Louis apparently

attached to the project, the king then started to fret whether Pandolfini would communicate the urgency of the king's wishes to his masters in Florence in proper fashion. Consequently, just two days after his meeting with the Florentine ambassador, Louis took the unprecedented step of writing to the Signoria *himself,* in a letter drafted by Florimond Robertet (the same counselor who had previously commissioned the *Madonna of the Yarnwinder* from Leonardo). "Very dear and close friends," the king began, "As we have need of Master Leonardo da Vinci, painter to your city of Florence, and intend to make him do something for us with his own hand, and as we shall soon, God helping us, to be in Milan, we beg you, as affectionately as we can, to be good enough to allow the said Leonardo to work for us such a time as may enable him to carry out the work we intend him to do."[2]

This rather convoluted phrase, "to work for us such a time as may enable him to carry out the work we intend him to do," clearly suggests that the king had no intention of revealing what he had in mind, and tried to hide it in flowery language. Louis probably knew that a massive undertaking such as the production of a life-size copy of *The Last Supper* would summon all Leonardo's resources, including his associates and assistants, and Louis knew better than to tell the Signoria that it could forget about seeing its artist in the foreseeable future.

And so it came to pass. The French king duly arrived in Milan and, we believe, formally charged Leonardo with executing a faithful copy of *The Last Supper,* on canvas, as close to scale as was practical. And Leonardo must have acceded to his wish, because in the next communication from the royal French government of Milan, the artist was now referred to as "Master Leonardo da Vinci, painter to his most Christian Majesty." Louis himself would call Leonardo *nostre peintre, "our* painter." All of a sudden, Leonardo had become the court painter of the French king.

THE *LAST SUPPER* COPY FOR GAILLON

Thus, work began on copying *The Last Supper*. In fact, we would suggest that Leonardo and his workshop began not one, but *two* copies of the mural. This was not unusual; Leonardo often charged his associates with making copies of his original works, given that he produced so few of them. And because Leonardo was usually involved in supervising the execution of such copies, the lines between master and workshop, between original and copy, were often blurred. Thus it is that we have a copy of the *Mona Lisa* by Salaì, two versions of the *Madonna of the Yarnwinder*, several copies of the *Saint Anne* (including one presumably painted by either Salaì or Francesco Melzi), and of course at least two versions of *The Virgin of the Rocks*. What distinguishes these works from later copies is that they are veritable products of Leonardo's studio, executed under his supervision, as attested by numerous *pentimenti,* or artistic alterations, that have recently been revealed by infrared photography.[3]

Yet who commissioned the second *Last Supper* copy? Who would have possessed the means, other than the king, to finance such a stupendous enterprise? The answer, in our opinion, is the very individual who served as the first French governor of Milan and who, at that time, was the second most powerful man in France: Cardinal Georges d'Amboise, uncle of Charles. The evidence for this hypothesis is found in the inventory of his estate in Gaillon, Normandy, written some thirty years after the cardinal died in 1510. This inventory refers to *La Cène faicte en toile en grands personnaiges que feu Monseigneur fist apporter de Milan* ("the Last Supper made on canvas with monumental figures, which Monsignor had transported from Milan").[4] We also know that Georges d'Amboise had arranged for a Milanese artist to travel to France to decorate his chapel at the Gaillon estate. This artist was none other than Andrea Solario, one of Leonardo's leading pupils, who, as we saw, had executed a crucifixion in 1503 influenced by Montorfano's fresco in the refectory. In 1507, Solario

even painted a portrait of the cardinal's nephew, the then-governor of Milan, Charles d'Amboise.

All this strongly indicates that Solario was a favorite of the d'Amboise family. That would suggest that as a member of Leonardo's Milan circle, he would have been the natural choice to execute the *Last Supper* copy for the cardinal. It is equally plausible to think that, upon its completion, Solario supervised the transport of the huge canvas to France. Once there, Solario was invited to stay and paint a number of murals in the chapel of Château de Gaillon. A Gaillon accounting statement dated January 20, 1509, lists the remittance of 129 *livres* and 10 *soldi* (around $1,500) "à Milan au peintre maistre André de Solario."

We are not the first to think that Solario was the artist responsible for the *Last Supper* copy sent to France. This idea was already suggested by art historian E. Möller, who in 1952 wrote an authoritative study of all extant copies of *The Last Supper*. His suggestion was accepted by another art historian, Luisa Vertova, who dated the copy to the 1506–7 time frame, exactly the period when Leonardo was in Milan. The attribution was subsequently rejected by Leo Steinberg in his 2001 publication, even though, in a subsequent paragraph, Steinberg admits that the Solario copy is one of the two "most accurate copies" still in existence.[5]

Yet where is this huge canvas? What happened to the work after it was delivered to Leonardo's patron Georges d'Amboise at his château in Gaillon? Church records show that the canvas was acquired in 1545 by a cleric named Abbot Streyters, for the choir of a new abbey church that was then under construction near the Belgian village of Tongerlo.[6]

Meanwhile, Solario had returned to Milan, where, we believe, his success in faithfully producing a *Last Supper* copy on canvas led to another contract: to paint *another* copy, this time a fresco(!), for the monastery at Castellazzo.[7] Very few photographs exist of this remarkable work, which was destroyed during World War II. But the few black-and-white images that have survived reveal the extraordinary mastery of Solario in capturing both the form and the spirit of Leonardo's original.

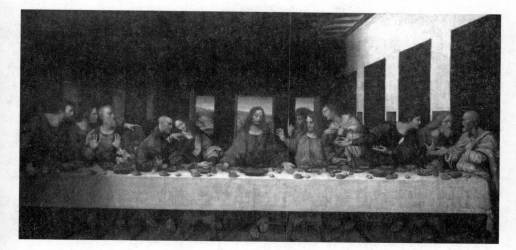

Andrea Solario, *The Last Supper after Leonardo,* also known as the Tongelro copy, ca. 1507.

Amazingly, Solario's first copy is still visible in the Tongerlo Abbey to this day, but as with so many other works by Leonardo and his followers, the painting did not survive the five-hundred-year interval without damage. Just before 1721 the work was moved to the central nave, near the northern transept, as part of the refurbishing of the church in the rococo style. The French Revolution and Napoleon's subsequent conquest of the Netherlands exposed the work to the real danger of either theft or destruction. In response, the huge canvas was moved into the home of a notary, a man known as te Herselt, while the abbey was decommissioned and the monks were evicted.

In 1825 the work then resurfaced in an inventory of a painter in the Belgian city of Mechelen, and from there it wound up in the private collection of the Belgian king Leopold I. In 1840, after the abbey was restored, it naturally initiated a campaign to reclaim the painting, ostensibly to place it in the Tongerlo convent church once more. These efforts were ultimately successful, and documents show that the prior reacquired the canvas in 1868. But the prior had something else in mind for the work. It transpired that he had offered it for sale to museums in Brussels, Antwerp, and

Berlin, as part of a fund-raising effort for his abbey. A sale was indeed agreed upon, to a buyer in England and, as a result, the large canvas was shipped to Spalding, Lincolnshire. However, no buyer materialized in the end.

In 1902 the work returned to Belgium, where it was once again framed and placed in the right transept of the abbey church in Tongerlo. Unfortunately, some thirty-four centimeters was cut from the width and forty-four centimeters from the height of the canvas. In 1920 the painting was moved to a location above the entrance, and it is here that disaster struck in 1929: a fire broke out in the church. In the frantic efforts to rescue the painting, more damage was inflicted. Eventually, an Antwerp restorer named Arthur van Poeck conducted a thorough restoration, the result of which is the painting we see today.

THE COPY FOR THE FRENCH KING

But what about the copy for the French king? What happened to that painting? It is conceivable that this canvas was painted by another of Leonardo's leading associates, Giovanni Pietro Rizzoli (active 1495–1549), who is referred to in Leonardo's notebooks as "Gian Pietro" or "Giampietrino." This artist was previously responsible for a faithful copy, in oils, of Leonardo's drawing of nude Leda, kneeling next to her newborn children.

Giampietrino's copy, also known as the "Certosa di Pavia copy," is particularly noteworthy since the width closely matches that of the original fresco, some twenty-five feet, which strongly suggests that it was executed for a prominent (and wealthy) donor (the upper third of the painting was cut away, for no reasons that anyone has been able to establish). Unlike Solario, however, Giampietrino was not able to execute this enormous enterprise within the span of mere months. Pietro Marani believes it could not have been completed until 1515–20, and other historians have dated it even later. But the commissioning patron has never been established, which in our opinion argues for a possible provenance at the

French court in Milan.[8] What's more, Louis XII died in 1515, which may explain why the painting never left the duchy. In 1626 it appears in the inventory of the Certosa di Pavia, the vast monastery complex established in 1395 by the first official duke of Milan, Gian Galeazzo Visconti. London's Royal Academy then acquired the Certosa copy in 1821, only to conclude in our modern day, to the astonishment of the art world, that it had no room to display it.

In 1993 this magnificent work of art was sent "on loan" to Magdalen College in Oxford, which had no room for it, either. It was thus decided to hang the canvas high up over the entrance to the Magdalen Chapel. This unfortunate placement, casting the painting in the shadows while exposing it to the dampness and cold of the British winter, guarantees that no visitor can find it, let alone enjoy it. A lecture about the work by the distinguished art historian Sir Ernst Gombrich, delivered at the time of its transfer to Oxford, could not mask the tragedy of the work's removal from the main circuit of the London art world.[9]

Nevertheless, what these two copies—executed, presumably, under the supervision of Leonardo himself—allow us to do is look at the *Last Supper* fresco with new eyes, and recognize the work as the transformative masterpiece of the sixteenth century.

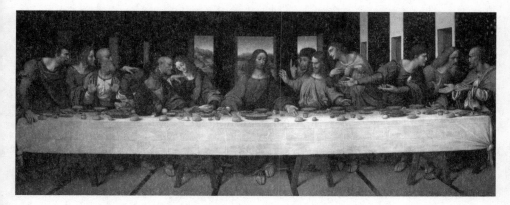

Giampietrino, *The Last Supper after Leonardo,* also known as the Certosa copy, ca. 1507–15.

The current placement of Giampietrino's copy in the chapel of Magdalen College in Oxford, where the high placement and poor lighting all but guarantee that visitors can no longer appreciate it fully.

THE LAST SUPPER: AN ASSESSMENT

If Leonardo had been a film director, critics would undoubtedly have praised him for choosing the right moment in the story with an exquisite sense of high drama. He has frozen his film right at the point where, in the Gospel of John, Jesus has just declared, "Very truly, I tell you, one of you will betray me." We thus see how this announcement moves across the room like a shock wave, like a tsunami. Those seated closest to Jesus recoil visibly, stunned by the suggestion that there could be a traitor in their midst.

As they lean backward, they also effectively distance themselves from the taint of betrayal, leaving Christ isolated and abandoned in the center of the composition.

Yet the reaction within each of these inner triads is not the same. To the right of Christ, Thomas, James the Great, and Philip prepare to protest their innocence. James spreads his arms wide in a classic demonstration of guiltlessness. Thomas, ever the most impetuous of the Apostolic

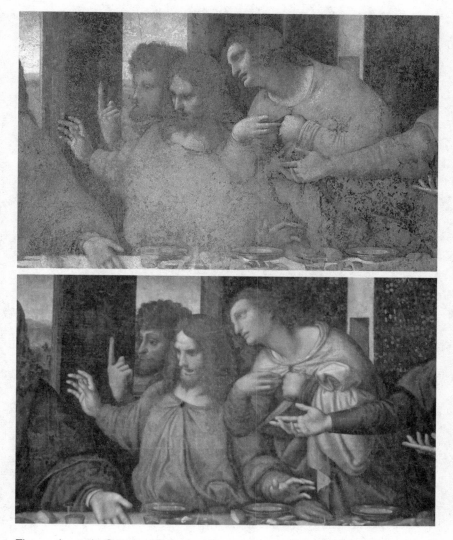

Thomas, James the Great, and Philip, from Leonardo's original and Solario's copy.

circle, has left his seat and rushes to Christ's side, defiantly pointing his finger upward as if to say, "No way you're going to hang this on me!" But the most poignant reaction belongs to Philip. Deeply wounded by Jesus' words, he bends forward while pointing to his heart, saying (as Goethe would later put it), "Lord, it isn't I, is it?"

The response on the opposite side is much more complex. John, "the

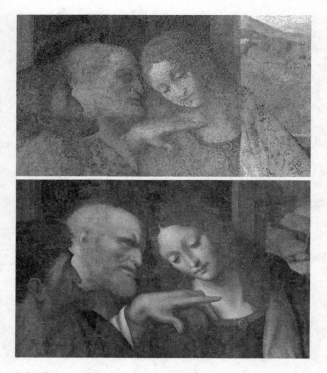

Judas, Peter, and John, from Leonardo's original and Solario's copy.

beloved disciple," has uncharacteristically turned away from Christ, even though, according to the medieval convention, he is supposed to be sleeping on Christ's lap, or nestled close by his side. Instead, John turns the other way, toward the most senior man in the group, Simon Peter. In this, Leonardo followed John's Gospel closely. After Jesus made his announcement, says the Gospel, everyone was overcome with shock, and no one dared to ask Jesus whom he was talking about. But Simon Peter, who was aware of the great affection that Jesus bore John, motioned to him that he should "ask Jesus of whom he was speaking" (John 13:21). This is why John is inclined to Peter's ear, for Peter has beckoned him and is whispering what he wants John to do.

While Peter is making his request, gesturing with his left hand, his right hand is quietly curling around a knife on the table. Peter has not forgotten his role as Jesus' right-hand man, as his principal aide and pro-

Andrea Solario, *The Last Supper after Leonardo,* detail of Peter's hand holding a knife.

tector. He knows that, if indeed there is someone within the group who poses a threat, it is *his* duty to defend Jesus. So, out of sight of both John and the dark figure in front of him, his hand reaches for the knife and firmly grips the handle. The gesture is doubly significant, because in a few hours' time, in the garden of Gethsemane, one of Jesus' disciples will raise his sword and cut off the ear of one of the Temple servants (Mark 14:47).

Meanwhile, the figure seated between Peter and John has carefully moved backward, so as to distance himself from Christ without anyone noticing. His right hand is clutching the bag of thirty silver shekels, his reward for reporting Jesus' location to the chief priests (Matthew 26:14–16). His left hand is about to reach for the lump of bread, next to a dish of oil, but the gesture has suddenly frozen in midair.

For, at that very moment, Jesus responds to John's question, and reveals who the traitor is. "It is," says Jesus, "the one to whom I give this piece of bread when I have dipped it in the dish" (John 13:21–26). That's when Judas realizes he's been found out, that Jesus *knows*. Judas' face is masked in shadow, in strong contrast to the white-haired Peter, further underscoring his guilt.

Andrea Solario, *The Last Supper after Leonardo*, detail of Judas' hands.

THE OUTER GROUPS

Because the two inner triads of Judas-Peter-John and Thomas-James-Philip are seated so close to Jesus, they are the ones who absorb the emotional shock wave of their master's bombshell announcement. This allows those in the outer clusters, seated at a safe distance from their master, to turn inward and debate the news among themselves, and with a greater measure of emotional detachment. On the right, both Matthew and Thaddeus have turned *away* from Jesus, and are focusing their attention on Simon, who is holding forth on the words they have just heard.

Matthew, the youngest, leans forward to hear what his two companions, who are considerably older and more experienced, have to say about the situation. Of the two, Thaddeus is the most surprised, whereas Simon expounds his theory with remarkable composure and gravitas—an impression that is reinforced by his flowing garments. Simon is the only figure at the table whose beautiful robes are seen in full, reaching all the way to the floor.

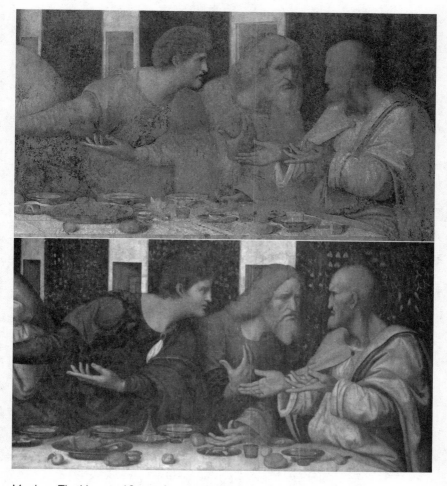

Matthew, Thaddeus, and Simon, from Leonardo's original and Solario's copy.

On the opposite side of the table we are witnessing a different reaction yet again. Here, gestures of consternation and disbelief prevail. Whereas the behavior of the elderly Simon on the right implies that this announcement did not come as a surprise, that he had suspected such betrayal all along, his opposite number on the left, Bartholomew, can merely signal mute shock. Andrew has instinctively raised his hands, as if to protest their innocence: *It is not me, Lord! Don't for a moment think it's me!* The man seated in their midst, James the Younger, has spotted the

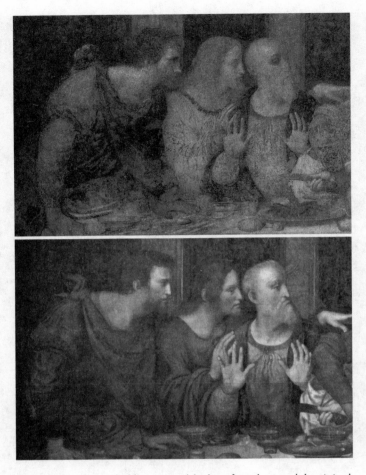

Bartholomew, James the Younger, and Andrew, from Leonardo's original and Solario's copy.

whispered conversation between Peter and John, and is reaching over to Peter as if to ask, *What did he say? Does he know who Jesus is talking about?*

JESUS AND JOHN

Jesus himself, meanwhile, sits calmly in the eye of this emotional storm. The palm of his left hand is turned upward, a gesture that in the art of the Middle Ages often signified an exposition, such as a teaching

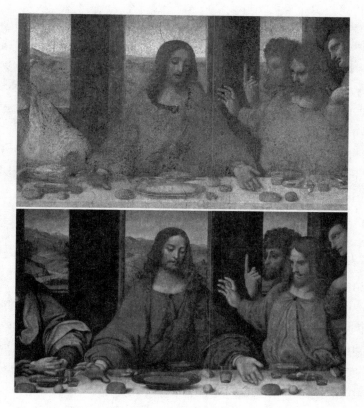

Christ, from Leonardo's original and Solario's copy.

or sermon. His right hand, by contrast, appears to reach for—what, we don't know. Is it the cup of wine, which will soon become the symbol of his blood in the celebration of the Eucharist, or is he aiming for the clump of bread, to give it to Judas?

It is possible that the gestures seek a parallel with Montorfano's *Crucifixion*, directly opposite *The Last Supper*. According to this theory, the open hand welcomes the penitent thief at right to the heavenly kingdom, while the downturned hand condemns the impenitent thief to damnation and hell.

Jesus' expression, meanwhile, is noteworthy for its deep expression of sorrow. Vasari wrote that the head of Christ was left incomplete, "since he thought it was not possible to render that celestial divinity which is

required for the representation of Christ." This is probably another example, as some have claimed, of Vasari trying to exonerate Leonardo from any statements in his notebooks that could be considered heretical, by representing him as a deeply pious man. For in both copies and in the admittedly damaged original, the face of Jesus appears to be fully developed.

What is remarkable, however, is that Jesus' eyes are downcast. Here, too, Leonardo probes the psychology of a man on the eve of his trial and execution. Reading the Gospels, Leonardo may have recognized that Judas was not the only one who would betray Jesus. All his disciples would. At the crucial moment when he needed them most—at the indictment at Caiaphas' residence, during the hearing in front of Pilate, and finally during the agonizing hours on the Cross—none of the Apostles would be with him; they all had fled (Mark 15:40). Leonardo brilliantly expresses this feeling of abandonment, of utter desolation, by surrounding Jesus with empty space. For all their bravura, none of the Apostles reaches over to console their master, their rabbi. At the hour of his death, it is only the women (Mary, the mother of James the Younger; Salome; and above all, Mary Magdalene) who will steadfastly remain by him.

Is this the reason that John, the beloved disciple, is portrayed with such feminine features? In his 2012 monograph, Ross King effectively demolishes the myth, propagated by Dan Brown's *The Da Vinci Code,* that the young figure seated at Jesus' right is actually Mary Magdalene. As we saw previously, Mary Magdalene was one of the Dominican Order's patron saints. As such, she appears prominently at the center of Montorfano's *Crucifixion.* It is safe to say that if the Gospels had made any reference to her as part of the Last Supper scene, the Dominicans would have jumped at it. But the Gospels are very explicit. The Last Supper was shared only by Jesus and the twelve Apostles. Any deviation from this iconographic program would have constituted a breach with the Gospel tradition, and that is something the Dominicans, guardians of Catholic orthodoxy, could never have countenanced.

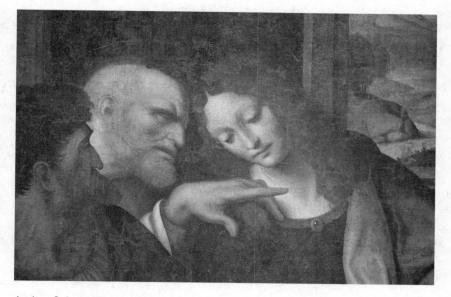

Andrea Solario, *The Last Supper after Leonardo,* detail of John.

Yet there is no question that this elfin-like figure, the beloved disciple, is in many ways a throwback to the Madonna portraits of Leonardo's Florentine and early Milan period. Compared to the robust masculinity of the other Apostles, the ambiguous gender of this young disciple is striking. We wouldn't be surprised to learn that it was the model for *The Virgin of the Rocks* who sat for John's portrait. What did Leonardo mean by this?

Does he want us to interpret Jesus' love for this young follower in a homoerotic sense, as several scholars have suggested as of late? Or is the obvious similarity to Leonardo's Madonna paintings (the tilted head, the long flowing hair, the downcast eyes filled with love and sorrow) a deliberate allusion to Mary, the only other human being who loved Jesus without any qualification? The cult of Mary was very strong in Florence—indeed much stronger than in Milan. The Florence Cathedral, the Duomo, was dedicated to Santa Maria del Fiore, Saint Mary of the Flower, symbol of her perpetual virginity. Mary is perhaps the only female who appears consistently throughout Leonardo's oeuvre, not only in the form

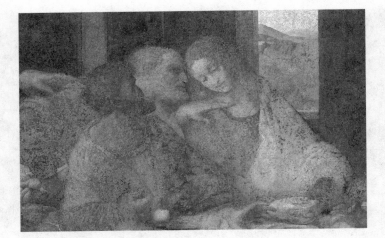

Leonardo da Vinci, *Last Supper,* detail of John.

of commissioned paintings, but also in scores of sketches and studies. Many of these were intended for specific projects, but many others were simply ruminations on the theme.

As a mother, Mary was a feminine motif that Leonardo could be comfortable with; that he could explore ad infinitum without any concern for the sexual connotations of the female form. Of course, the real answer for John's hermaphroditic appearance may always elude us. It is one of those mysteries that are deeply rooted in Leonardo's enigmatic mind, and may leave us to speculate at will.

THE LAST SUPPER AS A STAGE PLAY

Unlike any of his predecessors, Leonardo did not cast his scene in ubiquitous light, as had been the tradition in sacred art since the Byzantine era. In all the preceding Last Supper frescoes, every face, figure, and gesture, down to the smallest nook and cranny, is lit by the same intense light. Leonardo's *Last Supper* is the first monumental painting to break with this centuries-old paradigm. In his *Lady with an Ermine,* he had discovered the

The interior courtyard of the Castello Sforza, where Leonardo directed several masques and plays (*courtesy Pantheon Studios, Inc.*).

intense psychological power that the skillful manipulation of light and shadow, an emotional spotlight as it were, could bestow upon his sitter. In this fresco, that technique is expanded to encompass the entire stage.

During this sojourn in Milan, Leonardo was often called upon to organize and direct masques and plays, as was usual for artists at the time. In 1490 he prepared the settings, masks, and costumes for the Festa del Paradiso, and five years later he prepared the stage for the theatrical comedy *Danae,* by Baldassare Taccone, featuring Jupiter and Danae as the principal protagonists.

As a result, Leonardo was familiar with the importance of proper stage lighting, even though the spotlights of the late fifteenth century were limited to torches, oil lamps, and partially covered candelabras. An Italian architect from the early sixteenth century, Sebastiano Serlio (1475–ca. 1554), wrote how the problem of lighting complex scenery onstage involved "innumerable lights, both large, medium and small."

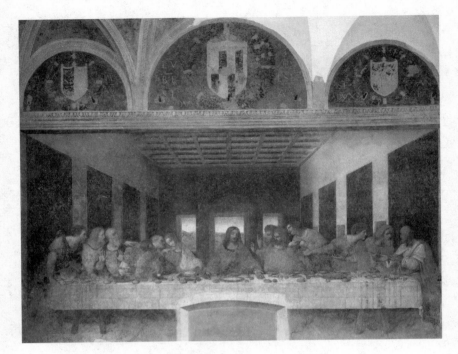

Leonardo da Vinci, *The Last Supper*, 1494–98.

A later designer at the Gonzaga court in Mantua, the Jewish-Italian playwright Leone de' Sommi (ca. 1525–ca. 1590), stressed how stage direction in a tragedy is entirely dependent on the right lighting.

This experience must have prepared Leonardo for the bold decision to illuminate the entire *Last Supper* from a single light source at stage right—that is, from the beholder's left side, since the refectory was lit by a row of windows on the left. This not only produced the raking light that allowed Leonardo to draw the portraits of the Apostles in multiple shades of light and shadow, but also plunged the left side of the room in darkness, leaving the right side brightly lit. This dramatic lightning, a future hallmark of the Late Renaissance and the Baroque, magnifies the inner turmoil and drama of the thirteen monumental figures at the front of the stage.

EPILOGUE

In 1507, Leonardo was compelled to return to Florence. His favorite uncle, Francesco, had died a few months earlier. Francesco's will stipulated that Leonardo was to receive his property near Vinci. Unfortunately, Leonardo's half-brothers, the legitimate children of Ser Piero, vowed to deny him his uncle's estate, and filed a suit with the court.

Just before leaving Milan, Leonardo personally supervised the lavish decoration of the city for the entry of King Louis, complete with triumphal arches, sacred tableaux, ballets, masques, and dances. The king was charmed. Furthermore, Leonardo had the good fortune of being introduced to an exceedingly bright young man named Francesco Melzi, who had ambitions to become a painter. Leonardo wasted no time in hiring the lad, but recognizing Melzi's intellect, he also appointed him as his secretary, or what today we might call his "personal assistant." It was an inspired choice, for without Melzi's diligent organizational skills, it is unlikely that the treasure trove of Leonardo's manuscripts would be with us today.

The lawsuit in Florence dragged on for months, and this time Leonardo felt emboldened to turn to the French king for support. The monarch was happy to oblige. On July 26 the king fired off a note to

the Signoria, urging that "this lawsuit be brought to a conclusion in the best and swiftest rendering of justice possible." This letter is the one that referred to Leonardo as "nostre peintre et ingénieur ordinaire," that is, the official artist and engineer at the royal court of France. It signaled that any injustice against this artist would be considered an affront to the sovereignty of the king of France himself. Nevertheless, the case dragged on until the early months of 1508.

Leonardo used his enforced stay in Florence to resume his study of cadavers, this time at the Ospedale di Santa Maria Nuova. Usually one was allowed to dissect a body only if the cadaver was a male, and either a criminal or a stranger. "By law only unknown and ignoble bodies can be sought for dissection," the physician Alessandro Benedetti wrote in 1497, just ten years before Leonardo's arrival at the hospital in Florence; "[people] from distant regions without injury to neighbors and relatives."[1] Dissection and its attendant violation of the body were still considered an affront to the honor of the surviving family.

In due course, however, Leonardo ignored this restriction and began to dissect female cadavers. Few men had as yet ventured to dissect a female, because a woman's chastity was a highly prized virtue in the Middle Ages. A dissection would expose her most intimate parts to the eyes of strangers, thus compounding the grief of her relatives with shame. Yet, for Leonardo, the anatomy of a woman was the ultimate mystery, for it held the key to the creation of *life*. The red chalk drawing now in Windsor Castle is perhaps the first scientific anatomical study of an adult woman ever made.[2] Among other elements, Leonardo correctly identified the uterine artery and the vascular system of the cervix and vagina. What's more, he drew the uterus as a single chamber, contrary to the contemporary belief that the uterus was comprised of several compartments, potentially to accommodate more than one fetus.

As soon as he returned to Milan in 1508, Leonardo was once again plunged into a maelstrom of concepts, designs, and commissions that could be found only at a profligate court of Louis XII, and that satisfied

his peripatetic mind. He worked on the design for an equestrian monument to Gian Giacomo Trivulzio, a condottiere in the employ of the French in Milan, but like Leonardo's ill-fated Sforza monument, it never came to pass. Next, he was consulted on the choir stalls of the venerable Milan Duomo, or Cathedral, while his private studies were wholly absorbed, once again, by the mysteries of moving water. A notebook entitled *Di mono ed acque,* or "On the World and Its Waters," was begun on September 12, 1508.[3] In between, he continued his anatomical studies under the tutelage of the brilliant physician Marcantonio della Torre, a professor of anatomy at the University of Padua.

On top of this frantic activity came the demands of a wealthy court, and its never-ending appetite for beautifully staged dances, musical performances, and masques. Naturally, set design was once again the responsibility of Milan's impresario par excellence, Leonardo da Vinci. Among these was a group of elaborate stage sets for a performance of *Orfeo,* a lyrical drama composed by the fifteenth-century humanist Agnolo Ambrogini (commonly known as Poliziano), first staged in Mantua.

But the idyll was once again short-lived. Charles d'Amboise, the thirty-eight-year-old French governor of the duchy, died unexpectedly on March 10, 1511. The cause of his death is uncertain; a sudden illness, possibly from malaria, or a battlefield injury may be the reason, since the governor was in the field fighting the forces of Pope Julius II. The war did not go well; by late 1512 the French had been pushed back across the Alps. As a result, Milan was soon in Italian hands once more, ruled by a son of Ludovico Sforza. Fortunately, Leonardo spent these tumultuous months in relative safety. He had been invited to stay at the bucolic estate of Francesco Melzi's father, near the small village of Vaprio d'Adda, some twenty-five miles northeast of Milan. Here, on April 15, 1512, he celebrated his sixtieth birthday; perhaps Melzi marked the event by creating his famous profile drawing of the master.

. A few months later, another political landslide shook Italy when two sons of Lorenzo de Medici, bolstered by troops from Prato, staged a coup

in Florence, ousted Gonfaloniere Soderini, and once again established Medici rule in the city. The reins of state were taken up by Giuliano di Lorenzo de' Medici, who had been quietly biding his time in Venice until the French, traditionally Florence's ally, were driven from Italy and the city lay vulnerable to a coup d'état.

The Medici victory was made complete when the "warrior pope" Julius II died on February 21, 1513, at age sixty-nine, and Giuliano's brother Giovanni, a cardinal since the age of thirteen, was elected Pope Leo X on March 11. The fact that Giovanni had never been ordained a priest was apparently not an obstacle; he was hastily accepted into the priesthood and given a bishop's miter on March 17. Two days later he was formally crowned pope at age thirty-seven.

Then news arrived that Louis XII was once again planning a military campaign to take possession of Milan. In an effort to bolster Florence's defensives, the pope replaced his brother Giuliano with his more energetic nephew Lorenzo di Piero, given that the bookish Giuliano did not have much of a reputation as a commander. Giuliano was recalled to Rome with vague promises of becoming the ruler of the newly formed aggregate of central Papal States.

Thus, Giuliano de' Medici found himself in Rome laden with titles but with little else to do. This may explain why he took up the pen and wrote to Leonardo, offering him a position at the new Medici court in Rome. Leonardo accepted, and with that his life had come full circle. Remarkably, the family that had spurned him in Florence in the early 1480s now offered him sanctuary and patronage when his fortunes were once again at a low ebb. "I left Milan for Rome on 24 September 1513," he wrote in one of his notebooks, "accompanied by Giovan, Francesco de Melzi, Salaì, Lorenzo and Il Fanfoia." We know Melzi and Salaì, of course, but the identities of "Giovan[ni]" and the aforementioned "Il Fanfoia" are uncertain; perhaps these were artists who worked in Leonardo's Milan workshop, creating copies of his paintings.

Yet Leonardo's stay at the Medici court in Rome was not a happy one.

His accommodation was certainly comfortable; Giuliano gave him a suite of apartments in the Villa Belvedere, just then undergoing renovation. Nearby was a courtyard where Julius II had installed his extensive collection of Roman sculpture. Giuliano may have hoped that this would further raise Leonardo's spirits, though, as we know, Leonardo was never as interested in copying Roman statuary as his contemporaries were. The pièce de résistance of this collection was the famous *Laocoön Group,* discovered in 1506 and immediately pounced upon by the pope.[4]

Yet Rome wasn't Florence, and it certainly wasn't Milan. Crumbling, overgrown, and beset by thieves and prostitutes, it was not a place for a cultured and sophisticated man such as Leonardo. Much worse were the rivals who roamed the halls of the Vatican itself, the "celebrity" artists of the new century, men such as Raphael, Bramante, and Michelangelo, who were busy launching projects with the full support and encouragement of the new pope. The fact that Leonardo was a protégé of Giuliano's, rather than of Leo X himself, also did not help.

Vasari tells us that the pope was finally prevailed upon to give Leonardo something to do, presumably in the form of a commission. But when this came to pass, Leonardo straightaway began to experiment with a new distillation of oils and herbs, "in order to make the varnish." When Leo X heard this, he exclaimed, "Bah! This man will never accomplish anything, because he's already thinking of the end of the work, rather than the beginning."

In 1515, Leonardo's health began to fail. We may infer this from a letter he wrote to Giuliano: "I was so greatly rejoiced, most illustrious Lord, by the desired restoration of your health, that it almost had the effect that my own illness left me [*male mio da me s'è fuggito*]."[5] Then, fate intervened once again. In October 1515, he was included in the pope's entourage as the pontiff traveled to Bologna to meet the new French king, François I. François had defeated the short-lived Sforza restoration in Milan, and France was once again in control of the duchy. The pope hoped to put an end to all this squabbling over Milan by negotiating a European treaty

that would bring peace to the former belligerents, and allow them to focus their combined energies on a far greater danger: the looming threat of the Turks. The significance of this meeting for our story is that François I was able to meet Leonardo da Vinci in person. No doubt he had heard plenty about this enigmatic artist from his predecessor, Louis XII; now he could behold the famous maestro with his own eyes. As subsequent events would attest, the impression was favorable; an envious Benvenuto Cellini would later write that François was "totally besotted" with Leonardo.

And not a moment too soon, for in March 1516, Leonardo's patron Giuliano died, weakened by tuberculosis. Five years later, when Michelangelo began building the New Sacristy at the San Lorenzo in Florence as a Medici pantheon, he designed the now-famous tomb with the sculptures of *Day* and *Night,* in which Giuliano's remains were eventually laid to rest. Giuliano's untimely death left Leonardo marooned in Rome without a patron, just as the fame of Raphael and Michelangelo was reaching its zenith. Late in the summer of 1516, the master finally acknowledged that his time in Rome, and indeed in Italy, had run its course. He accepted the offer of King François and moved into comfortable retirement, and royal honors, at the king's residence in Amboise, on the Loire. "Here you will be free to dream, to think and to work," François is reputed to have said as he took Leonardo through his new dwelling.

Vasari claims that, as Leonardo approached death, "he earnestly wished to learn the teaching of the Catholic faith, and of the good way and holy Christian religion; and then, with many moans, he confessed and was penitent . . . and [took] devoutly the most holy Sacrament, out of his bed." Vasari also writes that, as he lay on his deathbed, his head cradled in the loving arms of the French king, Leonardo confessed "how much he had offended God and mankind in not having worked at his art as he should have done."

Yet a nineteenth-century researcher, Léon de Laborde, discovered that, on May 3, the day after Leonardo's death, François I happened to be in

Saint-Germain-en-Laye to sign an edict. Saint-Germain-en-Laye, as modern commuters know all too well, lies northwest of Paris, at a distance from Amboise of some 165 miles; to cover the distance, the king would have had to race at a full gallop, straight through the night.[6]

It is more likely that Leonardo died peacefully in his manor with only his faithful assistant, Francesco Melzi, by his side.

By that time, the fame of a fresco in a Milanese convent had spread like wildfire throughout Italy. Within a short time, everyone was beginning to paint like Leonardo. The obsession with linear perspective was abandoned. From this point forward, artists concentrated on painting in monumental fashion, with figures that dominated the space with their soulful presence, cast in penetrating hues of shadow and light, against panoramas that stretched to the sky.

Leonardo had liberated Italian art. He had freed it from the lingering strictures of medieval convention to pursue a level of naturalism not seen since the days of imperial Rome. What had begun as a promise, as a glimpse, in *The Adoration of the Magi* in Florence had become a reality. With *The Last Supper,* Leonardo firmly turned his back on the Quattrocentro to usher in the age of the High Renaissance. It was Raphael, Michelangelo, Giorgione, Titian, and countless others who would go and spread this triumphant new style around Italy and the world—but it began with the single-minded genius of a painter from Vinci.

ACKNOWLEDGMENTS

This book is the fulfillment of our lifelong interest in the work of Leonardo da Vinci, and particularly the period of his apprenticeship in Florence and subsequent years in Milan. It is an attempt to reconstruct those years, and to dispel some of the misconceptions that have accumulated on the subject in both the scholarly and popular literature over the past few decades. In doing so, we owe a debt to many scholars, past and present, whose research proved indispensable to our book, including Bülent Atalay, Ludwig Heydenreich, Martin Kemp, Jean-Pierre Mohen, Charles Nicholl, Domenico Sguaitamatti, and Frank Zöllner, as well as the titans of Leonardo connoisseurship, Kenneth Clark and Carlo Pedretti.

In addition, we are deeply grateful to several prominent art historians who agreed to share their thoughts with us, including Luke Syson (now Iris and B. Gerald Cantor Curator in Charge of European Sculpture and Decorative Arts at the Metropolitan Museum of Art in New York) and Larry Keith (Head of Conservation and Keeper at The National Gallery in London), who both curated the landmark 2011 exhibition *Leonardo da Vinci: Painter at the Court of Milan* at the National Gallery; Vincent Delieuvin, curator of Italian art at the Louvre museum in Paris and editor of the 2012 exhibition *Saint Anne: Leonardo da Vinci's Ultimate Masterpiece;* Arnold Nesselrath, deputy director of the Vatican Museums in Rome; and Andreas Schumacher, curator of Italian art at the Alte Pinakothek in Munich. We are also indebted to Giuseppe Pallanti for sharing with us the fruits of his research in the public and private archives of Florence; and for the research staff at several academic libraries, particularly the Young Library at

Acknowledgments

UCLA, Westwood campus; Oxford University's Bodleian Library; and the research library at Magdalen College, Oxford.

We must also thank Cameron Jones, editorial assistant at Thomas Dunne/St. Martin's Press, a division of Macmillan Publishers, for his unfailing support in the development of this book, while we owe a debt of gratitude to our two superb graphic artists, Jesse Martino and Jason Clark, for their invaluable help in preparing the illustrations for this book.

Thanks are due to our literary manager, Peter Miller, and his staff at Global Lion Intellectual Property Management. Finally, we must express our deepest gratitude to our muses, Sabrina and Cathie, who continue to be our indefatigable companions during our many journeys through Renaissance Italy.

NOTES

1. Beginnings in Florence

1. Peter Burke, *Culture and Society in Renaissance Italy,* 69.
2. Serge Bramly, *Leonardo: The Artist and the Man,* 106. Leonardo would later describe this technique in his *Treatise on Painting.*
3. Frank Zöllner, *Leonardo da Vinci: The Complete Paintings and Drawings,* 37

2. *The Adoration of the Magi*

1. "Of Portrait and Figure Painting: Of the Way to Learn to Compose Figures in Groups," in *Libro di Pittura,* Asburnham I Codex, reprinted in Jean Paul Richter, *The Notebooks of Leonardo da Vinci,* 287.
2. Scipione Ammirato (1531–1601), *Opusculi,* 2 vols., published in Florence in 1640.
3. Maurice Seracini, "Diagnostic Investigations on *The Adoration of the Magi* by Leonardo da Vinci, in *The Mind of Leonardo—The Universal Genius at Work,* ed. P. Gauluzzi (Florence: Giunti, 2006), 94–101.

3. An Artist in Milan

1. In 2004, documents came to light that the conspiracy was even abetted by Federico da Montefeltro, the Duke of Urbino, who planned to send troops to Florence as soon as Lorenzo was declared dead.
2. Charles Nicholl, *Leonardo da Vinci: Flights of the Mind,* 166.

3. Galeazzo Maria Sforza to Bartolomeo da Cremona, 1473. Messer da Cremona was tasked to "search in our city for a master who can execute this work and cast it in metal, and if no such master is to be found in our city, we wish you to investigate and find out whether in another city or elsewhere there is a master who knows how to do it . . . We wish you to search in Rome, Florence and all other cities where the master can be found who could this work successfully." Reproduced in, Frank Zöllner *Leonardo da Vinci, 1452–1519: The Complete Painting and Drawings*, 85.

4. Mendes da Silva was also known as "Amadeus of Portugal." One of Leonardo's inventories lists a "libro dell'Amadio," as cited in Carmen Bambach et al., *Leonardo da Vinci, Master Craftsman*, 433. Madrid Codex 8936, fol. 34.II

5. M. A. Gukovskij, *Madonna Litta: Kartina Leonardo da Vinci v Ermitaze* (Leningrad: gosudarstvennoe izdatel'stvo Iskusstvo, 1959), reproduced in Luke Syson et al., *Leonardo da Vinci: Painter at the Court of Milan*, 2012.

4. The Sforza Commissions

1. Edoardo Villata, *Leonardo da Vinci: I documenti e le testimonianze contemporanee* (Milan: Castello Sforzesco 1999), n. 44.

2. Claire J. Farago, *An Overview of Leonardo's Career and Projects until c. 1500*, 65.

3. *Codex Urbinas Latinus*, 110 vols.

4. John Pope-Hennessy, *The Portrait in the Renaissance* (Princeton, NJ: Princeton University Press, 1963), 101–2.

5. *Codex Urbinas Latinus*, 60 verso. (McM248).

6. Richard O. Copsey, "A Carmelite Link to Leonardo da Vinci," from British Province of Carmelite Friars (website), December 26, 2011, at www .carmelite.org/carmstudies.htm.

6. The Santa Maria delle Grazie

1. Ross King, *Leonardo and* The Last Supper, 42.

2. Ludwig H. Heydenreich, *Leonardo:* The Last Supper, 107.

3. Michael Baxandall, *Painting and Experience in Fifteenth-Century Italy*, 20.

7. Montorfano's *Crucifixion with Donors*

1. Luca Fanelli to Lorenzo de Medici, August 12, 1487, as reproduced in Serge Bramly, *Leonardo: The Artist and the Man*, 205.

2. Ross King, *Leonardo and* The Last Supper, 89.

3. Leo Steinberg, *Leonardo's Incessant* Last Supper, 143.

4. Julia Cartwright, *Beatrice d'Este, Duchess of Milan, 1475–1497: A Study of the Renaissance,* 306.

5. The complete sentence reads, "Item de' solicitare Leonardo Fior. no perché finisca l'opera del Refettorio delle Gratie principiata, per attendere poi ad altra Fazada d'esso Refettorio et se faciamo con lui li capituli sottoscripti de mane sua che lo obligiano ad finirlo in quello tempo se convenera con lui." From L. Beltrami, *Documenti e memorie riguardanti la vita e le opere di Leonardo da Vinci* (Milan: Fratelli Treves, 1919), doc61.

6. Heydenreich, *Leonardo:* The Last Supper, 107.

8. The Theme of *The Last Supper*

1. Baxandall, *Painting and Experience in Fifteenth Century Italy,* 41.

2. Theodor Lücke, *Leonardo da Vinci: Tagebücher und Aufzeichnungen* (Leipzig: publisher, 1940), 889f.

3. Carlo Pedretti, *Leonardo: Studies for* The Last Supper *from the Royal Library at Windsor Castle.* Exhibition catalogue (Washington DC: National Gallery, 1983), 44.

4. Martin Kemp, ed., *Leonardo on Painting,* 144.

9. Painting *The Last Supper*

1. Matteo Bandello, *Le Novelle* (Bari, 1910), 2:283.

2. *The Travel Journal of Antonio De Beatis 1517–1518* (London: The Hakluyt Society, 1979). De Beatis was a secretary to Luigi Cardinal of Aragon and visited Leonardo at his home in Amboise, France, in 1517.

3. Lücke, *Leonardo da Vinci,* 711.

4. Bülent Atalay, "Painting by the Numbers," *Math and the* Mona Lisa: *The Art and Science of Leonardo da Vinci* (New York: Harper/Smithsonian Books, 2006), 26–52.

5. Bülent Atalay and Keith Wamsley, *Leonardo's Universe: The Renaissance World of Leonardo da Vinci* (Washington, D.C.: National Geographic, 2008), 128.

6. A palm was literally a "handbreadth"; a cubit was around 18 inches (46 cm); while a *passus* was the length of a stride, roughly a yard and a half.

7. Heydenreich, *Leonardo:* The Last Supper, 16.

8. Lorenzo Matteoli, "Four Lectures on Leonardo da Vinci," Lorenzo Matteoli website, January, 2005, matteoli.iinet.net.au/html/Articles/Leonardo3.html.

10. Seeing *The Last Supper* with New Eyes

1. According to this story, told by Vasari, the Florentine cashier offered Leonardo his monthly stipend in stacks of *quattrini,* or "pennies," whereupon the artist indignantly exclaimed, "I'm no penny painter!" If anything, the anecdote illustrates the growing irritation between Leonardo and the Florentine head of state, who greatly favored Michelangelo and probably considered Leonardo an inflated prima donna who had yet to complete anything of merit in his native town. This irritation would explode into full-blown animosity when Leonardo used the power of the French Crown to extricate himself from the *Anghiari* commission, leaving the Signoria high and dry with two unfinished compositions. Of course, Michelangelo had abandoned *his* battle fresco as well; then again, in Soderini's eyes, Michelangelo could do no wrong.

2. Louis XII, Letter to the Signoria of Florence, January 14, 1507, reproduced in Vincent Delieuvin, *Saint Anne: Leonardo's Ultimate Masterpiece* (Paris: Musée de Louvre, 2012), 127.

3. Delieuvin, *Saint Anne,* 166. The *Saint Anne,* presumably painted by Salaì, is now in the Hammer Museum at University of California–Los Angeles, and currently exhibited in the Getty Museum of Los Angeles. Infrared reflectogram photography has revealed numerous modifications, arguably made under Leonardo's supervision.

4. E. Möller and J. Martin-Demezil, "L'art et la Pensée de Léonard de Vinci, Communications du Congrès International du Val de Loire," in *Etudes d'Art* (Paris-Algiers: 1953–1954), 263.

5. Steinberg, *Leonardo's Incessant* Last Supper, 244. Strangely, Steinberg makes no attempt to identify another painter who could have been responsible for the painting, even though its high fidelity to the original, and its dating, strongly suggest that it originated from Leonardo's immediate circle, and was painted during Leonardo's stay in Milan.

6. R. H. Marijnissen, *Het Da Vinci Doek van de Abdij van Tongerlo* (Tongerlo, Belgium: Abdij Tongelro, 1959), 4. That the friars took the preservation of their valuable canvas seriously is attested by the fact that in 1594, special curtains were procured and dyed to serve as protection against the sun.

7. J. Murray, *The Academy* (London: Chancery Lane, 1882). The author also visited the abbey of Tongelro, where he admired the newly restored copy by Solario "in an excellent state of preservation."

8. Pietro Marani, *Leonardo da Vinci: The Complete Paintings* (New York: Abrams, 2000), 309.

9. E. H. Gombrich and Piers Rodgers, "Papers Given on the Occasion of the Dedication of *The Last Supper* (after Leonardo)," Magdalen College, Oxford, March 10, 1993. Gombrich opened his remarks by saying that "it is most unlikely that Leonardo would have approved of my attempt to talk about this work or its copy." Given the astonishing lack of care shown to the painting in its current position, high above the entryway of Magdalen's chapel, against the damp brick and utterly cast in shadows, I would tend to agree with him.

Epilogue

1. Gombrich and Rodgers, "Papers Given . . . ," 12.

2. *View of the Organs of the Chest and Abdomen and of the Vascular System of a Woman*, c. 1508. Windsor Castle, Royal Library, RL 12281r. Reproduced in Zöllner, *Leonardo da Vinci: 1452–1519; The Complete Paintings and Drawings;* 446.

3. This is one of those rare instances when Leonardo carefully dated and located his work: "Cominciato a Milano a dì 12 di settembre 1508."

4. The villa itself no longer exists, though the adjoining courtyard, the Cortile del Belvedere, designed by Bramante in 1506, still forms the core of the Vatican Museums today.

5. Draft of a letter to Giuliano de' Medici, 1351, in Richter, ed., *Notebooks,* 407.

6. Some scholars now question whether the edict would have required the king to be present, since it doesn't bear his actual signature, merely his name. This could have placed him in Amboise on May 2. Nevertheless, the sentimentality of the scene certainly makes it suspect.

SELECT BIBLIOGRAPHY

Baskins, Wade. *The Wisdom of Leonardo da Vinci*. New York: Barnes and Noble, 2004.

Bambach, Carmen, Stern, Rachel and Manges, Alison. *Leonardo da Vinci, Master Draftsman*. Catalogue to an Exhibition at The Metropolitan Museum of Art. New Haven: Yale University Press, 2003.

Baxandall, Michael. *Painting and Experience in Fifteenth-Century Italy: a primer in the social history of pictorial style*. Oxford, UK: Oxford University Press, 1988.

Bramly, Serge. *Leonardo: The Artist and the Man*. New York: Penguin, 1994.

Burke, Peter. *Culture and Society in Renaissance Italy, 1420–1540*. London: B.T. Batsford, 1972.

Clayton, Martin. *Leonardo da Vinci: A Singular Vision*. Exhibition catalogue. Queen's Gallery, Buckingham Palace. New York: Abbeville Press, 1996.

Delieuvin, Vincent. *Saint Anne: Leonardo's Ultimate Masterpiece*. Exhibition catalogue. Paris: Musée du Louvre, 2012.

Farago, Claire J. *An Overview of Leonardo's Career and Projects until c. 1500*. New York: Garland Publishers, 1999.

Farago, Claire J., ed. *Leonardo da Vinci, Selected Scholarship: Leonardo's Projects, c. 1500–1519*. Oxford: Taylor and Francis, 1999.

Heydenreich, Ludwig H. *Leonardo: The Last Supper*. New York: Viking Press, 1974.

Kemp, Martin. *Leonardo da Vinci: The Marvelous Works of Nature and Man*. Oxford, UK: Oxford University Press, 2006.

————, ed. *Leonardo on Painting*. New Haven, CT: Yale University Press, 1989.

King, Ross. *Leonardo and the Last Supper*. New York : Walker & Company, 2012.

Ladwein, Michael. *Leonardo da Vinci, The Last Supper: A Cosmic Drama and an Act of Redemption*. Forest Row, UK: Temple Lodge Press, 2006.

MacCurdy, Edward. *The Notebooks of Leonardo da Vinci*. New York: George Braziller, 1954.

Marani, Pietro C. *Leonardo da Vinci: The Complete Paintings*. New York: Harry N. Abrams, 2000.

Nicholl, Charles. *Leonardo da Vinci: Flights of the Mind*. New York: Penguin, 2004.

O'Malley, Charles D. *Leonardo on the Human Body*. New York: Dover, 1983.

Pedretti, Carlo. *Leonardo: A Study in Chronology and Style*. Los Angeles: University of California Press, 1982.

Richter, Jean Paul, ed. *The Notebooks of Leonardo da Vinci*. Vols. 1 and 2. New York: Dover, 1970.

Sguaitamatti, Domenico. *The Last Supper: The Masterpiece Revealed Through High Technology*. Rome: White Star Publishers, 2013.

Steinberg, Leo. *Leonardo's Incessant Last Supper*. New York: Zone Books, 2001.

Suh, Anna, ed. *Leonardo's Notebooks*. New York: Black Dog and Leventhal Publishers, 2005.

Syson, Luke et al. *Leonardo da Vinci: Painter at the Court of Milan*. Exhibition catalogue. London: National Gallery Company, 2011.

Taglialagamba, Sara, and Carlo Pedretti. *Leonardo and Anatomy*. Poggio a Caiano: CB Publishers, 2010.

Vezzosi, Alessandro. *Discoveries: Leonardo da Vinci*. New York: Harry N. Abrams, 1997.

Zöllner, Frank. *Leonardo da Vinci: 1452–1519; The Complete Paintings and Drawings*. Köln, Los Angeles: Taschen, 2012.

Zöllner, Frank, Johannes Nathan, and Karen Williams. *Leonardo da Vinci: Sketches and Drawings*. Los Angeles: Taschen, 2006.

INDEX

Page numbers in *italics* indicate photographs not in the color insert.